Cincinnati Art Museum

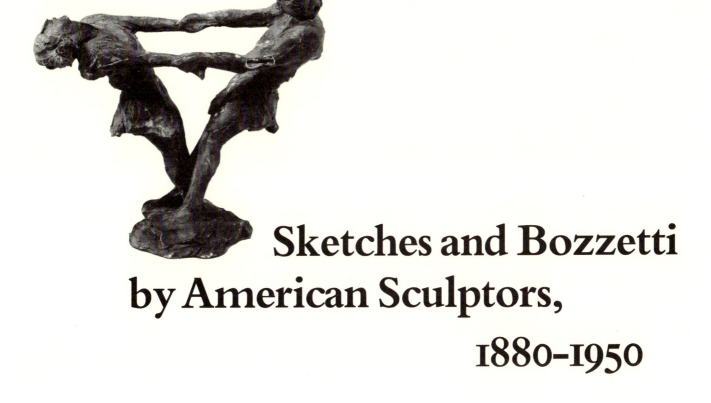

Sketches and Bozzetti by American Sculptors, 1880-1950

by Millard F. Rogers, Jr.

Copyright 1987 by the Cincinnati Art Museum
Eden Park, Cincinnati, Ohio 45202
All rights reserved

Editor: Carol M. Schoellkopf
Designer: Noel Martin
Typesetter: Cobb Type
Printer: Eastern Press, Inc.

The author and the Cincinnati Art Museum express their
appreciation to The Henry Luce Foundation and the Luce Fund
for Scholarship in American Art for a grant that enabled research
and publication.

Cataloging Notes:

Rogers, Millard Foster, 1932-
 Sketches and bozzetti by American sculptors 1800-1950.

 Bibliography: p.

 1. Models (Clay, plaster, etc.) 2. Sculpture, American –
History – 19th century. 3. Sculpture, American – History – 20th
century. 4. Sculpture, Modern – 19th century – United States.
5. Sculpture, Modern – 20th century – United States.
I. Cincinnati Art Museum (Ohio) II. Title.

NB 205 R63 1987 730.9'73
ISBN 0-931537-08-8

Contents

To Seth

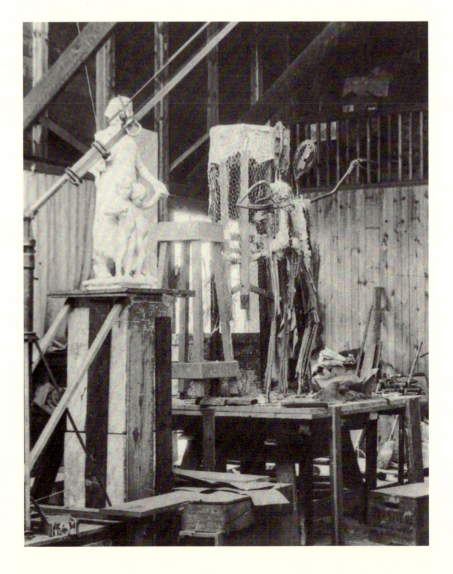

Charles Grafly's one-half size enlargement (left) in plaster of *Pioneer Woman Memorial*, 1913-15, with armature for full-scale enlargement (right).

Acknowledgments

The Luce Fund for Scholarship in American Art "was designed to encourage the growth of serious scholarship on every aspect of American fine and decorative arts, a field that has often been undervalued by art historians. A secondary agenda is to assist American museums in placing greater emphasis on research and scholarship than has generally been possible in the face of other pressures." In 1983, the Cincinnati Art Museum was awarded a grant from the Henry Luce Foundation, working through the Luce Fund, to support my study of American sculptors' sketches and *bozzetti* created in the century-and-a-half from 1800 to 1950. The author and the Cincinnati Art Museum express their appreciation for this grant that enabled research and publication.

I am grateful to the following curators, scholars, collectors, art dealers, sculpture experts, and colleagues who shared their knowledge or provided information and photographs: Marjorie P. Balge, Elisabeth Batchelor, Peter Bermingham, Stephen Bonadies, Martin H. Bush, William J. Chiego, Janis Conner, Wayne Craven, Philip N. Cronenwett, James M. Dennis, Beth DeWall, John H. Dryfhout, Jonathan Fairbanks, Stuart P. Feld, William H. Gerdts, Jennifer A. Gordon, Kathryn Greenthal, George Gurney, Donna J. Hassler, David C. Henry, Gary A. Hood, Domenic J. Iacono, Kathleen Jones, Mitchell D. Kahan, Michael Kelly, Gloria Kittleson, Leanne A. Klein, Paula Kozol, Susan Frisch Lehrer, Richard H. F. Lindemann, Genevieve A. Linnehan, Mary Alice Mackay, John W. Mecom, Jr., Susan E. Menconi, Jean Miller, Margaret M. Mills, Martha Mincey, Theodora Morgan, Beatrice Proske, Lisa Quatt, Jan S. Ramirez, Harry Rand, Marilyn Reichert, Norman Rice, Michael Richman, Betty Rosasco, Joel Rosenkranz, Richard S. Schneiderman, Darrel Sewell, Audrey Karl Shaff, Howard Shaff, Michael Shapiro, Lewis I. Sharp, Mary Smart, Ira Spanierman, Margaret Sullivan, William H. Truettner, Reagan Upshaw, J. Carson Webster, Allen S. Weller, Stephen E. Whitesell, Roger Williams, Richard Wunder, Marjorie MacMonnies Young, and Tina Zaras.

For comments and advice on the text I am indebted to John Dryfhout. Thanks are due Noel Martin for his design of the book, and Carol M. Schoellkopf and Beth DeWall for editorial and publishing coordination. Particularly to be acknowledged is Terrie Benjamin, who coordinated all aspects of the project and typed the manuscript. Her help was essential and is greatly appreciated. To my wife and son, my gratitude for their patience and support.

Cincinnati, Ohio

Millard F. Rogers, Jr.

Charles Grafly working on full-scale enlargement in clay of
Pioneer Woman Memorial, 1913-15

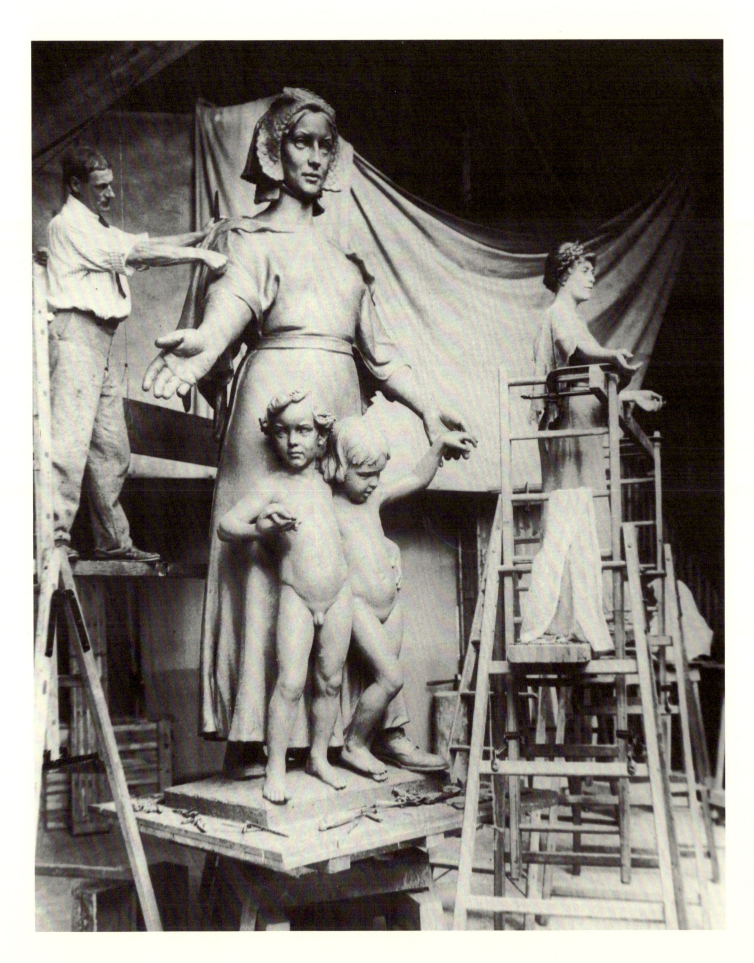

Introduction

Describing the studio of Kenyon, the young American sculptor in the *Marble Faun*, Nathaniel Hawthorne recorded the appearance of a typical expatriate's creative environment. More important than his description was the suggestion that the vital, creative spark of the artist is seen in clay modeled by his own hands: ". . . there are a few roughly modeled little figures in clay or plaster, exhibiting the second stage of the idea as it advances towards a marble immortality; and then is seen the exquisitely disguised shape of clay, more interesting than the final marble, as being the intimate production of the sculptor himself, molded throughout with his loving hands, and nearest to his imagination and heart" (Hawthorne 1860, 91-92).

A sensitive visitor to the studio, like Hawthorne, could see in this common, impermanent material the creativity expressed in clay, so scorned by most Victorians who praised instead "white moonlight" carved in marble. Because clay was so fragile, fired in a kiln or not, few sketches and models exist today when counted against the marble and bronze ultimately derived from them. The fragility of clay and its denigrated status in the nineteenth century combined to produce the loss of some of the most expressive sculpture created by America's nineteenth- and early twentieth-century sculptors.

American sculptors of the nineteenth century and early decades of the twentieth, like their predecessors of centuries past, were modelers in clay. Nascent ideas were developed first in clay as roughly fashioned sketches or *bozzetti*, followed by more developed, finished handling in subsequent sculptures of the same subject. Successive sketches became more detailed and less abstract while size increased. Studio assistants usually joined the sculptor at various stages in the progress from sketch to finished work. Except for an artist fashioning the first, smallest *bozzetto,* assistants frequently helped attach clay to armature and made plaster casts of the work along the way, while marble carvers or bronze-casters were employed finally to execute the final stages in the sculpture process.

To most patrons, collectors, and the sculptors themselves in the nineteenth century, fine sculpture meant carved Carrara marble, not clay. Cast bronze was seldom accorded the same high praise, except when needed for public monuments or in portraiture. Precedent for this adulation had been established by the great Antonio Canova (1775-1822) and Bertil Thorvaldsen (1770-1844) in the beginning of the century. This preference for marble sculpture persisted for 100 years. Once a sculptor became recognized through patronage and popular subjects, it was his practice to hire stonecutters to translate his model into marble. The act of translating the artist's conception, first fashioned by his hands, removed the artist from his work, and a vacuous and unfeeling sculpture often rich in surface detail but weak in expressiveness frequently resulted. Bronze casting, increasingly popular by the end of the nineteenth century, captured more or less the sculptor's finished model as intended. Bronze-cast sculpture did not suffer from unfeeling artisans' hands as marble did when interpreted by cutters and polishers, but bronzes still were once removed from the artist's own workmanship and modeling.

In spite of the period's considerable devotion to sculpture, for works with literary and mythological allusions, for portraits and public works alike executed in exquisitely carved or cast realism, it is remarkable that there is so little literature or writers' comments in the nineteenth and twentieth centuries on the important role and attractiveness of the sculpted sketch. But the sculptors themselves disregarded publicly all but the ultimate result of their efforts. Any preliminary, conceptualizing statements in clay or plaster, examples of the most

active participation of the artist, were kept hidden and unobserved from patron and public.

This study of an overlooked aspect of American sculpture in the century-and-a-half since 1800 focuses attention on an unappreciated but foundational, highly expressive genre of American sculpture: the sketch or *bozzetto*. It illustrates sculptures that best convey directness, creativity, and sensitivity in modeling through clay, plaster, or other materials. It records examples where the cast may be the only available record of the artist's initial, direct modeling. The study is not a catalogue of every known *bozzetto* or sketch by American sculptors, an impossible task, but rather, it assembles a large number of significant and interesting examples. It unearths the real basis of American sculpture between 1800 and 1950. It is the first time a study with this thesis has been undertaken. It also illustrates that the hand-and-tool-modeled original sketches best record the creative spark of the sculptor's creativity stages, and that the traditional, accepted aesthetic for the sculpture of the period must be enlarged to recognize what was once ignored.

Sketch, Bozzetto, Model

The *bozzetto*, sketch, model – by whatever name the artist's three-dimensional manipulation in modeling material is called – is to the sculptor what the preparatory drawing or sketch on paper is to the painter. *Bozzetto* is an Italian word meaning sketch, model or outline. It defines the work of the sculptor's own hands, usually diminuitive, in clay, wax, or plaster that serves as a preliminary model for a proposed sculpture. Frequently the final sculpture was on a larger scale and of more durable material. A *bozzetto* may or may not be roughly modeled, but it usually is suggestive of a more finished composition to be realized later. *Bozzetto* and maquette are often used synonymously. The French term, maquette, is derived from the Italian *macchia* and implies to some historians something more roughly fashioned than a *bozzetto*.

Clay, wax, or plaster sketches, even from decades or centuries apart in time, have a commonality about them, a sameness in technique and appearance that has persisted since the Renaissance. While the final appearance of the sculpture changes between sculptors, from the polished marbles of Powers, Greenough, and Crawford to impressionistically treated bronzes by Grafly, Bartlett, and MacMonnies, their sketches have a resemblance that underscores the foundation role they played in 150 years of American sculpture history.

The *bozzetto* or sketch in clay rarely equalled the size of the bronze or marble to be derived from it. Hired artisans were available in the sculptors' studios to translate sketches and construct an enlargement built around a large-scale armature. One famous member of the expatriate American sculptors of the Victorian decades suggested that the sculptor "carefully studies the composition of his statue, the proportions, and the general arrangements of the drapery, without regard to very careful finish or parts. This being accomplished, and the small model cast in plaster, he employs someone to enlarge his work to any size which he may require; and this is done by scale and with almost as much

precision as the full-size and perfectly finished model is afterwards copied in marble" (Hosmer 1864, 734).

Bozzetti or sketches emphasized plastic qualities rather than specific detailing that would express literary, mythological, or religious subject matter. Models in clay helped to resolve questions of light and shade, mass, and the interrelationship of forms in space. Such sketches, however uncollected and ignored, were truly expressive of sculpture's form and function in the most abstract depictions of mass, pose, proportion, mood, and so on. This expressiveness was largely unappreciated by nineteenth-century patrons, and the sculptors themselves did little to beckon collectors to understand, or at least admire, the beauty of the *bozzetto*. The contrast between the appearance, size, materials and finish of *bozzetto* and the same elements in the finished sculpture is echoed in the difference between the sculptor's private appreciation of the sketch and the public's admiration of the final work in marble or bronze. Even today, public critics and sculpture historians alike have ignored the sketch.

In a letter to his mother, March 17, 1875, Augustus Saint-Gaudens anguished in New York City over the lack of public appreciation for the *bozzetto*: "Now what I propose to do, if I am unsuccessful during the summer in getting other orders, is to rent a studio here and model a sketch of Columbus or Gutenberg or the 'Farragut,' and on that sketch try and get a commission so as to have it presented to the Central Park. For I almost despair of receiving any orders on the sketches that are coming over. They are not finished enough I am afraid. The more I go around the more I see how little the public comprehends, and how necessary it is that a sketch be highly *polished* for them to understand it. We shall see. The photos of my sketches decidedly make impressions only on artists" (Saint-Gaudens 1913, 117). One of the appreciative few was the artist John LaFarge who wrote to Saint-Gaudens in 1878 regarding the chancel commission for St. Thomas Church, New York City: "When I get a photograph in the open air with sun I shall send you one. Everybody so far is pleased except the stonecutters here who think that the work does not look finished. They are evidently disguised as New York Academicians – or writers on the *Evening Post* – and we need not worry about them" (*Ibid.*, 212).

The finished look of a sculpture obviously was important above all else to the prosperous purchasers. Most sculptors felt this way as well, or at least considered their sketches as private, unrealized works, not suitable for public display. When American *bozzetti* were not destroyed through neglect or the plaster-casting process, they gathered dust on studio shelves. Today we admire sculptured sketches for their small size, richly modeled surfaces, and their freshness and spontaneity. The sculptors of the nineteenth and early twentieth century, trained in academies or *ateliers*, would not have considered such works as finished and rarely would they exhibit publicly their small sketches and studies.

Abstractions are more difficult to comprehend than realistically detailed, representational, finely-wrought works. For a nineteenth-century public that worshipped verisimilitude, however idealized or imaginatively treated, the rough abstractions in *bozzetti* were little understood. Sculptors encouraged this mystery, retaining sketches in their studios as personal mementoes, endorsing the popular estimate that only finished sculpture was credible as "public" art. "The history of American sculpture through the early years of the 20th century is inseparable from ideas concerning sculpture's purpose or destination: consequently it is deeply involved in questions of patronage. Unlike painting, which could tolerate individual eccentricities, sculpture remained a public art" (Whitney 1976, 113). Not

only was sculpture expected to be appreciated, it was esteemed as statuary, as figural work, and was allied with architecture, memorialization, and public settings. By the late nineteenth century, a sculptural aesthetic was confirmed in the constitution of the National Sculpture Society, founded in 1893, that demanded ideal works, public commissions, figural examples, and architectural decoration. It also asserted that the Society should "...foster the taste for, and encourage the production of, ideal sculpture for the household and museums" (*Ibid.*, 158). Furthermore, the Society promoted "the decoration of public and other buildings, squares, and parks with sculpture of a high class," aligning itself officially with the practice of earlier decades of sculptors, patrons, and critics.

Charles Grafly blocking out a *bozzetto* in clay, c. 1890

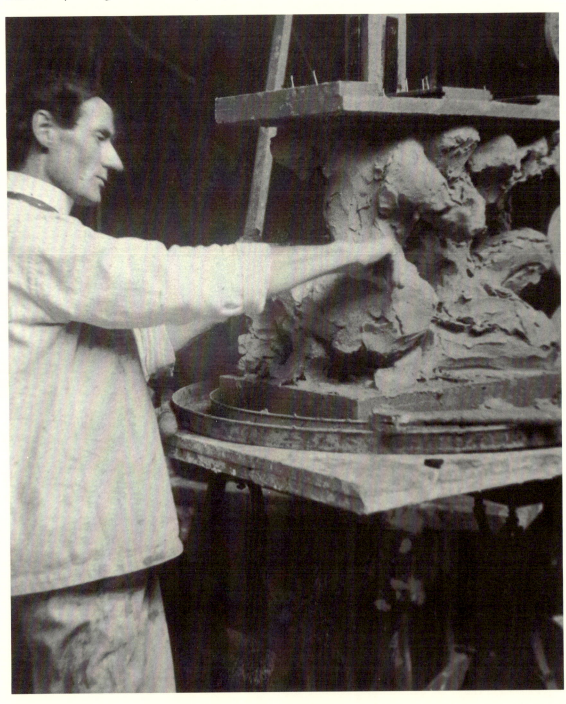

Modeling: "Sculpture...born in clay"

Thorvaldsen is credited with the remark that "a sculpture is born in clay, dies in plaster, and is resurrected in marble." Of these three materials commonly employed in nineteenth-century American sculpture, marble was the most important to the artist, collector, and patron. A work in clay was regarded as a preliminary, unrealized sculpture. But shaping the clay was the creative act; the clay model was the direct expression of the sculptor. Underlying the work of the neoclassical sculptors in the early to mid-nineteenth century, through the period of Paris-dominated training and the Ecole des Beaux-Arts influence, and into the period of large-scale expositions and World War I, whether or not the work was eventually realized in marble or bronze, clay modeling of a sketch was essential to the sculptor's craft.

Among the earliest European writers on modeling, Giorgio Vasari (1511-1574), eminent Italian artist and historian of the High Renaissance, wrote knowledgeably of the clay and wax sketch, substantiating its role as the initial step that concluded in a finished marble or bronze sculpture. In *Lives of the Artists,* first published in 1550, Vasari's paragraphs on techniques defined the practice still pursued three hundred years later: "Sculptors, when they wish to work a figure in marble, are accustomed to make what is called a model for it in clay or wax or plaster; that is, a pattern, about a foot high, more or less, according as is found convenient, because they can exhibit in it the attitude and proportion of the figure that they wish to make, endeavouring to adapt themselves to the height and breadth of the stone quarried for their statue" (Vasari 1907, 148).

Sixteenth-century modeling techniques in clay and wax were similar, according to Vasari, who remarked on the careful attention required for proper armatures or the interior skeletons for models in wax (but not in clay): "Should he wish to make his model in clay, he works exactly as with wax, but without the armature of wood or iron underneath, because that would cause the clay to crack open and break up; and that it may not crack while it is being worked he keeps it covered with a wet cloth till it is completed" (*Ibid.*, 149-150). The sketches or *bozzetti* of the sixteenth century exist today in terra cotta (fired clay) originals, primarily, and not as plaster casts, miracles of preservation. Plaster casts of clay sketches were seldom made. Vasari also stressed the importance of the full-scale model in clay: "When these small models or figures of wax or clay are finished, the artist sets himself to make another model as large as the actual figure intended to be executed in marble. In fashioning this he must use deliberation, because the clay which is worked in a damp state shrinks in drying; he therefore, as he works, adds more bit by bit and at the very last mixes some baked flour with the clay to keep it soft and remove the dryness. This trouble is taken that the model shall not shrink but remain accurate and similar to the figure to be carved in marble" (*Ibid.*, 150).

Giovanni da Bologna (1529-1608) encountered the elderly titan, Michelangelo, about 1550, to whom he reportedly showed a sculpture of his in clay. The older master squashed it and re-made it, adding: "Now go off and learn to model first, before trying to finish anything" (Baldinucci 1846, 556). From this account one may reason either that Michelangelo disdained the younger artist's handling of the clay or he advocated accomplished practice in modeling *bozzetti* before attempting a "finished" work. And Giambologna evidently accepted the advice, for many sketches by him have survived, showing his interest and, indeed, that of later collectors in preserving these fragile sculptures.

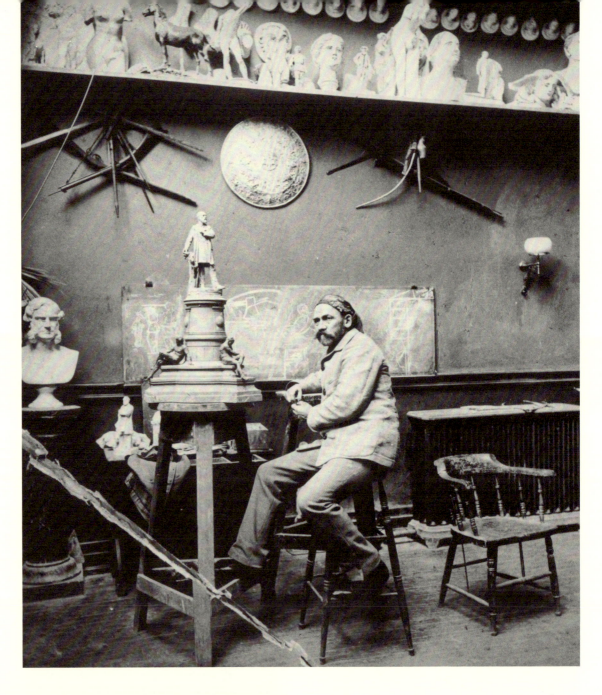

John Quincy Adams Ward in his studio with *bozzetto* of
Garfield Monument, c. 1885.

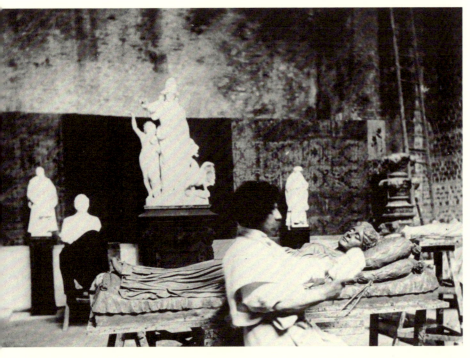

Sir Moses Ezekiel in his Roman studio in the Baths of
Diocletian, c. 1890

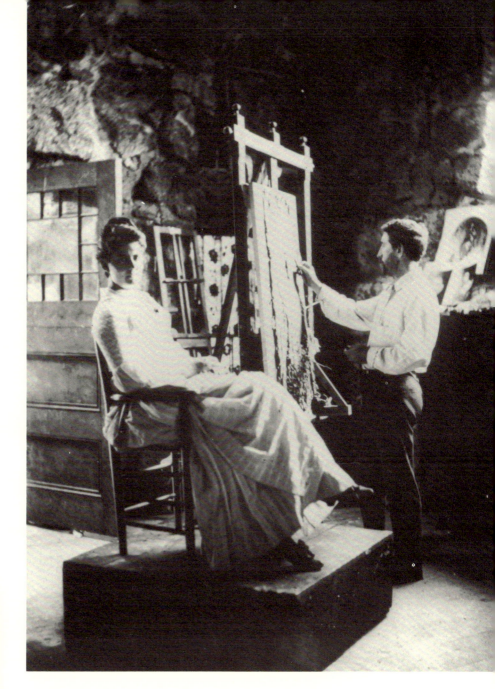

Augustus Saint-Gaudens modeling clay relief of Mrs.
Grover Cleveland, 1884

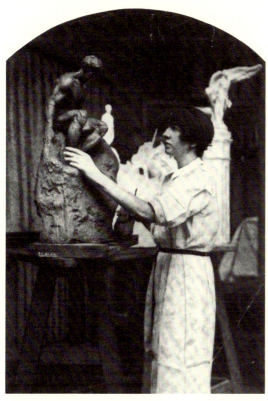

Gertrude Vanderbilt Whitney with clay sketch

Four centuries after Vasari wrote his treatise on sculpture, a concise discussion of nineteenth-century modeling, casting, and carving techniques was prepared by the American Harriet Hosmer (1830-1908), who wrote in "The Processes of Sculpture" that "Many suppose the sculptor to hammer away upon a block of marble, until his mental conception is embodied, never conceiving that the artist lavishes all his care and best powers upon a clay model of the work to be wrought in the stone" (Hosmer 1864, 33). The sculptors could only blame themselves, however, for any misunderstanding, for sculptors negated all but the final translating of their works into pure Carrara marble. Most visits to sculptors' studios revealed plaster casts or marble replicas as samples of sculpture that could be ordered; seldom was an original sketch in clay to be seen. Visitors who saw clay models in artists' studios were not necessarily unappreciative of works in clay, and some were equally moved by both marble and clay if they were permitted to see the latter. They commented often, however, in their letters and diaries, that a sculpture seen in a studio was "still clay," an indication that this state was but a minor one leading to a more accomplished stage (Walker 1866, 103).

Writing later than Hosmer, William Ordway Partridge (1861-1930) echoed the lady sculptor's revelations in a valuable account published in 1895: "Modern sculptors do little upon the marble with their own hands, which fact, in a measure accounts for the characterless result of many finished statues, when compared with a clay model" (Partridge 1895, 91). Partridge's comparisons did not express the majority opinion of his predecessors or contemporaries, but he succinctly identified the issue of modeling versus carving and the techniques involved. Partridge's account is invaluable for its step-by-step discussion of working in clay. His essay describes the practice of every American sculptor trained in the traditional manner.

Modelers usually worked with an eye-level stand that revolved, as photographs confirm showing sculptors in their studios, so that the gradual build-up of forms could be monitored easily. The pliable clay preferred by the sculptors "should be soft as velvet," Partridge recommended. American clay was preferred to that found in Europe (*Ibid.*, 55). The sketch was built up by bits and pieces, melding balls and pellets of clay together, a traditional technique taught in the best academies and art schools in Europe and America. Partridge urged the sculptor "to keep all at the same state of advancement . . . attend to mass, first, then detail will come naturally" (*Ibid.*, 56). An armature of wire or wood was constructed for sketches larger than six or eight inches or for works with extended arms, legs, or drapery over which clay could be formed. If the sketch was to be fired, no armature was employed. The most important modeling tools were available for cutting, rasping, or smoothing the clay. Partridge stressed the importance of a well-built armature, for "A flimsy construction has ruined many a noble statue" (*Ibid.*, 61). He advocated that clay first be pressed to it to form the torso, followed by the limbs.

If the finished work in marble or bronze was to be very large, at least a *bozzetto* and a full-size model (or an enlargement) would be modeled by the sculptor, the latter work aided by assistants. This sculpture also was built over an armature. Harriet Hosmer described the process as requiring a "skeleton in iron, the size and strength of the iron rods corresponding to the size of the figure to be modeled; and here, not my strong hands and arms are requisite, but the blacksmith with his forge, many of the irons refusing to be heated and bent upon the anvil to the desired angle. This solid framework being prepared, and the various irons of

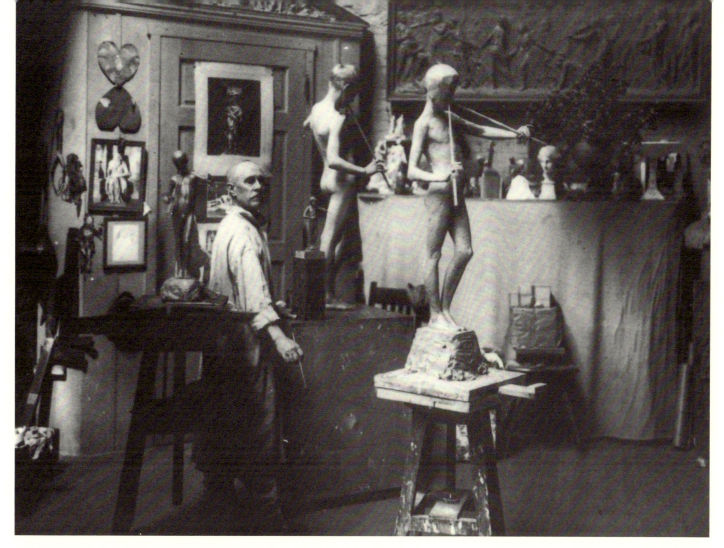

Clement J. Barnhorn with full-size model of Morgan G.
Bulkeley Fountain, Hartford, Connecticut, and its *bozzetto*
(between sculptor and live model), c. 1917

which it is composed firmly wired and welded together, the next thing is to hang thereon a
series of crosses, often several hundred in number, formed by two bits of wood, two or three
inches in length, fastened together by wire, one end of which is attached to the framework.
The clay is then pressed firmly around and upon the irons and crosses with strong hands and
a wooden mallet . . . when the clay is properly prepared and the work advanced as far as the
artist desires, his own work is resumed, and he then laboriously studies every part, corrects
his ideal by comparison with living models . . . and gives to his statue the last refinement of
beauty" (Hosmer 1864, 735). This process suggests that artisans created the enlargement,
and the sculptor finished and corrected their work. The time required for the completion of
steps from *bozzetto* to finished marble replica varied from sculptor to sculptor. A time frame
experienced by Hiram Powers (1805-1873) likely was typical, and the progress took many
months. As a young sculptor trained by Frederick Eckstein in Cincinnati, Powers in 1823-25
was experienced in wax- and clay-modeling techniques. Later he demonstrated his
mechanical abilities at Joseph Dorfeuille's Western Museum with animated figures that
brought horrifying drama to the Queen City. Powers conceived his marble masterpieces
first in clay, and wrote about several works and the process to patron-friends. The first
sketch for *Eve Tempted* was modeled in December 1839 and nearly finished by January 1840
(Reynolds 1975, 133-134, quoting letter of Hiram Powers to Sidney Brooks, December 29,
1860). The full-size model in clay was finished on April 13, 1842; the plaster mold was
removed April 18; the cast made on April 21; and the plaster replica completed April 30. The
process from *bozzetto* to finished plaster for Powers' famous work took some twenty-seven
months to prepare the work for the marble cutters.

American sculptors seldom fired their *bozzetti* in kilns and only rarely preserved their more finished clay models. European sculptors, however, preferred to harden their clay sketches by kiln-firing, producing terra cotta. The plastic, workable natural earth, frequently a stoneware clay, was vitrified in a kiln if the model was to be preserved (Rich 1970, 25). Air space within the sketch was required for firing, so hollowing out the sculpture was imperative if drying and little cracking were to occur equally throughout the piece. The clay sketch had to be as dry as possible before firing. After firing, during which shrinkage occurred at a rate of one-tenth of an inch per inch of clay, it ranged in color from grayish buff to rusty red. There is no equivalent in American sculpture to the European's appreciation of terra cotta surfaces for glazing, painting, or gilding as seen in works by Ghiberti, the della Robbia family, or Verrocchio, so fired clay invariably was left unglazed. Compared to European terra cotta *bozzetti*, American artists in the nineteenth century accepted the use of clay for three-dimensional sketches. But European modelers recognized the *bozzetto's* multiple use for suggesting to patron the concept and mood of the commission; it sometimes served as a finished work in itself, and it could be an inexpensive reproduction of a popular piece. From the nineteenth and early twentieth centuries, only a small but significant corpus of sketches and *bozzetti* by American sculptors can be recorded. For a number of the artists, including several of the luminaries of American art, very few examples remain to show the genesis of their works. Horatio Greenough, William Wetmore Story, William Henry Rinehart, and Harriet Hosmer represent sculptors whose sketches are missing, unfortunately, a loss repeated with many other great names of a century-and-a-half of American art.

Horatio Greenough (1805-1852) learned the rudiments of modeling in 1819-20 from Solomon Willard, the Boston sculptor-architect, and from J.B. Brion, a French sculptor in Boston, when Greenough was a youth in his teens (Wright 1963, 24). When Greenough established his studio in Italy in 1828, he went to the quarries of Carrara to select blocks of marble for his portrait busts and other works, but he, like his fellows, was a modeler primarily, not a carver: "By this time, in fact, a sculptor might never even touch marble. He was now chiefly a worker in clay, who usually modeled first a small figure and then a full-sized one. The clay model was given to a molder to reproduce in plaster and the plaster model to a marble cutter, customarily being sent to Carrara" (*Ibid.*, 58). As important as the rough sketch was the finished clay model from Greenough's hands. This latter work preceded a final marble or bronze sculpture, but even such a clay model is seldom encountered, suffering destruction through neglect or at the hands of the plaster caster. Interestingly, Greenough and Hiram Powers are rare commentators on clay as raw material or on its desirable qualities. Both Greenough and Powers apparently imported American clay, feeling it was more tenacious than some Italian varieties and susceptible of a high degree of finish (*Ibid.*, 210). A reporter's visit to Powers' studio recalled his preference: "Mr. Powers' patriotism is so extreme that he prefers to model in American clay, which is regularly imported, as he told us, for his use. Home soil is better to him than that of classic Arno or Tiber" (Walker 1866, 105). This extraordinary importation had its parallel in an equally unusual method of working directly in plaster of Paris instead of clay, developed by Powers, so that a separate stage of casting was not required. Some works in plaster by Powers survive, but Greenough's sketches in clay or plaster that might have illustrated the sculptor's earliest perceptions are not extant.

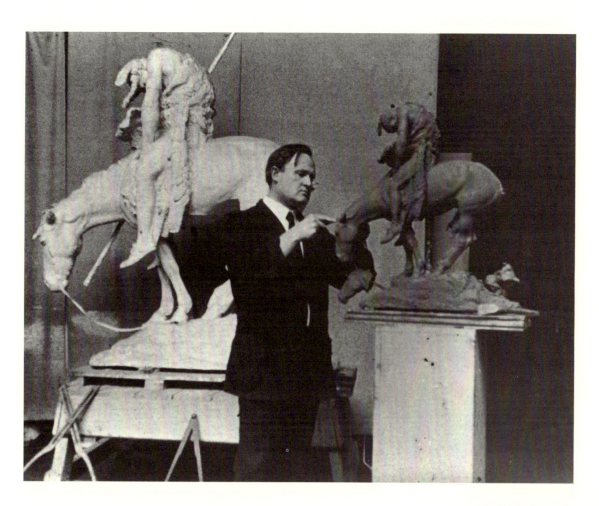

James Earle Fraser and two versions of *The End of the Trail*,
c. 1894

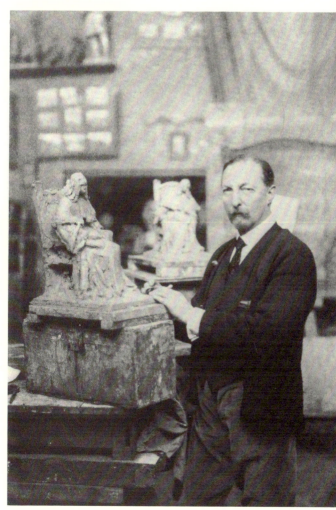

Paul Wayland Bartlett in his studio, c. 1920.

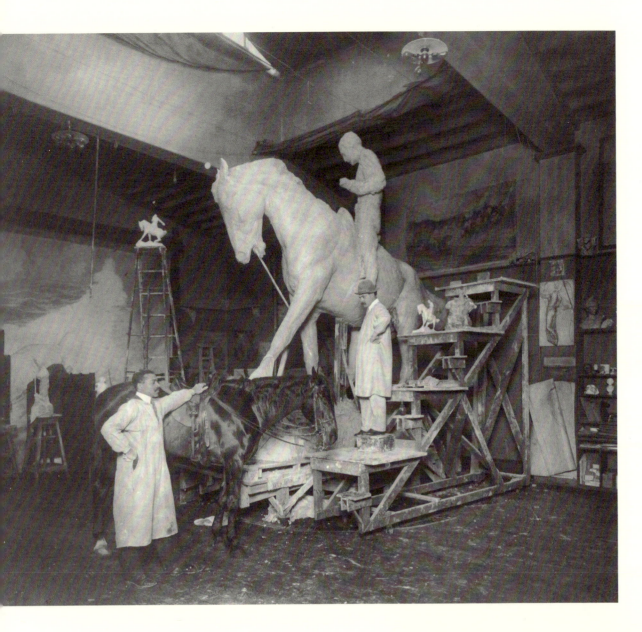

Gutzon Borglum and *bozzetto* (on step) with full-size model
of *General Philip Sheridan*, c. 1905-06

William Wetmore Story in his studio, with clay *bozzetto* on
lower tier of modeling stand, 1865.

Hardly any mention of William Wetmore Story's work in clay is made in the principal biographies of the sculptor, underscoring that clay-modeling as an activity, absolutely essential to one's livelihood as sculptor, was not important to the author's perception of Story (1819-1895) as artist. As a young man in 1843-45, Story's spare hours were spent in writing, listening to music, and working with clay (Phillips 1897, 71). Later, as a mature sculptor, his studio in Rome on the Via San Martino a Macao boasted work in various stages of activity or completion: "A visit to these apartments, filled with casts, clay models in various stages of development, designs, and finished works, was a revelation of those preeminent talents which constitute genius" (*Ibid.*, 171). And tantalizing is Phillips' listing of his *oeuvre* in her account of Story's life, concluding with a notation of "sketches and statuettes without number" (*Ibid.*, 298).

Harriet Hosmer's rank as sculptor is perhaps equalled in importance by her reporting on nineteenth-century methods in "The Processes of Sculpture," her article published in *Atlantic Monthly*, that delineated the roles of sculptor, studio assistant, and hired carver. Trained as a modeler by John Gibson, who was considered England's greatest sculptor of the 1800s, Hosmer's sketching talents in clay earned her master's praise in a letter to Hosmer's father: "We have here now, the greatest sculptor of the age, Rauch of Berlin, seventy-seven years of age. He came to my studio and staid [sic] a considerable time. Your daughter was absent, but I showed him all she had done, including a small sketch-model for a statue life size" (Carr 1912, 24). The pseudonymed correspondent Florentia saw Hosmer about the same date in Gibson's studio, commenting: "At the present time she must be under twenty, and to see her with her little artist-cap jauntily stuck on one side of her head, her glowing, beaming eyes bent upon her work, and her delicate little hands labouring industriously on the clay, is as pretty a sight as one would wish to see any fine summer day" (Florentia 1854, 354). While Hosmer never recanted the aesthetic bylaw governing most American sculptors of her day, that "a work can never be really finished till it is in marble" (Carr 1912, 38, quoting letter of Harriet Hosmer to Wayman Crow, October 12, 1854), an observer in her studio was cognizant, even appreciative, of Hosmer's sketching in clay: "I was glad to see it the clay model of the *Waking Faun* in this stage, as it shows how entirely the whole expression of this statue is due to the sculptor himself, and how mechanical is the work of the chisel" (*Ibid.*, 221, quoting letter of unknown correspondent to the Rev. Robert Collyer, 1867).

William Henry Rinehart (1825-1874) left little evidence of his abilities as a modeler, although *bozzetti* for both ideal sculpture and portraits surely existed. One letter to a patron in 1873 shows that Rinehart used his sketches to give form and body to a concept: "I received your letter a few days ago but have been so busy that I have not found time to write. I have enclosed you a photograph of my sketch. It is very rough but will give you some idea of what I propose to make. I have been so pressed that I found it impossible to make a more finished sketch" (Rusk 1939, 38, quoting letter of William Henry Rinehart to John W. Paine, February 26, 1873). More interesting than Rinehart's mention of the sketch, perhaps, is the record this letter provides of photography as an effective intermediary between patron and artist.

Discussing his working methods with a writer for *Harper's Monthly* in 1878, John Quincy Adams Ward (1830-1910) referred to his sculpture then in the studio, and the writer reported: "His method of work is first of all to draw a sketch on paper – sometimes two,

three, or even four sketches - for the purpose of experimenting with composition, pose, and expression. Next he makes a small model in clay - often two or three models; for a large equestrian figure half a dozen of them - again for the sake of experimenting. The object is to determine the manner of treatment, to get the most comprehensive position, pose, and expression" (Sheldon 1878, 66).

Arguably the most popular American sculptures in the nineteenth century, *Rogers Groups* were cast plaster vignettes drawn from English history, contemporary political events, American literature and other appealing subjects. The purchasing public sought both story-telling and parlor decoration in these mass-produced slices of life. Correct costumes, accurate portraits of well-known men and women, and a frozen moment in time were the elements of Rogers' realism that so endeared the *Rogers Groups* to an eager public. The preliminary sketches or studies for them presumably were abstract and incomplete in comparison with the final cast plasters. John Rogers' (1829-1904) modeling methods were not unlike those of his contemporaries, with a rough sketch in clay, about one-third or one-fourth the size of the projected group, creating the shape and mass of his chosen subject (Wallace 1967, 285). Facial features and expressions were not detailed. After determining the final arrangement of figures for the depicted scene in a *Rogers Group*, the sculptor fashioned a finished model in clay: "With a lump of clay before me, I should not have a moment's lonely feeling if I did not speak to a human being for a week at a time" (*Ibid.*, 285). The finished clay sculpture always was intended for use in making molds from which the plaster replicas were cast in his own factory. Rogers preserved these small sketches, for in 1890 his studio contained many examples (*Ibid.*, 285). Unfortunately, none have survived.

Originality and Other Terms

Originality is a complex question when confronting a nineteenth-century American sculpture cast in bronze or carved in marble. If definitions of originality can be decided, do modern explanations mean the same as they did 100 years ago? Until the twentieth century, originality in sculpture was not a crucial issue. This study acknowledges the creative preeminence of the sketch or *bozzetto*: originality in the strictest sense resides in the *bozzetto* or sketch. The late H. W. Janson corroborated: "Thus, if we give the term 'original' its full meaning, as we do when we speak of an original painting or drawing, there are no originals in nineteenth-century sculpture unless the maquette has been preserved . . . "(Janson 1985, 10). As this study approaches nineteenth- and early twentieth-century American sculpture with a different thesis than encountered in other studies, an attempt to establish workable definitions will be useful in understanding and appreciating an extensive body of clay and plaster sculptures. Some definitions that follow may seem too arbitrary, and it is recognized that nineteenth-century sculptors' definitions are not necessarily current ones.

We know most sculptors' work from 1800 and into the next century through intermediaries, bronzes that reproduce the clay original in another medium and marbles that mimic hand-modeled plasters. Attempting to define "original" suggests the need for a term

that clearly indicates the artist's direct, modeling involvement, the sculptor's creative expression evidenced in a work fashioned by his hand, not by an intermediary's.

The term "autograph original" recognizes the physical manipulation of the plastic material or the sculptor's personal carving of the marble with hammer and chisel, but it does not necessarily foretell the completed, ultimate work of art. A nineteenth-century artist might consider his autograph original (in the case of a *bozzetto*) as a preliminary sketch or rough version, and the final medium (such as a cast bronze) as an original. Seldom was an autograph original intended to be the final product of the artist. His aesthetic credo and the patron's interests sought a more finished appearance than clay or plaster or wax could give, a more permanent material for its form. For some sculptors, their degree of intervention in the stages of casting or finishing added an autographic quality to the work.

Nineteenth-century sculpture is known primarily through "reproductions." Most of the works in marble by American sculptors in the nineteenth century by such artists as Hiram Powers, Horatio Greenough, Randolph Rogers, and William Wetmore Story, should be considered reproductions, although these sculptors and their patrons would not have used this term to distinguish works so precisely. While a host of determinants must be considered (sculptor's intent, purpose of the work, interpretive impact, etc.), the term "reproduction" broadly defines all types of sculpture that are not autograph originals. Casts, enlargements, replicas, copies, and reductions are reproductions, as these examples are not modeled or cut directly by the artist himself, except in those rare instances where the artist may have created an enlargement in a medium worked by his own hands. Antonio Canova promoted what he called the "original sketch plaster," a sculpture not dependent on church or aristocratic commissions and produced in an inexpensive material (plaster), monumental in size if desired. But nineteenth-century American sculptors marched to a more traditional drummer. Plaster was utilized primarily to preserve the shape and form of fragile clay in the *bozzetto* or intermediate and later stages of the model. Plaster had an existence of its own largely because it preserved work created in another medium and could serve as a sturdy guide to carver or bronze-caster. True, some American sculptors produced works in plaster on a speculative basis, having no commissions in hand, but plaster was never regarded as permanent as eternal marble or bronze. It was transient, temporary, almost like clay.

Within the broad category of reproduction are several sub-divisions. A "replica" is an exact duplication, such as a cast from an original, made or authorized by the artist himself. In the past, history has regarded a replica more highly than does present-day opinion. A cast not authorized by the artist, but made in the original mold or made from the autograph original, is considered by some to be a replica. But this definition should apply to a "copy," a sculpture cast from some model, usually resulting in a sculpture of about the same size as that model. A bronze casting by these definitions, then, is not an original but a replica or copy. Another term defining sculpture farther removed from the original than either copy or replica is the "surmoulage," a French word implying a "casting from a cast." Surmoulage may be employed because the plaster mold is lost, as in the casting of a new bronze from a previous bronze casting. The cast is smaller than the bronze from which it was cast, and frequently it is poorer in quality. A "reduction" or an "enlargement" of a sculpture is usually obtained as a final work in marble by a mechanical method known as a pantograph or pointing machine. For bronze casts in different sizes than the original, the sculptor's assistants developed reduced or enlarged versions of the original, and frequently these

versions in clay or plaster were touched up or partially modeled by the sculptor and not the plaster-caster. In the case of monumental sculpture in bronze or marble, enlargements from smaller originals were required, with expansion into quarter-, half-, and finally full-size scale sculptures in plaster that were then translated into durable metal or stone.

The Plaster Cast

Known to the Egyptians, casting in plaster is an ancient technique. Some casts of human limbs have been found at Tel-el-Amarna dating from c. 1400 B.C., but Pliny credits the sculptor Lysistrates with the development of plaster casting (Oxford Companion 1970, 879). Centuries later in the Renaissance, particularly in the *quattrocento*, there was a revival of casting. By the eighteenth century, academies and artists revered plaster casts and employed them in teaching programs. Casts found their way into museum collections in the nineteenth century, and whole careers of sculptors were preserved in plaster cast inventories well into the twentieth century.

The basic material of plaster is gypsum ($CaSO_4 \cdot 2\,H_2O$), the parent mineral from which plaster of Paris is derived ($CaSO_4 \cdot 1/2\,H_2O$). Sometimes called plaster or gypsum plaster, the

Illustration from William O. Partridge, *The Techniques of Sculpture,* Boston, 1895, fig. 1

Illustration from William O. Partridge, *The Techniques of Sculpture,* Boston, 1895, fig. 2

Illustration from William O. Partridge, *The Techniques of Sculpture,* Boston, 1895, fig. 3

Illustration from William O. Partridge, *The Techniques of Sculpture,* Boston, 1895, fig. 4

material is a sulfate of lime and is usually white, finely grained, and easily carved or cut. The drying of plaster is a chemical process, not one of water evaporation, as with clay, so no shrinkage occurs. Casting plaster is not popular for modeling, although Hiram Powers claimed to have worked directly in plaster, thus obviating the need for a preliminary clay model from which a cast would be made.

Collections of casts in art academies, called *gipsoteche,* were the common materials of instruction for sculptors. Teaching anatomy to art students, certainly in the nineteenth century, depended on the study of casts. Thorvaldsen spent four years (1781-85) at the Copenhagen Academy before he was permitted in the "plaster class." Then, one more year was occupied in the careful study and copying of these casts before he was permitted to draw from the living model. Besides their pedagogical use, plaster casts served other purposes. They were sculptor-authorized reproductions that preserved the clay originals, and they inexpensively duplicated his works. A library, historical society, or atheneum might easily afford a plaster cast costing a fraction of the price for the same sculpture carved in marble. Thus, economy played a role in the use and appreciation of casts.

More importantly, beyond the use of plaster casts for teaching or for easy reproduction of sculpture, American sculptors required plaster casts to preserve their clay *bozzetti,* sketches, and finished models. The European practice of firing clay *bozzetti* was never popular with American sculptors, and few examples in terra cotta by the latter are known. William Ordway Partridge's statement typified his fellow sculptors' attitude and practice that the original clay must be cast in plaster, to "put it in some more durable form or material" (Partridge 1895, 78). If the sculptor wanted to preserve his sketch, a plaster cast

was made even though the original and its cast were never intended to be exhibited. Each stage of the sculptor's progression toward finished marble or bronze was cast in plaster, and it is from the final version's plaster cast, or reproduction, that the marble carvers worked, copying as accurately as they could with chisel and file the work cast from yet another medium. To reproduce a clay sketch or finished model, the sculptor or a casting artisan, a master at his craft, fashioned a plaster skin (the mold) over the clay. An unknown correspondent writing for *Cosmopolitan Art Journal* in 1857, after discussing the clay model within the creative sequence, outlined the casting technique: "It is done by covering the clay with a coating of semi-liquid plaster, from one to two inches – provision being made for taking off the coating in sections when it is sufficiently hardened. A short time suffices to harden the plaster, when it is removed from the clay model, and then becomes a *mould*, after due cleaning, and the conjoining of sections, into which semi-liquid plaster is run, until the whole cavity is solidly full. This infusion is then left to solidify, which it does in a few days, when the "mould" is broken away from it, and there stands the statue of plaster, in the most minute particular, a facsimile of the clay model" (*Processes* 1857, 33). Because the mold is broken in removing the cast, this type of plaster-casting gives only one replica-cast of the clay model. Thus, it is called the "waste mold" method.

"Piece" molds in plaster were not usually formed from clay originals but cast from plaster replicas. In this method, small sections of the solid plaster positive were covered with wet plaster, allowing each section to dry before coating the edges with shellac to present the adjoining parts from adhering to each other. Finally, to create a cast from the many individual pieces, a "mother" mold placed around them secured the group.

Although the plaster cast was an integral, basic part of the sculpture process in the nineteenth and early twentieth centuries, often with more acceptance than the clay original, it was never given the esteem of marble or bronze. As early as 1827, a writer reflected this attitude in a review of that year's National Academy of Design exhibition: "The first *moulding*, and the *last touching*, are the appropriate label of the real sculptor; all the intermediate process is performed by workmen, and of these the plasterman's duty is least laborious and least intellectual" (Fanshaw 1827, 260). While the caster's work might be scorned, the plaster cast was not, of course. Partridge stated that "Nothing is so fine as the pure white plaster, provided a suitable light may be found for the cast" (Partridge 1895, 85). His appreciative appraisal was acceptable to his fellow sculptors, decades before and after his time. The plaster-casting process was inextricably part of the sculptors' training, their professional careers, and their patronage.

Notes on the Sculptors and on the Plates

Sculptors are arranged in alphabetical order with brief biographies of artists preceding descriptions of selected *bozzetti*, sketches, and models and illustrations of each. The sculptures are in chronological sequence by date of execution, if known, with sketches of unknown dates listed last under each artist. For titles, the sculptor's designation or the title of the monument derived from it is used. Credit lines for the *bozzetti* note the owners or the sources of illustrations. In certain instances where museum sculptures are illustrated, an accession number is included as the last part of the credit line. In some cases, illustrations were taken from archival photographs, primarily when now-lost original works are known today only from such historic documents.

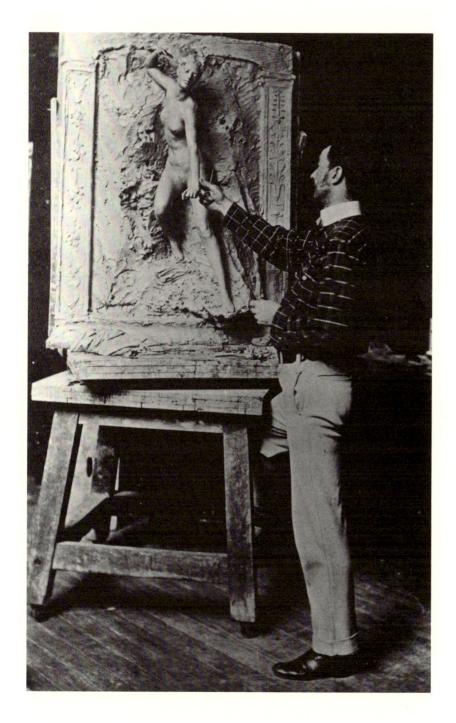

Karl Bitter and *Diana* relief for W.K. Vanderbilt's Long Island home, 1893

Clement J. Barnhorn 1857-1935

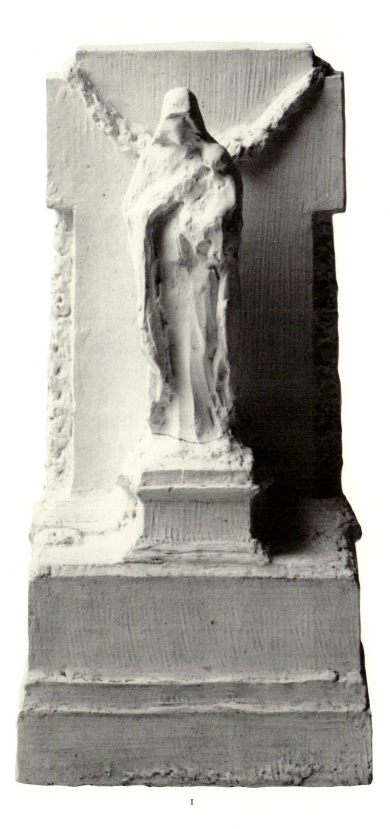

I

Born in Cincinnati. Studied at Art Academy of
Cincinnati for eleven years. European study
with Frémiet, Mercié, and Bouguereau, 1891.
Collaborated with Frank Duveneck on Mrs.
Duveneck's tomb sculpture, Florence, 1890-91.
Exhibited at Paris *Salon*, 1895 (honorable
mention) and Paris Exposition, 1900. Faculty
member of Art Academy of Cincinnati,
1901-35.

1. Barnhorn Monument, Cincinnati

1913. Plaster. Height 12½ inches (31.8 cm.).
Cincinnati Art Museum, bequest of Clement J.
Barnhorn, 1935.351

The plaster cast of Barnhorn's clay sketch is
inscribed in pencil on the reverse of the cross-
like background for the figure of the Virgin and
Child: "Original plaster Sketch model/ for
Barnhorn/ Family Monument/ St Johns
Cemetery/ St. Bernard/ 1913/ in bronze and
granite/ by Clement J. Barnhorn." Like his
contemporaries, Barnhorn was trained in the
academic tradition, and for three decades he
taught the traditional skills of modeling small
sketches in clay, followed by casting in plaster,
developing finished clay sculptures, more
casting in plaster, and bronze casting for the
final replicas and accepted versions.

Paul Wayland Bartlett 1865-1925

Born in New Haven, Connecticut. Studied under Frémiet, Cavelier, and Rodin. Exhibited at the Paris *Salon*, 1879, when only fourteen years old. Bronze casting by lost-wax method and special coloring effects on bronze surfaces he learned from French sculptor Jean Carriès. Assistant for a time to J.Q.A.Ward. Among leaders of French influences in American sculpture, he lived in Paris most of his life. Numerous awards given him during his lifetime: Chevalier, 1895, and Commander, 1924, Legion of Honor; member of the Institut de France, National Sculpture Society, and others.

2. Washington at Valley Forge

c. 1898-1901. Bronze. Height 8¼ inches (21 cm.). In the Collection of The Corcoran Gallery of Art, Gift of Mrs. Armistead Peter III

This impressionistic piece, its crevices and fissures still grainy and apparently unchased, is a bronze casting from a *bozzetto*. The equestrian figure may have been executed as a competition entry in 1901 for a monument to be erected on the Brooklyn side of the Williamsburg Bridge.

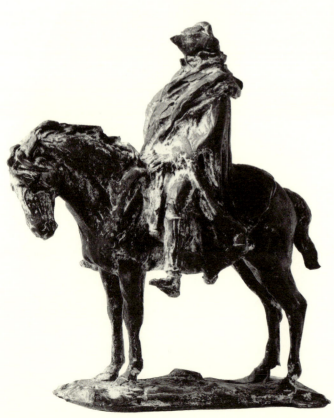

2

Bartlett was not successful, for the commission was awarded to Henry M. Shrady (1871-1922). An apparent enlargement of the sketch, a more detailed Washington on horseback, was illustrated in *The International Studio*, 1898 (Keyzer 1878, 247).

3. Philosophy

(for New York Public Library). 1909. Bronze. Height 7½ inches (19 cm.). Georgia Museum of Art, The University of Georgia, Gift of Mrs. Armistead Peter III

4. History

(Sketch A)(for New York Public Library). 1909. Bronze. Height 8¾ inches (22.3 cm.). Georgia Museum of Art, The University of Georgia, Gift of Mrs. Armistead Peter III

5. History

(Sketch B)(for New York Public Library). 1909. Bronze. Height 7½ inches (19 cm.). Georgia Museum of Art, The University of Georgia, Gift of Mrs. Armistead Peter III

6. History

(Sketch C)(for New York Public Library). 1909. Bronze. Height 7⅞ inches (20 cm.). Georgia Museum of Art, The University of Georgia, Gift of Mrs. Armistead Peter III

The New York Public Library was designed by the firm of Carrère and Hastings in classical-revival style, its façade replete with pilasters, entablature, and pediment. The projecting portions were to provide a setting for sculpture. Bartlett was awarded the commission for figures to adorn this portion of this building, December 6, 1908, and he accepted its terms and the $20,000 fee (Bogart 1982, 9).

He began work on the commission producing a series of small sketches, of which the four in the Georgia Museum of Art collection are part. Values, shading, light-and-dark relationships could be studied in these sketches, left roughened and with fingerprints unsmoothed on the bits of clay. These *bozzetti*, now cast in bronze, were intended to give some lasting form to Bartlett's first ideas. The figures probably were done in a scale of ¾ inch to one foot. In 1910-11, the size of the models increased to full-size, and the final marble replicas were put in place in December 1915.

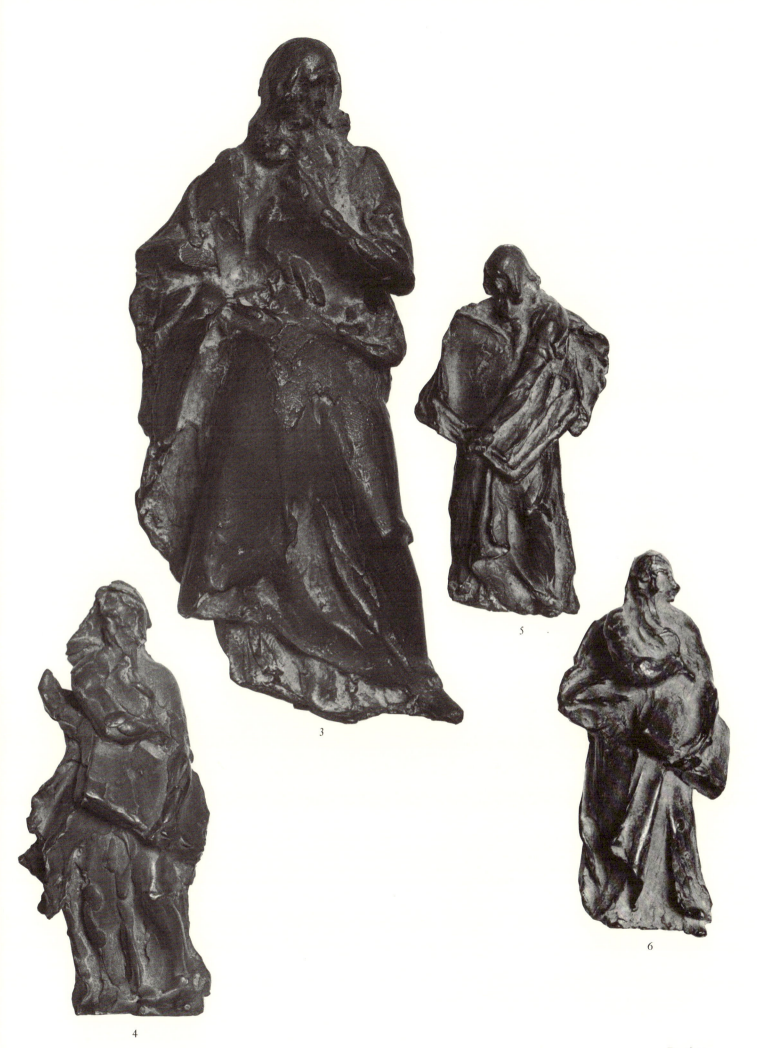

3

4

5

6

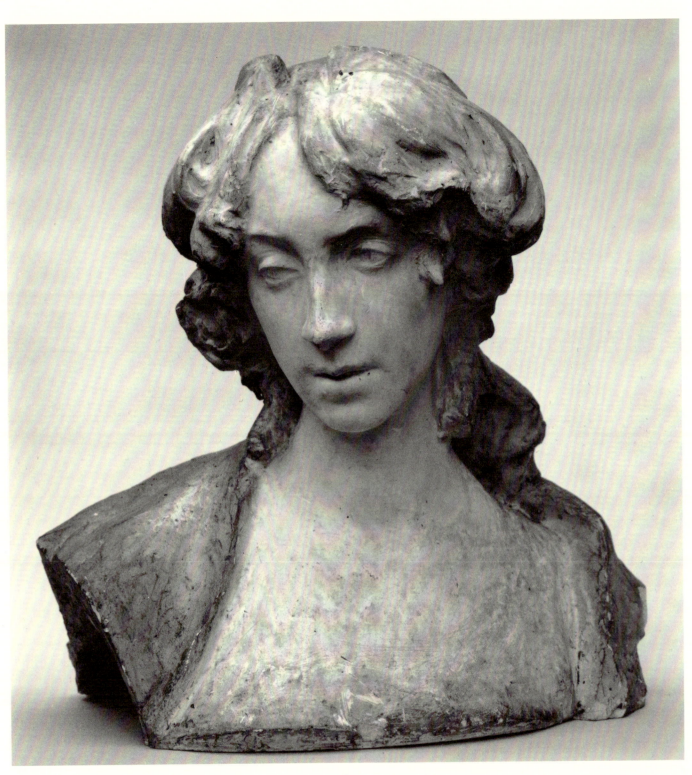

7

7. Study of a Head for Romance

(for New York Public Library). c. 1909-10.
Plaster. Height 17 inches (43.2 cm.).
Metropolitan Museum of Art, gift of the artist,
1919.35

A study for the head of one of the six figures on
the entablature of the New York Public Library
on Fifth Avenue, representing Philosophy,
Romance, Religion, Poetry, Drama, and
History, this winsome figure is very similar to
certain bust portraits by Italian Renaissance
masters, Andrea del Verrocchio or Antonio
Rossellino. Full-length plasters of some of the
Bartlett sculptures were finished by 1910, so
presumably this plaster can date from about the
same year (Bogart 1982, 13). By 1911, the
plasters were placed on the attic of the Library
to study their effect within the architectural
setting.

8. Seated Male Figures

(for *Fountain of the Engineers*). Before 1920?
Bronze. Height 3½ to 4 inches (8.9-10.2 cm.).
The North Carolina Museum of Art, Raleigh,
gift of Mrs. Armistead Peter III, G. 58.18.2

These four figures, gifts from the artist's
stepdaughter, were sketches for a commission
never completed for a site in Washington,
D.C., according to the museum donor. The
sculptures were left in the artist's estate, finally
dispersed in 1958. Bartlett had a wonderful
virtuosity, seen in these rudimentary models
with their basic representation of arms, legs,
heads, and torsos, seated or crouching on
square plinths. That the small sketches were
cast in bronze, presumably during the lifetime
of the sculptor, suggests their significance in the
artist's estimation. It is unlikely that bronze
casts were used as examples to exhibit to the
commissioners of the *Fountain of Engineers*, for
such models usually were in plaster or
occasionally in terra cotta.

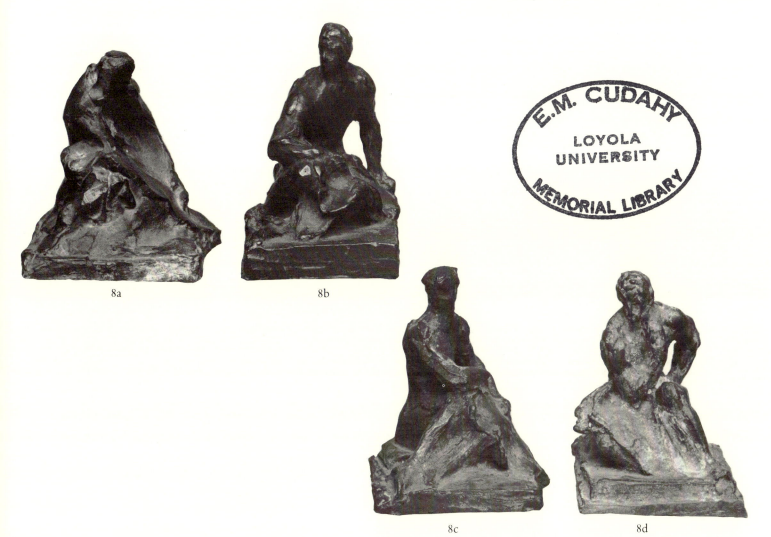

8a 8b

8c 8d

Karl Bitter 1867-1915

Born in Vienna. Studied at Academy of Fine Arts. Emigrated to United States, 1888. Worked for Richard Morris Hunt as architectural decorator. Modeled sculptures for Columbian Exposition, Chicago. 1892-94. Charter member of National Sculpture Society. Managed large, productive studio with many architectural commissions. Chief sculptor for Pan-American Exposition, Buffalo, 1901, and Louisiana Purchase Exposition, St. Louis, 1904. Explored abstraction before the Armory Show introduced pure abstraction to United States in 1913, but maintained basically conservative style.

9. Decorative Relief

(for United States Customs House, New York). 1907. Clay. Archives photograph, from James M. Dennis, *Karl Bitter Architectural Sculptor 1867-1915*, Madison, Milwaukee, London, 1967

Daniel Chester French's colossal figures in front of the Beaux-Arts style building designed by Cass Gilbert attracted more attention than Bitter's elegant heraldic emblem that decorates the cornice above the main entrance. The design of shield and two flanking females reflects the sculptor's work for the pylons of the triumphal causeway at Buffalo's Pan American Exposition modeled a few years earlier (Dennis 1967, 116). Bitter's clay sketch flows with Baroque elegance and grace from curve to curve, a rich explosion of forms contrasting

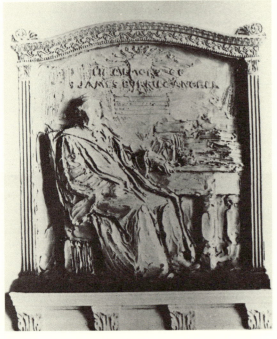

10

with the conservative architectural style of the building. The general design of the relief derives from the celebrated Trevi Fountain, Rome (*Ibid.*, 117).

10. James B. Angell

(Alumni Memorial Hall, University of Michigan). 1909. Clay. Archives photograph, from James M. Dennis, *Karl Bitter Architectural Sculptors 1867-1915*, Madison, Milwaukee, London, 1967

Bitter took his first sitting for the relief portrait of Angell at the University of Michigan president's house in Ann Arbor (Dennis 1967, 158). The work was modeled between May 1909 and January 1910. It was designed, not unlike some of Saint-Gaudens' reliefs (notably his *Shaw Monument*, Boston) as a portrait within a heavy architectural surround, the academically robed figure filling most of the classical frame. Bitter stated he did not want the relief to resemble examples by Saint-Gaudens (*Ibid.*, 163), yet the *bozzetto* shows clearly the influence of that master's hand and style. The modeling technique was essentially that of all well-trained sculptors of the late nineteenth century.

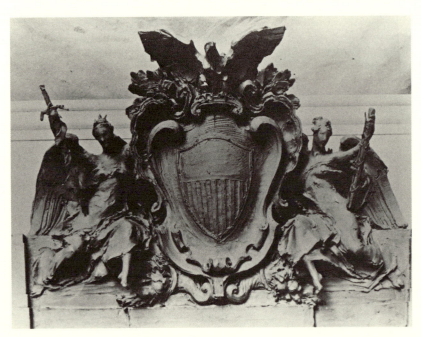

9

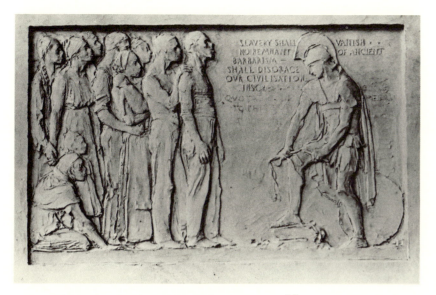

11

11. Relief

(for Carl Schurz Monument, Morningside Drive at 116th Street, New York). 1910. Clay. Archives photograph, from James M. Dennis, *Karl Bitter Architectural Sculptor 1867-1915*, Madison, Milwaukee, London, 1967

Subscriptions of $93,000 were raised to erect a monument to Schurz, noted Abolitionist and Civil War general, and Bitter provided an architectural-sculptural design that blended a full-length portrait, raised on a plinth, centered on a sweeping exedra balanced with reliefs at each end. By 1911, the form of the monument was decided, and Bitter worked extensively on the reliefs. The now-lost clay sketches for the low reliefs focus on Schurz's dedication to civil liberties. This panel, not translated exactly into the final granite relief, depicts a group of Negroes and a single Indian watching a Greek soldier breaking a whip over his knee. He made "experiment after experiment in order to find a worthy solution," (Dennis 1967, 200) indicating his reliance on the *bozzetto* to establish format and to solve problems.

12

12. Abundance

(for Wisconsin State Capitol, Madison). 1911. Clay. Archives photograph, from James M. Dennis, *Karl Bitter Architectural Sculptor 1867-1915*, Madison, Milwaukee, London, 1967

Bitter's largest commission was his sculptural ensemble for the Capitol at Madison, Wisconsin, a project that suited his talent for sculpture that embellished architecture. Developing elaborate pediment arrangements, the sculptor also designed monumental groupings on platforms that helped to anchor the classical building. One of the four groups was titled Abundance, located on the northwest side of the drum, and was "simple and classical" in style, Bitter said (Dennis 1967, 142). The clay mock-up for the granite group illustrates how Bitter visualized the work, combining sections of painted cardboard with his *bozzetto* to suggest scale and final form to be carved in granite.

13

13. Pomona, Goddess of Abundance

(for *Pulitzer Fountain*, New York City). 1914-15. Plaster. Height 24 inches (61 cm.). Hirschl and Adler Galleries, New York

At least since 1898, Bitter was concerned with a beautification project for a site east of the Plaza Hotel, New York, between 58th and 59th Streets (Dennis 1967, 230). Joseph Pulitzer's will provided a bequest of $50,000 for a fountain complex to be erected there, and by 1912 the New York Park Commissioners approved the concept. The special commission of artists requested from the National Sculpture Society included Daniel Chester French, Herbert Adams, and J. Scott Hartley. Bitter was given the sculpture portion of the project, while architect Thomas Hastings was named to design the base and fountain itself. Derived from the *Fountain of the Labyrinth* by Renaissance sculptor Niccolo Tribolo (1500-1550), located near Florence at the Medici villa of Petraia, *Pomona* was begun by Bitter in the autumn of 1914. A few months later, by early 1915, a sketch, two feet in height, was completed and cast in plaster. This was as far as Bitter progressed before he was killed in an automobile accident on New York streets. The finished, enlarged model was made by Bitter's assistant, Karl Gruppe.

Robert Frederick Blum 1857–1903

Born in Cincinnati. Studied at McMicken
School of Design, Cincinnati, where Kenyon
Cox was a fellow student. Influenced by
Fortuny, Boldini, and Whistler, he lived and
worked in Venice, 1881–82. Well traveled in
Europe and Japan, he was probably first
American painter to visit this Oriental country.
Painter, illustrator, and printmaker, he utilized
sculpture as studies for mural commissions.
Last studio in New York City.

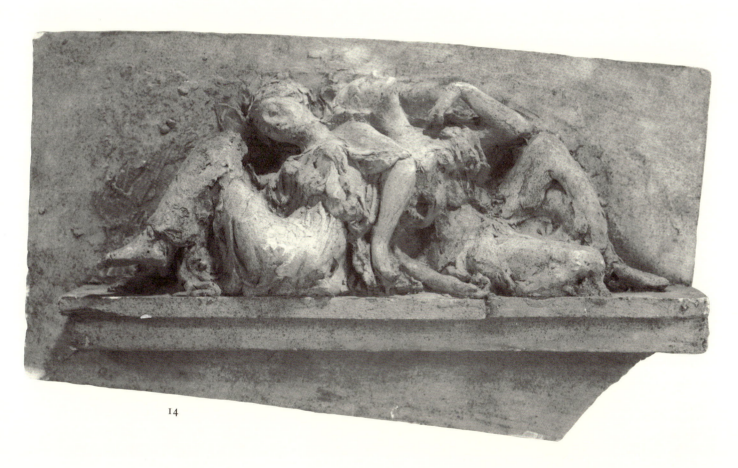

14

14. Group of Two Girls

c. 1890. Plaster. Height 9 inches (22.9 cm.).
Cincinnati Art Museum, gift of William J. Baer,
1921.250

To honor its son, the Cincinnati Art Museum
organized in 1905 the first retrospective exhibit
in memory of Blum, and the show's catalogue,
edited by William J. Baer, referred to it as an
"untitled study, symbolizing Summer."
Possibly modeled at the time of Blum's
Mendelssohn Hall commission, *Two Girls* was
found in Blum's studio after his death as a wax
sculpture. William J. Baer acquired it and had
casts made in plaster and bronze.

15. Dancing Figure

c. 1893. Plaster. Height 15¼ inches (38.7 cm.).
Signed: BLUM. Cincinnati Art Museum, gift of
Augustus Lukeman, 1911.1344

Blum received a commission in 1893 for a
mural, the *Moods of Music*, to decorate
Mendelssohn Hall, New York City. The project
occupied the Cincinnati-born artist until 1895.
This plaster cast of the clay sketch may relate to
the figure discussed by Blum in an article in
Metropolitan Magazine, July 1904: "I am a slow
worker when actual events alone are taken into
account. In some cases I drew a figure seven and
eight times, besides drapery and details for the
same, and a dummy of the whole idea was set
up in little wax figures, each one of which was
sometimes a week's work – and all this before I
got so far as even to think of making a sketch
for the picture." The American art critic and
historian, Royal Cortissoz, marveled at the
Mendelssohn Hall mural's plastic sense, asking,
"How was it obtained?" The article answered:
"Partly by the employment of one of the most
fascinating expedients of the artist. In order to
reinforce those lines of construction described
above, followed by the mural painter in his
labor in the dark, when he paints a long panel
piece by piece and guesses at the impression
which in the end he is going to convey, Mr.
Blum spent about three months in modeling his
composition, on a small scale, in sculptor's clay.
Setting up his figurines on a ledge, grouping
them and regrouping them little by little, he
held the scheme in the hollow of his hand. By
this means he could study each figure in the
round instead of in the flat, could block out the
perspective, could tell which knot of figures to
make prominent and which to subordinate,
and, in brief, handle a plastic theme in a plastic
manner" (Cortissoz 1899, 62). X-rays of the
plaster cast indicate that a wire armature is
present, and portions of it may be detected near
the surface through rust spots.

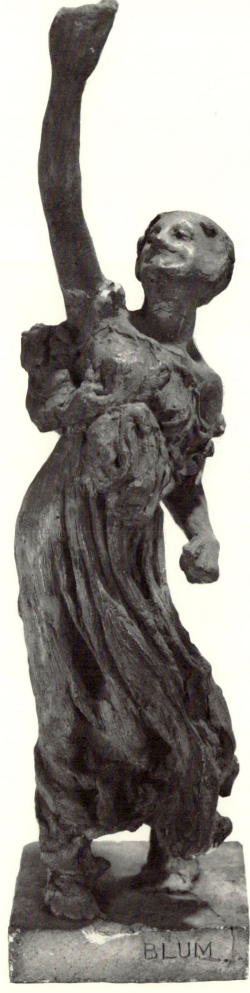

15

Gutzon Borglum 1867-1941

Reared in pioneer Nebraska. Later studied at Mark Hopkins Art Institute, San Francisco. Enrolled after 1890 in Académie Julian and Ecole des Beaux-Arts. Showed *Indian Scouts* at Columbian Exposition, 1893, after returning to America, and exhibited at Louisiana Purchase Exposition, St. Louis. Well trained in marble-carving as well as bronze-casting, Borglum was a frequently commissioned portrait sculptor (some 170 examples are known). Renowned for his mountainside sculptures at Stone Mountain, Georgia, and Mount Rushmore, South Dakota (the latter included monumental portraits of Washington, Jefferson, Lincoln, and Theodore Roosevelt, carved out of the side of the mountain and unveiled between 1930-39).

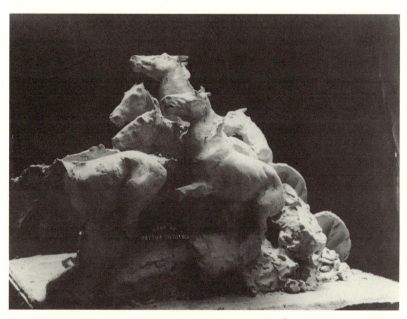

16

16. Mares of Diomedes

(Destroyed). 1902. Clay. Archives photograph, Rushmore-Borglum Story, Keystone, South Dakota

The first major work by Borglum, this now-lost *bozzetto* rendered a Western scene recalled from childhood, no doubt, in the great plains (Shaff 1985, 83). Although it depicts a naked Indian clinging to the back of one horse among a stampede of eight, it bore a title, *Mares of Diomedes*, given it by a friend who suggested that it depicted Hercules subduing the flesh-eating horses of King Diomedes. Modeled when most American sculpture was less descriptive of such high-spirited action, the

bozzetto was enlarged and developed as a large bronze (height 62 inches) and cast in 1904 (Metropolitan Museum of Art, New York).

17. I Have Piped and Ye Have Not Danced

(Destroyed). c. 1902. Clay. Archives photograph, Rushmore-Borglum Story, Keystone, South Dakota

Borglum's rich modeling technique gave form to his imaginative scheme for a two-figure group, male and female nudes, developed in his New York City studio on East 38th Street. The idea may have germinated in London as early as November 1901, during his stay in England. The sketch suggests the majestic works of George Grey Barnard (1863-1938), American sculptor and near contemporary of Borglum. Particularly close in subject and handling is Barnard's *Struggle of the Two Natures of Man*, 1889-1894 (Metropolitan Museum of Art, New York). There is no evidence, however, that Borglum knew Barnard by 1902, even though both studied in Paris in the 1890s and lived in New York at the turn-of-the-century. Borglum's *bozzetto* for *I Have Piped* bears tool marks in portions, while the modeling is quite polished and complete, ready for plaster casting, in others. The finished, enlarged version is at Forest Lawn Cemetery, Glendale, California.

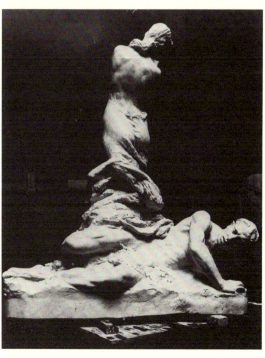

17

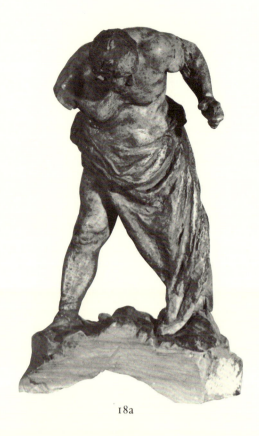

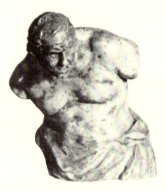

18a 18b

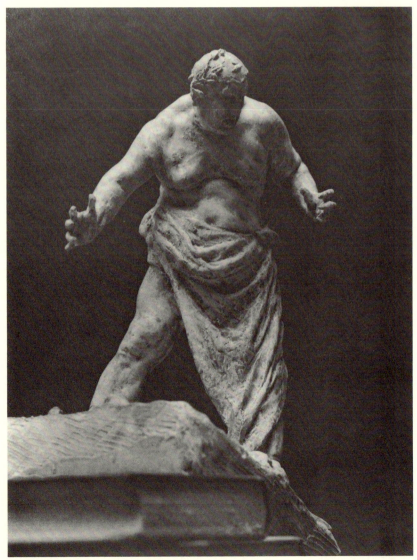

18c

18. Nero

(One-armed view, half-length view, full-length view). 1904. Plaster. Height 14 inches (35.5 cm.). Collection and Archives photographs, Rushmore-Borglum Story, Keystone, South Dakota

Corpulent as a Japanese *sumo* wrestler, Borglum's sketch of *Nero* represents the sculptor's early interest in portraiture and expressive features. Two sketches, one a fragment and the other missing an arm, may be better represented in a photogravure print copyrighted by the artist in 1910 and incorrectly labeled a "bronze." Ten years after Borglum modeled this Roman Emperor, he wrote a newspaper article, "How Your Face Betrays You," and explained his *Nero:* "Just as I fashion features in clay, so a man, by his thought process playing upon his facial muscles, assumes a countenance fitting the nature of his soul . . . Take my Nero, for example, in moulding the mouth of Nero I used my observation of men of his type. His mouth is full and loose; its thickness expresses sensuality and grossness. He had little upper lip – in fact, according to historians, his lower lip closed over the upper. His mouth was unquestionably of his own creation; its fullness and looseness were consciously molded by a mind which reveled in gross things . . . More eloquent than any characteristic, however, is the human face" (Shaff 1985, 85).

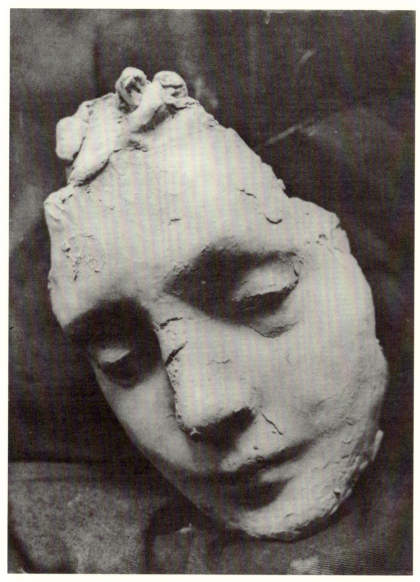

19

19. Angel of the Annunciation

(Destroyed). c. 1904. Plaster (?). Archives
photograph, Rushmore-Borglum Story,
Keystone, South Dakota

Borglum was commissioned by the Cathedral
of St. John the Divine, New York, to carve a
large number of sculptures for Belmont
Chapel, St. Savior's Chapel, St. Columbia's
Chapel, and for other parts of the vast edifice.
The sculptor's sketches for the Archangels
Gabriel and Michael were not well received by
the sculpture committee of the church, who
questioned the feminine features of the
Archangels, supporting their contention
through theological dogma that all angels were
male (Hughes 1906, 709). Borglum responded
with his well-known short temper by smashing
the sketches, retaining only the face of one.
Obviously not a finished enlargement but still
in sketch form when the angel figure was
destroyed, this delicately modeled, sensitive
visage exhibits Borglum's consummate
modeling skills, learned so well at the Paris
Ecole (*Ibid.*, 712).

20. General Philip Sheridan

(Front view, rear view) (Destroyed) (for *Sheridan Memorial*, Massachusetts Avenue at 23rd Street, Washington, D.C.). c. 1905-06. Clay. Archives photograph, Rushmore-Borglum Story, Keystone, South Dakota

The original commission for a monumental bronze equestrian of General Sheridan (1831-88), one of the Civil War's illustrious leaders, was awarded to John Quincy Adams Ward (1830-1910) in 1892 (Sharp 1985, 84). Ward was one of America's most celebrated and revered sculptors, but nearing the end of his career. Controversy haunted his efforts to produce a model acceptable to the commissioners and to Mrs. Sheridan, the General's widow. Her terms were unacceptable to Ward, the commission was withdrawn, and Borglum assumed the task. His assumption was not greeted with enthusiasm by Ward's conservative supporters. Borglum's *bozzetto*, illustrated here in two views, was a daring departure from the usual equestrian. The work expressed intensity, vigor, and agitation lacking in many large-scale monuments honoring Civil War generals. The final bronze sculpture, unveiled November 25, 1908, was placed at viewer's eye level, not raised on a high plinth. Its daring concept and the completion of such a prestigious commission clinched Borglum's important rank among sculptors at the beginning of the twentieth century.

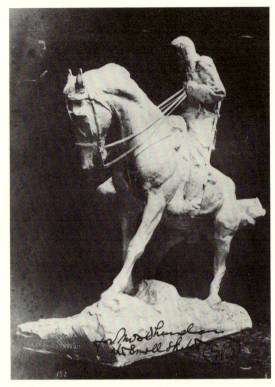

20a

21. The Seated Lincoln

(Back view, side view, head, front view) (Destroyed) (for County Courthouse, Newark, New Jersey). c. 1909. Clay. Archives photograph, Rushmore-Borglum Story, Keystone, South Dakota

In 1909, the sculptor's most important commission to that date occurred when Newark, through the Amos Van Horn bequest for a memorial to President Abraham Lincoln, offered him the coveted assignment. The final bronze was dedicated by ex-President Theodore Roosevelt on Memorial Day, 1911 (Shaff 1985, 126). The illustrations of Borglum's now-destroyed *bozzetto* show the work in at least two stages, the side and rear views probably constituting the earliest as they are more freely modeled than the illustrated head or the figure shown frontally. The marks of the modeling tools are evident.

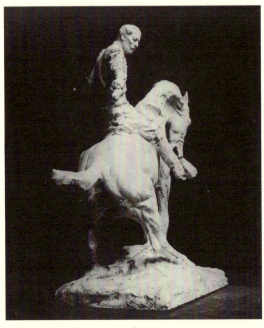

20b

21a

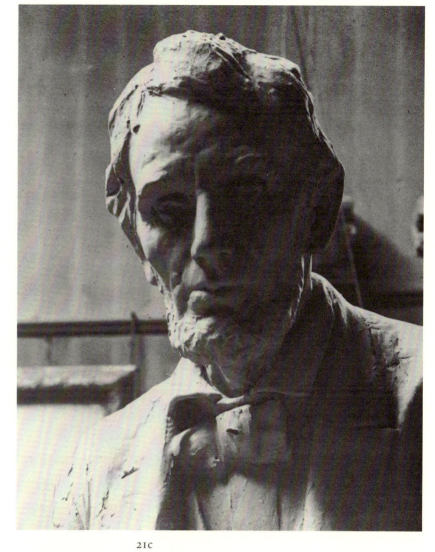

21c

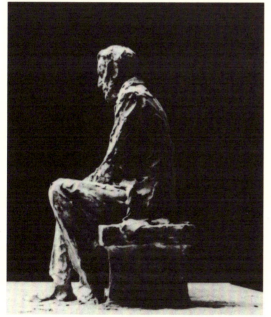

21b

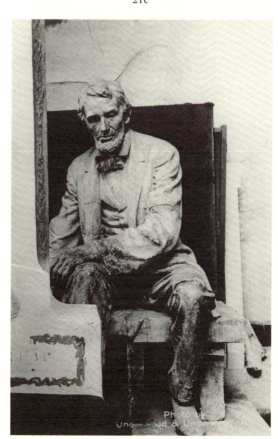

21d

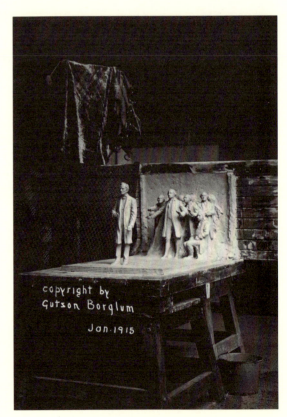

22a

22. The Debating Lincoln

(Side view, detail, front view) (Destroyed).
1914-15. Clay. Archives photograph,
Rushmore-Borglum Story, Keystone,
South Dakota

Lincoln, standing apart from the figures of
Washington, Franklin, and other great
Americans who preceded him, was the central
focus in an impossible but symbolic assembly.
Borglum's interest in President Lincoln
persisted throughout his career, several
monuments were devised over the years, and
his son was named for him. This sketch
illustrates the sculptor's use of a support in
fashioning clay to wood. Borglum's keen sense
of the theatrical, so vividly expressed at Mount
Rushmore, is acknowledged particularly in the
positioning of the isolated Lincoln apart from
the gesturing group. Photography was an
effective tool for Borglum, used with
professional skill, in capturing light and shadow
before a *bozzetto* was completed.

22c

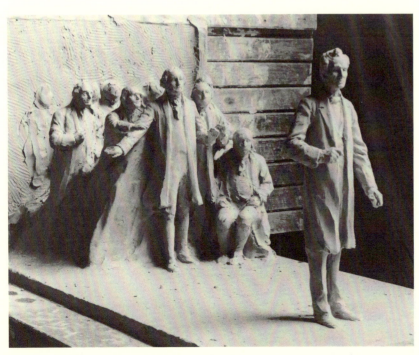

22b

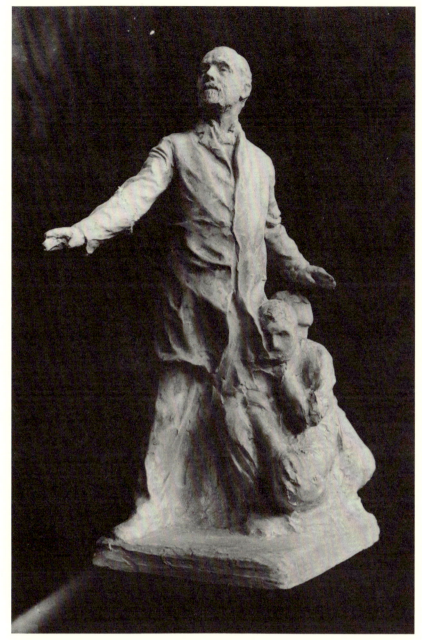

23

23. Governor John Peter Altgeld Memorial

(Destroyed). c. 1915. Clay. Archives photograph, Rushmore-Borglum Story, Keystone, South Dakota

Sturdy champion of human rights, Governor Altgeld (1847-1902) pardoned the Haymarket rioters and opposed use of Federal troops to quell strikes in Pullman, Illinois, during his term as Illinois governor, 1892-1896. Borglum's *bozzetto* was the study for the final monument in Lincoln Park, Chicago, to be cast in bronze. The distinctive features of Altgeld contrasted with the abstract faces of the figures grouped at the pardoner's knees. Political controversy swirled around the sculpture as well as around Altgeld, and the Chicago Municipal Arts Commission criticized the work severely. In

spite of the argument over the work's merits, the Memorial was dedicated successfully on Labor Day, 1915.

24. James Rogers McConnell Memorial

(Destroyed) (for University of Virginia, Charlottesville, Virginia). c.1917-18. Clay. Archives photograph, Rushmore-Borglum Story, Keystone, South Dakota

The obvious reference is to Icarus, the ill-fated flyer in mythology who soared above earth in wings attached with wax, but the intended airman for memorialization was a student at the University of Virginia, James Rogers McConnell. Serving in the famous flying unit, the Lafayette Escadrille, McConnell is thought to have been the first student from the University of Virginia to be killed in action in World War I. Shortly after the aviator's death on March 17, 1917, University President Edwin A. Alderman encouraged a monument to the youth, funds were raised privately, and Borglum was commissioned. The sculpture was dedicated in June 1919 on the campus in Charlottesville.

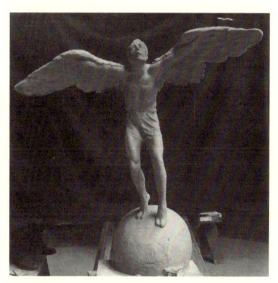

24

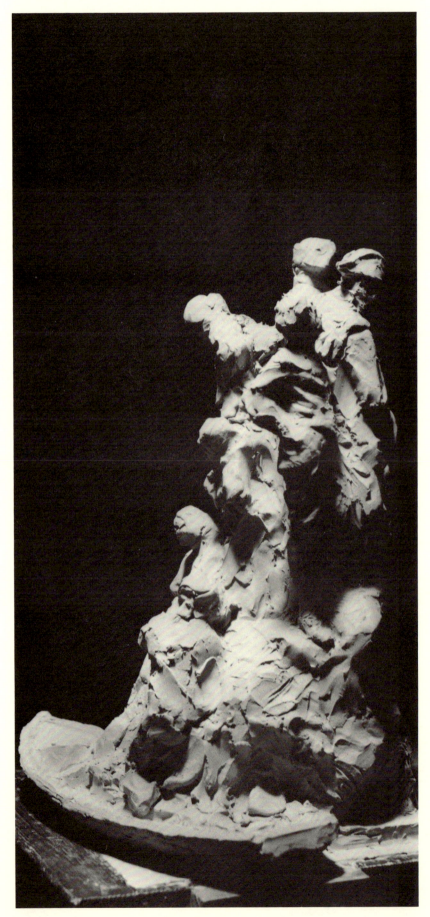

25a

25. The Wars of America

(Side view, full view, front view, rear view)
(Destroyed)(for Veterans Park, Newark, New
Jersey). c. 1919. Clay. Archives photograph,
Rushmore-Borglum Story, Keystone,
South Dakota

One of Borglum's major commissions fell to
him at the conclusion of World War I when the
City of Newark awarded him the contract for
The Wars of America, a large-scale work to
commemorate legions of exalted military
heroes as well as common soldiers. The
sculptor was free to develop his concept, for
interestingly, no sketch or model was required
by the commissioners for approval (Shaff 1985,
178). Borglum wrote about his earliest efforts,
probably about 1919: "'My first sketch,
following the abandonment of the shaft idea,
represented a confused group of men who were
attempting to organize themselves and move
toward leadership, with Washington and
Lincoln symbolically present I introduced
two horses because the horse is not only a
companion to man but the closest companion
in time of danger . . . artistically and
sculpturally, equine excitement and nervous
tension can be used realistically and
symbolically . . . the composition indicates such
organization . . . and such confusion as extends
behind the battle line in the recruiting source
and the home . . . the root of our whole political
existence is in the home . . . America's battles
are all in defense of her homes'" (Shaff 1985,
178, quoting Gutzon Borglum papers, Library
of Congress, Manuscript Division). Two
bozzetti illustrate the earliest stages of
development. One captures the figures at the
foremost position in the monument, giving
dimension and solid form by the quickest
manipulation of clay, tool marks and finger-
printed pellets throughout. The second *bozzetto*
is a rare visualization of the Memorial's
concept, an awesome grouping that eventually
contained forty-two heroic-size figures and two
horses. In these sketches, Borglum melded an
abstracted, expressive directness with hinted
detail and specific personifications.

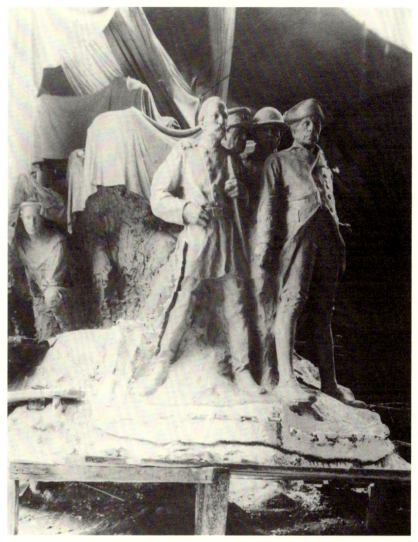

25b

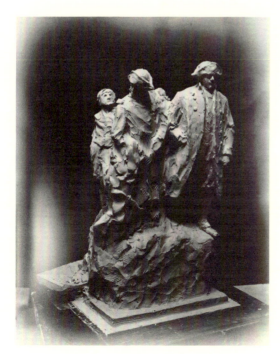

25c

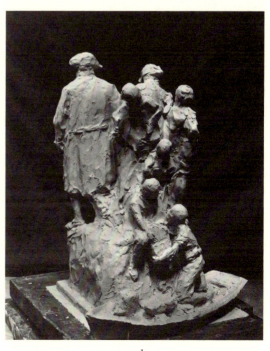

25d

26. The Wars of America

(Two views, possibly enlargements)
(Destroyed) (for Veterans Park, Newark, New
Jersey). c. 1919. Clay. Archives photograph,
Rushmore-Borglum Story, Keystone,
South Dakota

Borglum's enlargement of the sketch into the
size intended for casting was modeled in a tent
adjacent to his studio, Borgland, at North
Stamford, Connecticut (Shaff 1985, 180). A
studio assistant, Millard Malin, recalled the
discomforts and problems in modeling the
large-scale figures: " . . . My memory of him is
of a Titan stamping about in oceans of clay,
bringing order out of chaos with hands, feet
and a big mallet . . . " (*Ibid.*, 180). In the
illustrations, possibly of the enlargement or a
sketch as an intermediate stage leading to it, at
the far left may be seen the first stages of clay
blocked into the supporting armature. The
other illustration of the foremost part of the
sculpture shows unmodeled portions between
partially and nearly completed sections with a
protective wrapping that prevented too rapid
dessication.

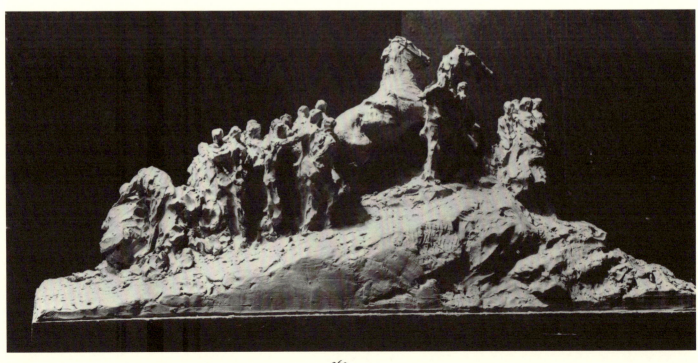

26a

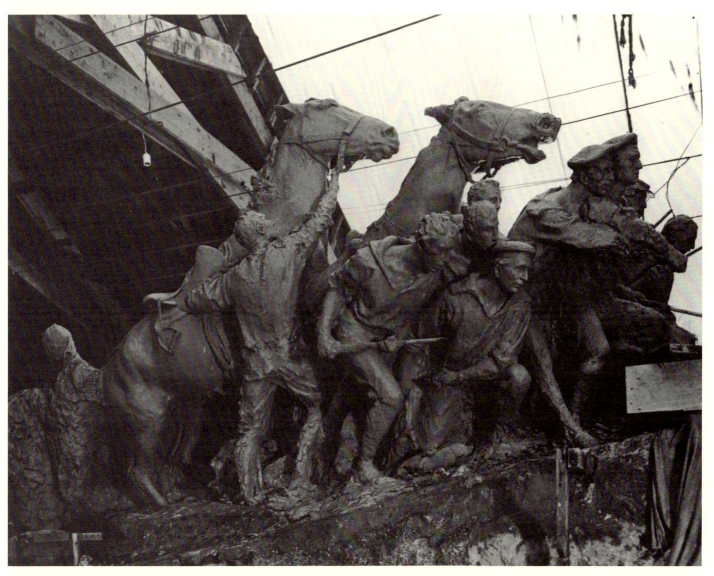

26b

Walter A. Clark 1848-1917

Born in Brooklyn, New York. Little-known sculptor and landscape painter, he apparently studied with George Inness. Exhibited at Pan American Exposition, Buffalo, 1901, and National Academy of Design, 1902.

27. Traveling

c. 1880-90. Terra cotta and wax. Height 9 inches (22.9 cm.). Signed on base: W. Clark. Inscribed, lower left of base: Travelling. National Museum of American Art, Smithsonian Institution; gift of Eliot Clark, 1973.163.1

Clark produced this directly modeled sketch perhaps for a monument or memorial never realized. The sketch has the appearance of a free-standing sculpture, its base suggesting placement on table top or pedestal. Its broadly fashioned planes and hinted details were meaningful enough to the sculptor to shape his concept of the work, even in monumental size. It is unusual in its mix of terra cotta and wax, the latter substance obviously added subsequent to the firing of the clay.

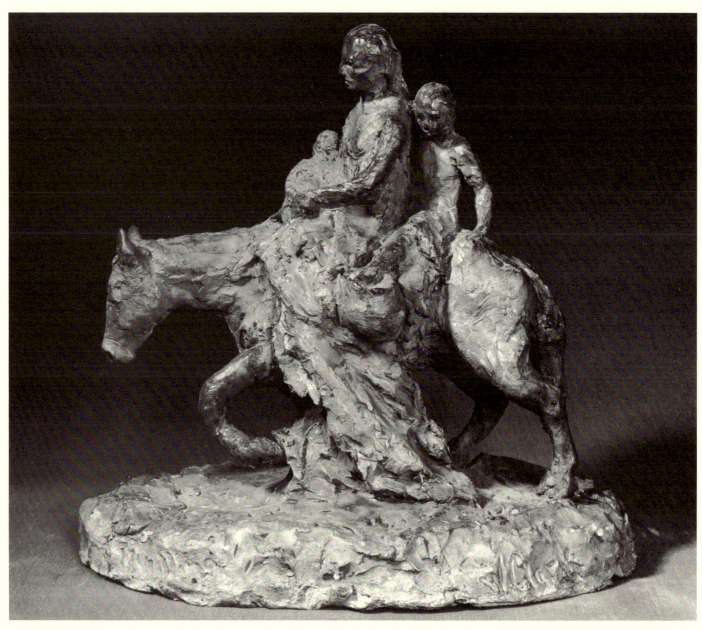

27

Thomas Crawford 1813?-1857

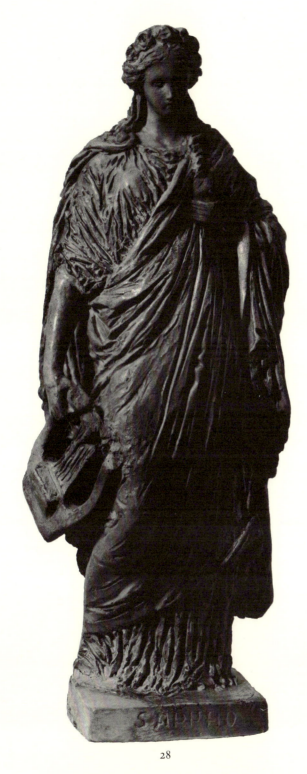

28

Born in New York City. Apprenticed to a wood-carver, he worked for Frazee's and Launitz's firm about 1827. Studied in Rome with Thorvaldsen, 1835. First major work, *Orpheus and Cerberus*, 1839, established his reputation in America. Awarded commission for Washington Monument, Richmond, 1849-50, and later for sculptural decorations for United States Capitol. Figure of *Freedom* for capitol dome was his major work in bronze.

28. Sappho

1855. Painted plaster. Height 21 inches (53.3 cm.) Inscribed reverse: T. Crawford Ft/Rome/ April 55. Inscribed front: SAPPHO. National Park Service, Longfellow National Historic Site, Cambridge, Massachusetts, gift of Louisa Ward Crawford, 1861

Louisa Ward Crawford, the sculptor's widow, wrote Henry Wadsworth Longfellow in 1861 that she sought a place for *Sappho* with the great poet: "In breaking up the dear old studio this spring, I was anxious that some of the beautiful sketches should remain in the hands of friends – and not be absorbed in the general collection [since lost]. As often as I looked at the 'Sappho' – broken-hearted, I thought of you – of the pleasure it would be to you to have it ever before your eyes – of the satisfaction that I should feel in knowing that it was yours. Will you value it, dear Mr. Longfellow, and give it a place in your quiet studio?" (Gale 1964, 223). Longfellow acknowledged the gift to Mrs. Crawford, retaining it in the comfortable old house on Brattle Street in Cambridge. Crawford's rendering of the chiton-clad Greek poetess clasping a lyre is a rare record of his modeling abilities. This tanagra-like and elegant little figure is the only extant sketch by Crawford, albeit in reproduction form, and no marble is recorded. However, the sculptor hinted that marble was intended in a letter to his wife: "The memorandum you sent me is from Fontana and relates to marble for the 'Saffo,' though no money is to be paid until my return." This would infer that one version, at least, was ordered in marble. *Sappho* once was with the *bozzetti* in "a room full of small clay sketches of sculptural ideas that had come to him while he was working on his larger projects. The flow of his ideas was of such force and insistence that he often had to stop work on his monuments to dash off these little models" (Gardner 1945, 26).

29. Freedom

(Destroyed) (for United States Capitol). 1855.
Plaster. Height 19 feet (5.79 m.).
Archives photograph, National Archives,
Washington, D.C.

Crawford produced the clay sketch and finished
rendering in clay at his residence-studio in
Rome, Villa Negroni (Gale 1964, 65). A choice
commission for an American artist, the work
was begun at the initiation of Montgomery C.
Meigs, who wrote to Crawford in 1855
suggesting a figure to surmount the Capitol
dome in Washington, D.C.: "The cupola is to
be surmounted by a statue sixteen feet in
height – of what, I am at a loss yet to say.
Suppose you make a sketch for it. We have too
many Washingtons, we have America in the
pediment. Victories and Liberties are rather
pagan emblems, but a Liberty, I fear, is the best
that we can get. A statue of some kind it must
be" (Ibid., 137). Crawford accepted the
challenge, sending photographs of a proposed
dome sculpture to Meigs in June 1855. In his
accompanying letter the sculptor explained his
intentions: "I have endeavored to represent
Freedom triumphant in peace and war. The
wreath on her head has a double significance in
allusion to this, one half of it being composed
of wheat sprigs and the other half of laurel. In
her left hand she holds the olive branch, while
her right hand rests on the sword which
sustains the shield of the United States. Those
emblems are such as the mass of our people will
understand. In order to connect the richness of
effect in the statue gradually with the
architecture of the dome, I have introduced a
base surrounded by wreaths indicative of the
rewards Freedom is ready to bestow upon
distinction in the arts and sciences" (Ibid., 141).
Crawford also remarked that his fee would not
"be excessive, as the model would not require a
high degree of finish but on the contrary should
be modeled with great boldness and spirit
considering the height it should be placed
upon."

During the summer of 1855, Crawford's
modeling of the figure progressed, and by
October he had revised the Amazon by adding
a liberty cap and fasces. Crawford reported to
Meigs in March 1856 that he had made further
alterations to the sketch, dropping the cap for a
feathered helmet, estimating the figure to stand

29

eighteen feet nine inches, and expecting his
figure "to combine if possible the grace of the
original sketch . . . with the lightness of the
second" (Ibid., 156). By July the sculptor had
fashioned the full-size work in clay. A few years
later and during the darkest days of the Civil
War, the bronze casting of Freedom in five parts
was completed, a tour-de-force accomplished
by Clark Mills, and the monumental figure was
raised to her perch in 1863. Although the plaster
cast of Freedom is not a true bozzetto but a
finished, full-size model from which the bronze
cast was taken, its place in this study is
warranted due to its historical importance in
American sculpture history and the record of
development from sketch to final work it helps
to illustrate. Interestingly, its physical height
has not been paralleled by artistic criticism:
"Perhaps no piece of sculpture executed by one
American enjoys so conspicuous and important
a situation, indeed, with the passing of years,
the pedestal has grown so important that today
the figure of Armed Freedom suffers an almost
total eclipse Certainly no monument in the
United States can rival the importance of its
location – though many enjoy an equally
conspicuous oblivion" (Gardner 1945, 27).

Franz Xavier Dengler 1853-1879

30

Born in Cincinnati. Studied at Xavier University (then College) in Cincinnati and worked as woodcarver for Schroeder and Brothers, 1870-72. Studied in Munich, 1872-74. Taught modeling in Boston after 1876. Instructor in sculpture at School of the Museum of Fine Arts, Boston, ending in resignation 1877 due to illness. Returned to Cincinnati but died in Jacksonville, Florida.

30. Painting

c. 1877-78. Plaster. Height 19¾ inches (50.2 cm.). Museum of Fine Arts, Boston, gift of Franz Xavier Dengler, Sr., 1879.39

31. Sculpture

c. 1877-78. Plaster. Height 20 inches (50.8 cm.). Museum of Fine Arts, Boston, gift of Franz Xavier Dengler, Sr., 1879.40

32. Architecture

c. 1877-78. Plaster. Height 19¼ inches (48.9 cm.). Museum of Fine Arts, Boston, gift of Franz Xavier Dengler, Sr., 1879.41

While Dengler taught at the School of the Museum of Fine Arts, Boston, he was asked to design three sculptures for the Museum's façade on its building on Copley Square. These plaster casts were made from Dengler's clay *bozzetti* for the female figures personifying the arts and symbolizing the purposes of the museum building itself. *Painting* holds a palette in her left hand, *Architecture* grasps a building plan and hammer, and *Sculpture* bears a chisel. The figures never were executed in marble or bronze, but the sketches remain as records of the first stage of a major commission for this short-lived artist. Such sketches reflect the academic tendencies Dengler learned in Munich under Knabl.

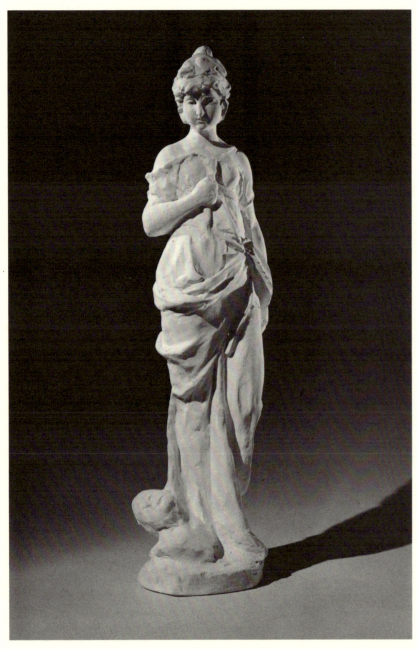

31

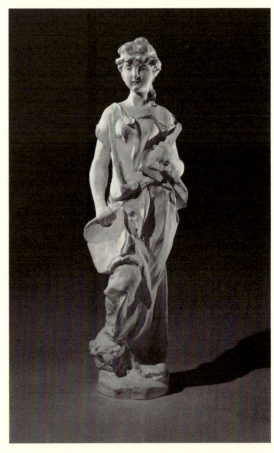

32

Thomas Eakins 1844-1916

Born in Philadelphia. Studied at Ecole des Beaux-Arts with Gérome and the sculptor Dumont. Faculty member of Pennsylvania Academy of the Fine Arts, teaching painting, anatomy, and life-drawing. Regarded as one of America's most important painters, he was talented as a sculptor, usually utilizing his sculpture as studies for paintings.

33. The Schuylkill Chained

c. 1876-77. Pigmented wax. Height 4¾ inches (12.1 cm.). Philadelphia Museum of Art, gift of Mrs. Thomas Eakins and Miss Mary A. Williams, 1929.184.41

34. Head of William Rush

c. 1876-77. Pigmented wax. Height 7¼ inches (18.4 cm.). Philadelphia Museum of Art, gift of Mrs. Thomas Eakins and Miss Mary A. Williams, 1929.184.37

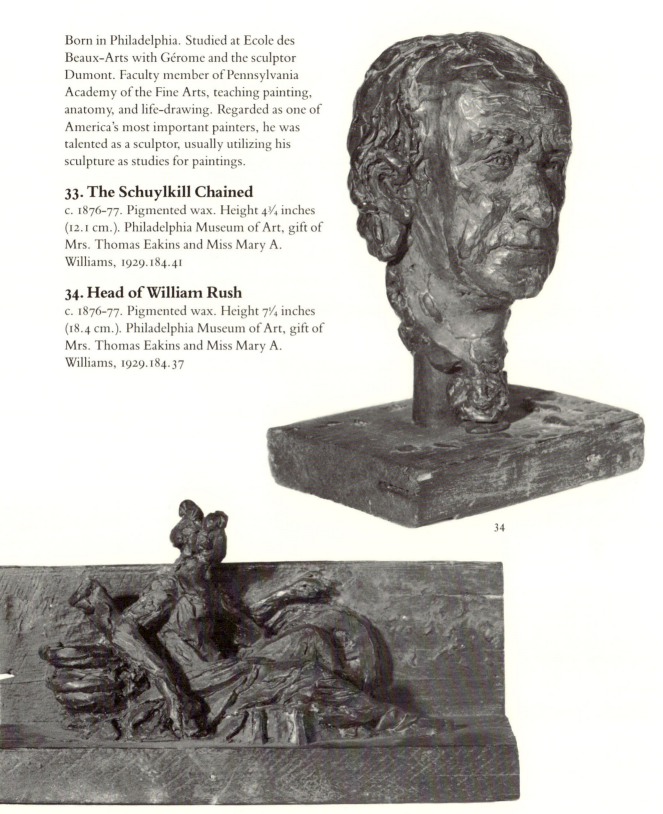

34

33

35. Head of a Nymph

c. 1876–77. Pigmented wax. Height 7¼ inches (18.4 cm.). Philadelphia Museum of Art, gift of Mrs. Thomas Eakins and Miss Mary A. Williams, 1929.184.38

36. Figure of the Schuylkill with Bittern

c. 1876–77. Pigmented wax. Height 9¼ inches (23.5 cm.). Philadelphia Museum of Art, gift of Mrs. Thomas Eakins and Miss Mary A. Williams, 1929.183.40

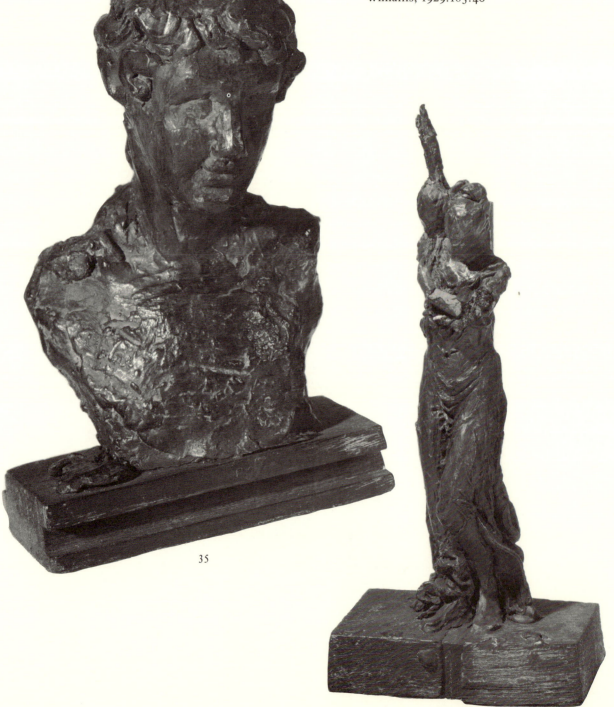

35

36

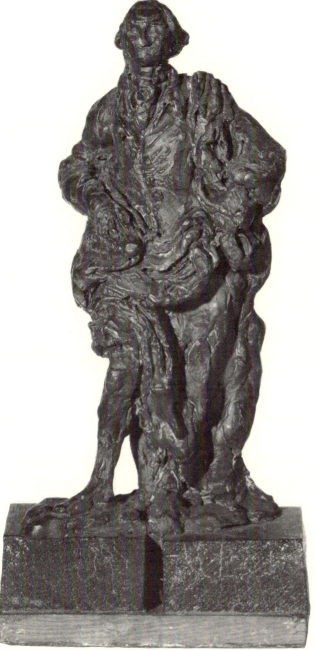

37

37. George Washington

c. 1876-77. Pigmented wax. Height 8⅜ inches (21.3 cm.). Philadelphia Museum of Art, gift of Mrs. Thomas Eakins and Miss Mary A. Williams, 1929.184.39

Eakins' interest in sculpture stemmed from his study in Paris with Augustin Alexandre Dumont (1801-84), where he was taught the traditional modeling methods of the Ecole des Beaux Arts. During his career he produced over ten more-or-less finished sculptures and seventeen sketches or studies, most of them supportive of his paintings and the relationships of elements or volumes in them. Eakins' painting, *William Rush Carving His Allegorical Figure of the Schuylkill River*, 1877 (Philadelphia Museum of Art), a complex arrangement of figures, one of them nude, was developed after he had made six wax studies. Only five of these studies exist today, the sole examples of Eakins' free-standing sculptures other than those for the *Fairman Rogers Four-in-Hand*. Pigmented wax was preferred by Eakins for modeling, and plaster casts of several of these sensitively handled works were made during the artist's lifetime. All of the artist's plasters were left to his widow, some were cast later in bronze, and some were given away or sold at her death. Of the non-surviving small sketches, a wax figure related to the diver in *The Swimming Hole* (Fort Worth Art Center), made in 1884-85 according to his student Charles Bregler, is an especially sad loss. Apparently, Eakin did not think of these sculptures as works of art, merely tools for working out elements in his canvases (Goodrich 1982, 127). Each of Eakins' wax studies for the William Rush painting was built up on wooden blocks or bases, with the wax tooled and smoothed, it appears, with a heated spatula. Freely and impressionistically treated, these original sculptures by a painter are among the finest sketches or studies produced in the nineteenth century.

38. The Mare Josephine

c. 1878. Plaster. 21¾ x 25 inches (55.3 x 63.5 cm.). Hirschl and Adler Galleries, New York

38

39

39. The Mare Josephine

c. 1878 (cast 1882). Bronze. 22½ x 29 inches (57.2 x 73.7 cm.). Inscribed lower center: EAKINS/1882. Inscribed lower right edge: ROMAN BRONZE WORKS, N.Y. Philadelphia Museum of Art, 1930.32.25

Seeking to understand equine anatomy, Eakins dissected horses to prepare himself for the Fairman Rogers painting. "The anatomical studies of the horse were made in quest of knowledge only. The opportunity came to me afterwards to profit by the knowledge in modeling the horses on the Brooklyn Solders' and Sailors' Monument, on the Trenton Battle Monument, on the painting of the 4 in hand coach of the late Fairman Rogers" (Goodrich, II, p. x 126, quoting Eakins' letter to Dr. Edward J. Nolan, Academy of Natural Sciences, Philadelphia, August 14, 1911). The *ecorché*, or flayed horse, was first expressed in sculpture for teaching and decorative purposes in the Renaissance, but it persisted into the nineteenth century, when Eakins must have encountered it in the Ecole classes. These two examples in plaster and bronze of one of the horses in the Fairman Rogers painting probably are rooted in the anatomical casts so prevalent in the academies and schools of the times. Related to these studies of *Josephine* were small studies (Philadelphia Museum of Art) Eakins made for the four horses of the Fairman Rogers painting, the animals in various trotting positions. Bronzes also exist of *Josephine* as full horse and skeleton, 1878, in the Butler Institute of American Art and the Corcoran Gallery of Art.

40. Spinning

1882–83. Painted plaster. Height 18⅞ inches (47.9 cm.). Hirschl and Adler Galleries, New York

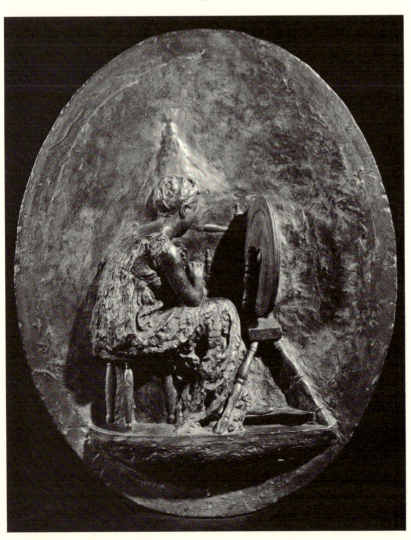

40

41. Knitting

1882-83. Painted plaster. Height 18⅞ inches (47.9 cm.). Hirschl and Adler Galleries, New York

Eakins' interest in relief sculpture is evident from his letters, and once he delivered a lecture on the art form, referring to Phidias and Ghiberti: "Relief work too have always been considered the most difficult composition and the one requiring the most learning. The more geometrical construction of the accessories in a perspective which is not projected to a single plane but in a variable third dimension, is a puzzle beyond the sculptors whom I know . . . " (Goodrich 1933, 64-65).

Eakins' first sculptures independent of his paintings were two oval reliefs modeled in clay, commissioned by James P. Scott through his architect Theophilus P. Chandler as chimneypieces for Scott's house at 2032 Walnut Street, Philadelphia. It was intended that both works would be carved in stone from Eakins' originals, but this was not to occur. *Spinning* and *Knitting* were rejected by Scott because he regarded the fee ($400) as excessive, and the original reliefs were returned to Eakins. The two quiet home scenes derive from earlier paintings by the artist. *Spinning* is related to an oil, *The Courtship*, 1878 (M.H.de Young Museum, San Francisco) and a watercolor, *Spinning*, 1881 (Metropolitan Museum of Art). The model was Ellen W. Ahrens, who was required to take spinning lessons so that the wheel and accessories would be manipulated correctly. An obvious dependence on the two-dimensionality of Eakins' paintings is suggested in the relief, dramatically emphasized by the slim figure seeming to emerge from the flat, nondescript background, perched on a narrow platform. Yet Eakins captured the illusion of depth, as he did so successfully in his canvases, by understatement in portions and strong light-dark emphasis in other sections. Of the few sculptures by Eakins, these two oval reliefs are considered to be the only completed works. However, only if their "final" form were bronze could they be considered complete, as the surface treatment, rough textural effects, and modeling marks would not easily translate into marble or stone. Thus, these two important reliefs are best considered as sketches or

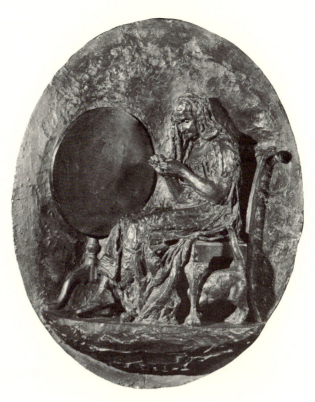

41

bozzetti, from which the marble cutters would devise the final works for the chimneypiece.

Knitting, like its companion piece, was based on a painting. Setting and subject referred to the figure, extreme right, in *William Rush Carving His Allegorical Figure of the Schuylkill River*, 1877 (Philadelphia Museum of Art), and the arrangement and figure in *Seventy Years Ago* (Art Museum, Princeton University), a watercolor done in the same year. The model seated in a Philadelphia-made eighteenth-century chair and next to a tilt-top table dominating the composition was "Aunt Sallie," or Mrs. L.G. King, a relative of the Crowell family. The reliefs of *Spinning* and *Knitting* on the New York art market were owned by Mrs. Thomas Eakins and later by the artist's closest friend, Samuel Murray. A pair of plaster replicas is in the Art Institute of Chicago; the Corcoran Gallery of Art has a plaster of *Knitting*, and *Spinning* is in the Philadelphia Museum of Art. Bronzes were cast in 1886 for Eakins (now in the Pennsylvania Academy of the Fine Arts), in 1930 for Mrs. Eakins (now in the Philadelphia Museum of Art), and again in 1930 for Samuel Murray (now in the Hirshhorn Museum and Sculpture Garden). A bronze cast of *Knitting* is in the Corcoran Gallery.

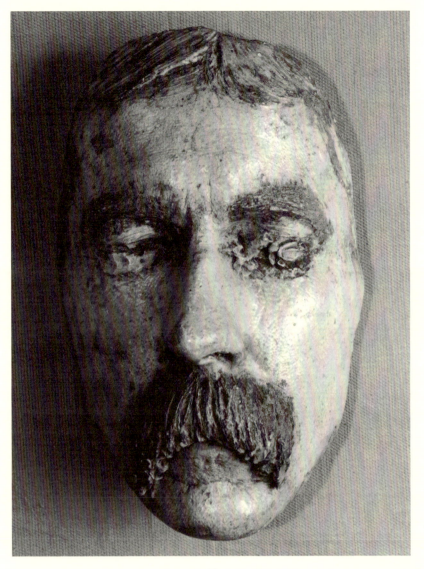

42. Life Mask of Talcott Williams, '73

c. 1889. Plaster. Height 8 inches (20.4 cm.).
Mead Art Museum, Amherst College, Gift of
Mrs. Talcott Williams, PL 1950.2

A journalist and critic with the *Philadelphia
Press*, Williams was responsible for introducing
Eakins to Walt Whitman in 1887 (Shepard 1978,
74). The work was sculpted by Eakins with
assistance from Samuel Murray, his longtime
friend and student, who was also a sculptor.
Eakins' attention to detail, his obsession with
realism in painting, is expressed in every pore
and whisker of this life mask he cast over
Williams' face and then modeled. Perhaps a
study for a commissioned sculpture or modeled
to help him in painting Williams' portrait in
1889, the work continues Eakins' earlier
explorations of anatomically correct flesh and
bones observed in dissections and then cast.

43. The Horse Clinker

(for Memorial Arch, Prospect Park, Brooklyn,
New York). 1892 (cast 1930). Bronze. Height 25
inches (63.5 cm.). Inscribed lower center:

42

43

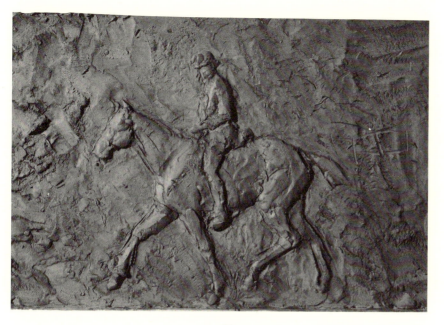

44

EAKINS/1892. Inscribed upper left: Clinker charger belonging to / A J Cassatt Esq/ Chesterbrook Farm Berwyn / Penna. Philadelphia Museum of Art, gift of Mrs. Thomas Eakins and Miss Mary A. Williams, 1930.32.24

This project was Eakins' first attempt at sculpture since the 1880s, but his hand at modeling the horses for the equestrian figures of President Lincoln and General Grant was sympathetic and experienced. While the figures of Lincoln and Grant for the inside of the arch were executed by William R. O'Donovan, close friend of Eakins, the horses were conceived and developed by Eakins, first in small-scale wax (¹⁄₁₆ size) and eventually in quarter-size clay (as requested by the monument's commissioners) before casting in plaster (Moffett 1895, 419-432). Carefully selected as models were the two horses from which Eakins fashioned the reliefs: Billy, his own gentle mount, for Lincoln; and Clinker, a thoroughbred owned by Mary Cassatt's brother, A. J. Cassatt. As illustrated in a photograph (Domit 1969, 60), working in the out-of-doors with the quarter-size relief propped before him on a wooden crate, Eakins observed Billy, patiently standing close to the improvised modeling stand at the farm near Avondale, Pennsylvania, owned by his sister, Frances Eakins Crowell. The relief is squared, both in background and on the horse, to enable proportional enlargement to full-size.

By April 1892, the full-size relief of Clinker was finished in clay and cast. Although the plaster models in different sizes of Billy and Clinker were in Mrs. Eakins' possession until her death in 1938, all of the plasters are lost from which the bronze sculptures were cast.

44. Study for Memorial Arch, Brooklyn

(Prospect Park, Brooklyn, New York). c. 1893. Wax. Height 6¾ inches (17.2 cm.). Signed: EAKINS. Hirshhorn Museum and Sculpture Garden, Smithsonian Institution, Gift of Joseph H. Hirshhorn, 1966

Eakins' sensitively rendered sketches of horses, including this low relief, a succinct recording in shallow modeling of the animal he knew so well. Although signed, the work is clearly unfinished, finger printed, incised here and there – a working statement epitomizing the *bozzetto*.

Sir Moses Jacob Ezekiel 1844-1917

45

Born in Richmond, Virginia. Student at Virginia Military Institute, he served in the Confederate Army and graduated from VMI, 1866. After studies at Virginia Medical College, he moved to Cincinnati in 1868 to work with Thomas Dow Jones and J.I. Williams. In 1870, Ezekiel arrived at Berlin's Royal Art Academy, remaining until 1874. Studied in Rome, 1874-76, and settled there permanently with studio in Baths of Diocletian. Numerous portrait commissions in 1870-90 as well as work for Columbian Exposition, 1893.

45. Religious Liberty
(Single Figure) (Destroyed). 1873. Clay?. Archival photograph, American Jewish Archives, Cincinnati, Ohio

46

46. Religious Liberty

(Destroyed) (for Fairmount Park, Philadelphia).
1873. Clay. Archival photograph, American
Jewish Archives, Cincinnati, Ohio

Only two years after Ezekiel received his
schooling in clay modeling and sculpture in
Berlin, following rudimentary training in
Cincinnati two years before, the sculptor was
commissioned by Philadelphia's B'nai B'rith to
sculpt a monument for that city's Fairmount
Park. *Religious Liberty* probably was the first
work ordered by an American Jewish
organization from an American Jewish artist.
The unveiling coincided with the Nation's
Centennial celebration of 1876. Ezekiel's earliest
contact with the B'nai B'rith chapter is
unknown, but during his visit to America
following his completion of studies in Berlin in
1873, he presented a "sketch model" of the
monument (Tarbell 1985, 16). During 1874-76,

the sculptor developed the finished clay model
and had the work carved in marble. Although
Ezekiel executed at least one *bozzetto*
employing only the single figure of a woman
(Republican Freedom), the second illustration
depicts two figures as resolved in the final
sculpture. Ezekiel's modeling technique was
staid and solid, not given to impressionistically
handled surfaces, and duplicating that practiced
by the German academic sculptors.

47. Fürst Otto von Bismarck

(Destroyed). c. 1895. Clay. Inscribed: EZEKIEL.
Archival photograph, American Jewish
Archives, Cincinnati, Ohio

The "Iron Chancellor" (1815-1898) might be
expected as a portrait subject, at least in *bozzetto*
form even if no commissions were in hand, for
Ezekiel had a German bias, fostered by five
years of study in Berlin with Professor Albert
Wolff. Also, Ezekiel had been awarded the
Golden Cross, a sort of knighthood of the
House of Hohenzollern by Emperor Wilhelm II
in 1893 (Tarbell 1985, 9).

47

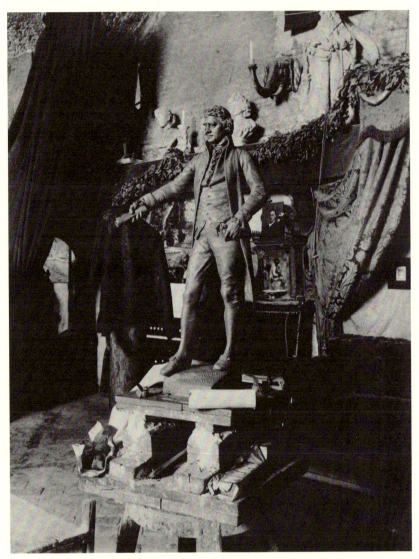

48

48. Thomas Jefferson

(Destroyed). After 1900. Clay. Archival
photograph, American Jewish Archives,
Cincinnati, Ohio

Accurate in its features, Ezekiel's *bozzetto* of
President Jefferson still was in the modeling
stages when photographed in the sculptor's
Roman studio, with blobs of clay and tools laid
aside on the stand. Finished, large-scale
sculptures derived from this sketch exist in
Louisville, Kentucky, and at the University of
Virginia. The sketch appears undramatically
posed and stiff, a work of little vivacity, yet
Lorado Taft considered it to be the most
significant sculpture Ezekiel ever sent to the
United States (Taft 1924, 263).

49. King Victor Emanuel of Italy (?)

(Destroyed). Clay. Archival photograph,
American Jewish Archives, Cincinnati, Ohio

A nearly finished *bozzetto* for an equestrian
monument, Ezekiel's carefully crafted work
was photographed in his studio, still on its
modeling stand and posed before a white sheet.
The sculpture's frontal view in the photograph
is unusual, emphasizing the portrait of the king.

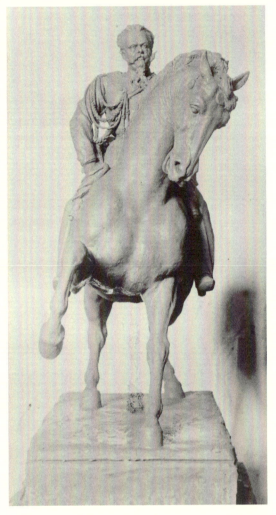

49

James Earle Fraser 1876-1953

Born in Winona, Minnesota. Prior to attending Art Institute of Chicago classes, Fraser lived as a youngster in Dakota territory, planting his lifelong interest in western subjects. Studied in Paris at the Ecole des Beaux-Arts with Falguière, at the Académies Julian and Colarossi, and with Augustus Saint-Gaudens in Paris, becoming his assistant. Worked with Saint-Gaudens until 1902, when he established a New York City studio. Teacher at Art Students League, 1906-1911. Particularly noted for *End of the Trail*, a sympathetic rendering of the vanquished Indian, and the Buffalo and Indian-head nickels.

50. End of the Trail

(Destroyed). 1894. Clay. Archival photograph, Fraser Collection, George Arents Research Library for Special Collections at Syracuse University

Fraser's *bozzetto*, first sketched in 1894 and inspired by monumental compositions the sculptor saw at the Columbian Exposition in Chicago, is known only in an archival photograph recording the now-destroyed work. Fraser's unpublished *Memoirs* recalled the impact of sculptures seen at that great fair: "... these all showed me how I could do a group that I had in mind, which was suggested when, as a boy, I remembered an old Dakota trapper saying, 'The Indians will someday be pushed into the Pacific Ocean.' I began making the model shortly afterwards and finished it as far as I could. I called it, 'The End of the Trail.' I still have the model which I did in 1894" (Krakel 1973, 2). His model, undoubtedly the larger one illustrated here, developed from a modest sculpture by Fraser called *Windswept*, shown below the horse's head and the lance point. Features in the sketch not included in cast versions of the finished sculpture are the shield at the Indian's side, the extended feathers of the headdress, and the support under the horse's stomach. The *bozzetto* was unrealized as a commission until 1915 when a large-scale stucco version was ordered for the Panama-Pacific Exposition, San Francisco (now in the Cowboy Hall of Fame, Oklahoma City). No more

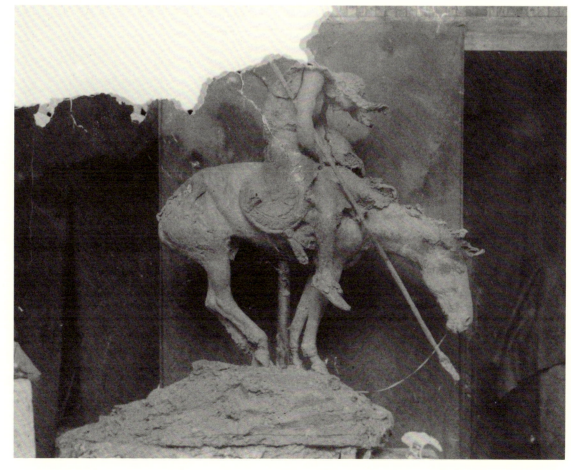

50

sensitive, haunting image of the American Indian has been rendered. The theme was drawn from a poem by Marion Manville Pope: "The trail is lost, the path is hid and winds that blow from out the ages sweep me on to that chill borderland where Time's spent sands engulf lost peoples and lost trails" (Proske 1943, 116). Conceived as a testimony to the Indian's sad vanquishment and last stand, Fraser hoped the sculpture in bronze would be sited on a cliff overlooking the Pacific Ocean in San Francisco, but this was never realized. Versions in various sizes exist in Brookgreen Gardens, St. Louis Art Museum, Waupun, Wisconsin, and elsewhere.

51. Abraham Lincoln, Seated

c. 1929. Plaster. Height 12½ inches (31.8 cm.). Fraser Collection, George Arents Research Library for Special Collections at Syracuse University, 69.646a

51

52

52. Abraham Lincoln, Standing

c. 1929. Plaster. Height 11½ inches (29.2 cm.).
Fraser Collection, George Arents Research
Library for Special Collections at Syracuse
University, 69.629

53. John James Audubon

c. 1930. Plaster. Height 10½ inches (26.7 cm.).
Fraser Collection, George Arents Research
Library for Special Collections at Syracuse
University, 69.584

An aesthetic that perceived directly carved
sculpture as the only true form of glyptic art
attempted to dominate in the second and third
quarters of the twentieth century in America,
particularly with some critics. For some, the

"greatest sin was to mix the manners – to
conceive a work in clay intending that it will be
pointed up into a large, carved piece" (Whitney
1976, 123). Fraser continued in the Beaux-Arts
tradition of modeling directly in clay, then
casting in plaster, well into the twentieth
century. He was untouched by the rising tide of
modernism, preferring to work in the earlier
methods and style promulgated by the French
academies and his mentor, Augustus Saint-
Gaudens. These three *bozzetti* by Fraser were
preparatory sketches for monuments of grand
and noble commemorative sentiments.
Although the final sculpture derived from each
sketch would be publicly displayed,
appreciation of such small modelings from the
sculptor's hand was private and usually
confined to those admitted to the studio or the
commissioners of the final works in bronze or
marble.

53

Daniel Chester French 1850-1931

Born in Exeter, New Hampshire. Studied with William Rimmer in Boston, J. Q. A. Ward in New York City, and Thomas Ball in Florence. Studied in Paris, 1886, after considerable fame had settled on him. Moved studio to New York City, 1888. Enormously popular throughout his long and prolific career. French modeled many colossal sculptures later cast in bronze, including the famous *Minute Man* (Concord, Massachusetts) and works for Columbian Exposition, 1893. Established studio and summer house, Chesterwood, near Stockbridge, Massachusetts. His most famous later work is the monumental marble *Abraham Lincoln* (Lincoln Memorial, Washington, D.C.).

54. Memory

1886. Plaster. Height 6 inches (15.3 cm.). Signed and inscribed, reverse: Feb. 1886/Daniel C. French. Chesterwood, Stockbridge, Massachusetts, a Property of the National Trust for Historic Preservation, 69.38.119

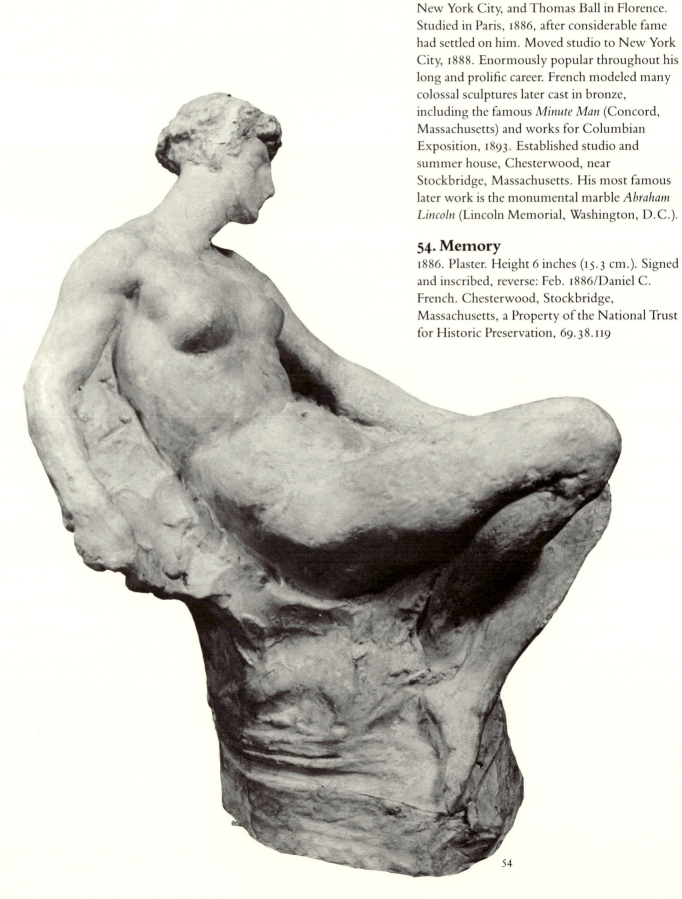

54

The last phase of French's study and training occurred in Paris in 1886, where he went intent on learning the rudiments of modeling in clay. But observation rather than formal enrollment in an atelier seems to have been the basis for his ten-months' training in France. French's methods were the same as those of Saint-Gaudens, MacMonnies, and others trained in Paris. Throughout his long years of studio work, French began his sculpture with a sketch modeled in water-soluble clay, occasionally in wax. Infrequently in later life, he worked in plasticine, an oil-based clay. *Memory* progressed through several stages in its development from this small sketch of 1886, to the finished, enlarged marble of 1919 (Metropolitan Museum of Art, New York). Hair and facial features were outlined in the *bozzetto*, the supporting rock still showing the imprint of fingers in pellets of clay. The sketch exudes a vigor and plasticity rarely achieved in French's highly polished final statement of the same subject. Mannerist in the female's elongation and extended neck, *Memory* illustrates the sculptor's eloquence in fashioning the small study. French considered the marble version "the chief effort of my life" (Letter, Daniel Chester French to Charles L. Hutchinson, February 5, 1919, Daniel Chester French Papers, Library of Congress), while the *bozzetto* is the earliest important, dated example of the female nude.

55. Martin Milmore Memorial

(Destroyed). 1889. Clay. Archives photograph, Chesterwood, Stockbridge, Massachusetts, a Property of the National Trust for Historic Preservation

The Boston sculptor Martin Milmore (1844-1883) is little appreciated and practically unknown, yet the powerful bronze relief executed by French to mark his grave in Forest Hills Cemetery, Jamaica Plain, Massachusetts, bestows a kind of eternal remembrance. French wrote that this maquette (now lost) was finished by September 1889 (Letter, Daniel Chester French to William French, September 1, 1889, Daniel Chester French Papers, Library of Congress). In this instructive first version, the angel stands erect with unshaded face and stays the sculptor's right hand. In the final full-size clay model, the youthful artist's left knee rests on the narrow ledge, while his left arm is grasped by the slightly bent arms of the heavily draped, long-winged angel of death. Also, the sphinx on which the sculptor works in the final version is not present in the *bozzetto*, but must refer to Milmore's *Sphinx* in Mount Auburn Cemetery, Cambridge, Massachusetts. The final version, cast in bronze and centrally placed within a stone setting with two low wings, has had three architects design separate settings: C. Howard Walker (1893), an unknown designer commissioned by Oscar Milmore (after 1914), and the Boston firm of Andrews, Jones, Boscoe, and Whitmore (1945). Ironically, French's suggested placement of figures with two wings springing from the relief on which the sculptor works as recorded in the lost sketch, is recaptured in the present version for the final setting in the cemetery.

56. Seated Female (Allegorical Figure?)

1893. Plaster. Height 10½ inches (26.7 cm.). Chesterwood, Stockbridge, Massachusetts, a Property of the National Trust for Historic Preservation, 69.38.3551

Bearing a round shield but lacking other attributes, this sketch for an unknown monument may have been a *bozzetto* for any of several commissions, such as *Brooklyn*, 1914. Its quiet, contemplative mood and compact mass are reminiscent of those qualities expressed in *Alma Mater*.

57. John Boyle O'Reilly Memorial, Boston

1895. Plaster. Height 3⅞ inches (9.8 cm.). Chesterwood, Stockbridge, Massachusetts, a Property of the National Trust for Historic Preservation, 69.38.10

Three figures made up the O'Reilly Memorial, a symbolic *Erin* enthoned in the center and on either side youths representing *Poetry* and *Patriotism*. The monument's triangular format, stable and balanced, developed through several stages with the earliest clay models depicting the two youths nude. Clothing and drapery were added in the full-size reproduction in French's finished clay sculpture. In this earliest extant *bozzetto* for the O'Reilly Memorial, while the mass is conceived compactly, the figures are better integrated one with the other, *Erin* not dominating the group as she does in the enlargement. A languorous attitude in the two side forms prevails. The sketch is one of French's finest accomplishments, illustrating his sensitivity to abstracted forms and volumes.

56

57

58. Architecture

(for *Richard Morris Hunt Memorial*, New York). 1897. Plaster. Height 13 inches (33 cm.). Private Collection

59. Painting and Sculpture

(for *Richard Morris Hunt Memorial*, New York). 1897. Plaster. Height 13 inches (33 cm.). Private Collection

Although the three sculptures by French for Hunt's memorial were dominated by the architectural surround, the stone and bronze tribute to the American architect was fittingly conceived as a classical arcade and exedra that suggested Hunt's professional career. French's three bronze works, a portrait bust and two standing allegorical figures representing

Architecture (holding a model of Hunt's Administration Building at the Columbia Exposition) and *Painting and Sculpture* (holding a hammer, small nude from the Parthenon pediment, and painter's palette), were placed in a balanced arrangement within the monument designed by Bruce Price. The two sketches, restrained and emphatically vertical, had French's characteristically smoothed sections of heads and arms while drapery and attributes were left rough. By February 1897, French finished these *bozzetti* and exhibited them at the annual exhibition of the Architectural League, New York. It was unusual for sculptors to show publicly their sketches and studies, but the commission for an architect's memorial may have prompted this rare participation.

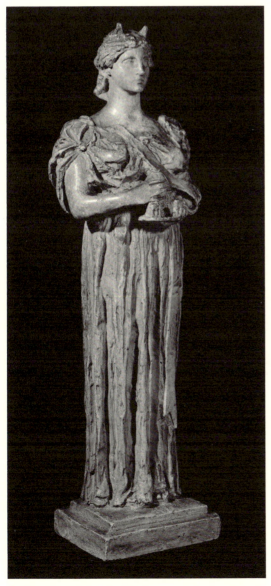

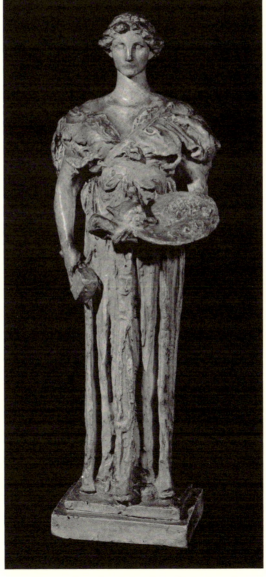

58 59

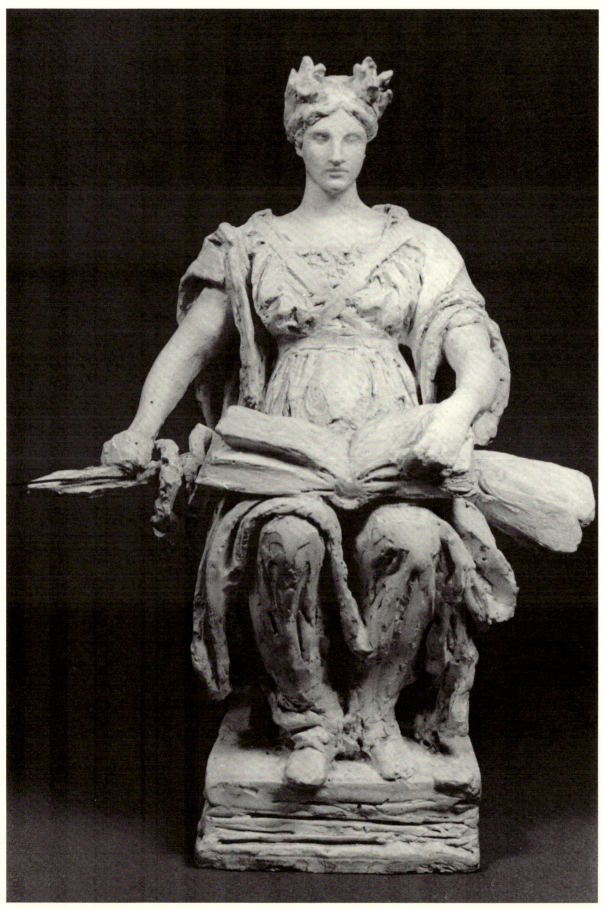

60

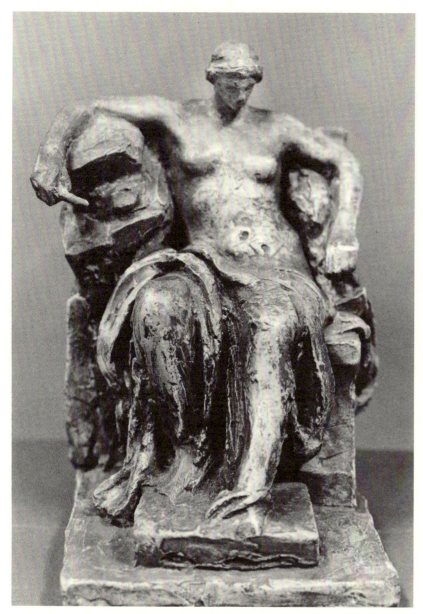

61

sketches. From sketch to twelve-foot finished work, French maintained a breadth of modeling that adapted itself finally to the space and setting at Columbia University.

61. Sculpture

1902–03. Plaster. Height 6 inches (15.3 cm.). Chesterwood, Stockbridge, Massachusetts, a Property of the National Trust for Historic Preservation, 69.38.3

Seldom did French err in the proportions of his sculptures, even in the maquette. Occasionally (as in this sketch for the finished work at St. Louis Art Museum) parts of figures were enlarged or reduced for dramatic emphasis. The large hands and small head in this female nude, symbolizing *Sculpture*, echo abstract elements in the modern works of Maillol and Rodin, though unconsciously. French was untouched by the wave of modernism in Europe led by these artists and others, and to the end of his career he was a sculptor practicing in the conservative style of the academies.

62. Africa

(from the *Continents*, United States Customs House, New York). 1903. Plaster. Height 5⅞ inches (14.9 cm.). Chesterwood, Stockbridge, Massachusetts, a Property of the National Trust for Historic Preservation, 69.38.209

60. Alma Mater

1900. Plaster. Height 11⅛ inches (28.3 cm.). Chesterwood, Stockbridge, Massachusetts, a Property of the National Trust for Historic Preservation, 73.45.1436

French was commissioned to execute a sculpture for Columbia University, *Alma Mater*, a commanding bronze goddess with raised arms and classical symbols, seated before Low Library. By February 1900, French had convinced Mrs. Harriette W. Goelet, commissioner of the sculpture, that a single figure was correct for the site, and during the same summer the sketch was completed. This work is presumably the earliest surviving study for the Columbia project and one discarded for a less static and broader personification. The drapery in French's *bozzetto* has a liquid, flowing quality to it. Arms and head are smoothed, as was the sculptor's custom in his

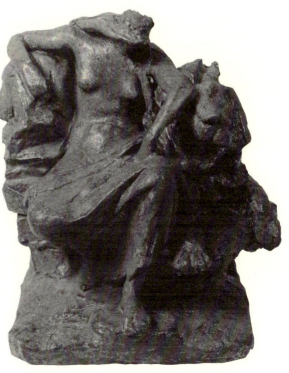

62

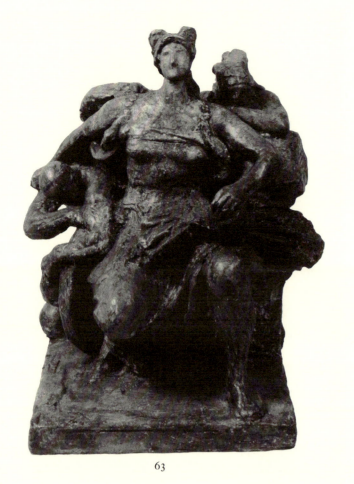

63

63. America
(from the *Continents*, United States Customs
House, New York). 1903. Plaster. Height 7¼
inches (18.3 cm.). Chesterwood, Stockbridge,
Massachusetts, a Property of the National Trust
for Historic Preservation, 69.38.210

64. Asia
(from the *Continents*, United States Customs
House, New York). 1903. Plaster. Height 6⅜
inches (16.3 cm.). Chesterwood, Stockbridge,
Massachusetts, a Property of the National Trust
for Historic Preservation, 69.38.208

65. Europe
(from the *Continents*, United States Customs
House, New York). 1903. Plaster. Height 6¾
inches (17.1 cm.). Chesterwood, Stockbridge,
Massachusetts, a Property of the National Trust
for Historic Preservation, 69.38.206

French's major architectural commission, four
symbolic figures or groups dominating the
entrance to the United States Customs House,
New York, was instigated by Cass Gilbert, the
building's architect. The sculptor conceptualized
the four *Continents*, subjects assigned by
Gilbert, in four *bozzetti* produced at
Chesterwood in 1903, each one forecasting the

bulk to be realized in monumental scale. Each
one suggested the attributes so detailed in the
ten-foot marbles. In 1904, architect Cass
Gilbert approved the sketches, the actual
plaster casts now in the Corcoran Gallery of
Art. French's quarter- and half-size clay
enlargements were worked up in his New
York and Chesterwood studios during the next
few years. Not until March 1907 were the
marble replicas by the Piccirilli brothers
finished (Richman 1976, 108). How many
sketches were discarded in the modeling
process is unknown, but the plaster replicas
now preserved at Chesterwood and the
Corcoran Gallery are French's accepted
bozzetti. The complexities of iconographical
symbols or attributes not displayed in the
sketches emerged in the marble enlargements.
In the *Asia* figure, for example, the rock-like
shapes below the feet translated into human
skulls, the long-tailed creature at the left
became a panther, and the bare-breasted
woman was decorated by necklaces and a
Buddha on her lap. At least three sets of the
final sketches were kept by the sculptor as
plaster casts, and one set was cast in bronze for
Cass Gilbert (Richman 1976, 109).

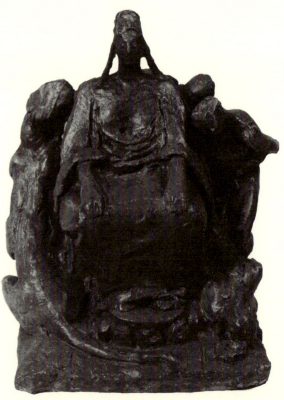

64

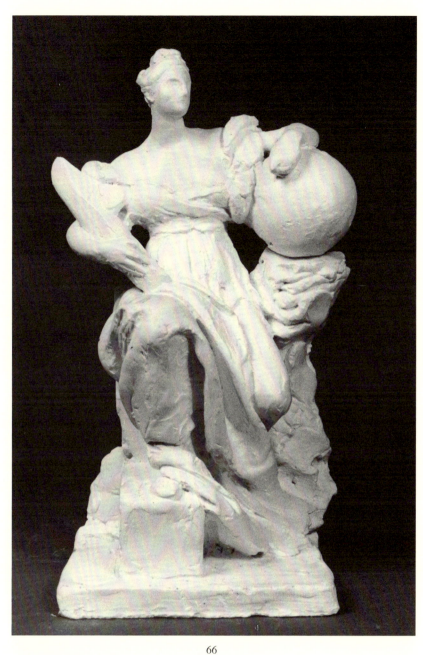

66

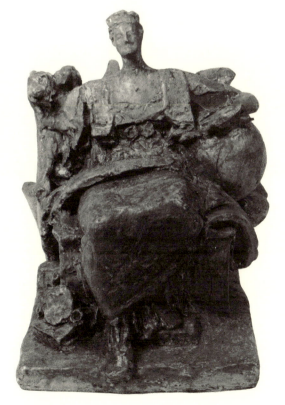

65

66. Commerce

(for Federal Building, Cleveland, Ohio). 1906.
Plaster. Height 9½ inches (24.1 cm.).
Chesterwood, Stockbridge, Massachusetts, a
Property of the National Trust for Historic
Preservation, 69.38.1127

Plaster's glaring brightness was tempered in
French's casts, apparently, with a tone rubbed
over the surface and into the crevices, staining
and subduing slightly the white skin with a
softer patina. French's *bozzetto* for *Commerce*,
one of two figures for the Federal Building in
Cleveland, is unusual for its unpatinated surface
and the poor relationship of parts in the lower
section to the whole concept.

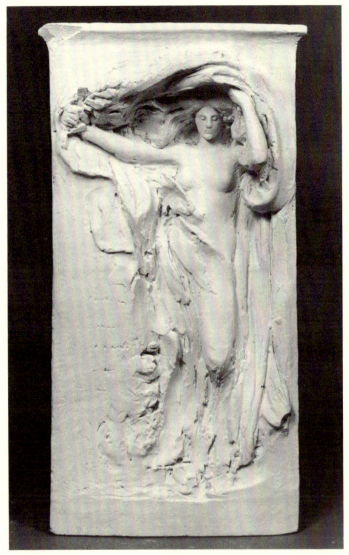

67

67. Melvin Memorial

1906. Plaster. Height 14⅞ inches (37.7 cm.).
Chesterwood, Stockbridge, Massachusetts, a
Property of the National Trust for Historic
Preservation, 69.38.1

The three Melvin brothers – Asa, John, and
Samuel – members of Company K, First
Massachusetts Heavy Artillery, died in the Civil
War. As a youngster, French knew them. So
when James C. Melvin, the surviving brother,
commissioned a monument to their lives and
services, the sculptor approached it with keen
personal commitment. By July 1897, French
was at work on the project he named *Memory*,
and on August 15, a cast was made of the sketch
(Richman 1976, 113). The first exercise was not
utilized, and the present sketch was modeled in
clay in 1906 along with an architectural base by
Henry Bacon. The *bozzetto* and resulting
monument for Sleepy Hollow Cemetery,
Concord, Massachusetts, are unlike anything in
French's career. Emerging from the
imprisoning block, the half-nude female lifts an
enveloping drapery above her downcast,
saddened face, one arm extends a laurel branch.
Low and high relief are combined in the sketch;
dramatic intensity vied with restraint.
Eventually, little change was made in
translating *bozzetto* into marble, except the
figure was reversed when carved because of a
problem in the memorial's placement in the
cemetery. Seldom in French's work did the
development process remain so true to the
sketch in appearance, proportions, and heroic
emotions.

68. Memorial Group

1908. Plaster. Height 11 inches (28 cm.).
Inscribed right side: Aug. 1908. Chesterwood,
Stockbridge, Massachusetts, a Property of the
National Trust for Historic Preservation,
69.38.177

69. Memorial Group

1915. Plaster. Height 11⅞ inches (30.1 cm.).
Inscribed left rear: D.C. French July 1915;
Inscribed in pencil on base: 31. Chesterwood,
Stockbridge, Massachusetts, a Property of the
National Trust for Historic Preservation,
69.38.1058

68

The plowboy hearing his country's call to arms, overshadowed by a protecting Victory, receives the laurel wreath from her right hand. Grace and *contraposto* are expressed in both examples in the female figure, among the most beautiful of the Tanagra-like sketches French wrought. It was his practice with his clay *bozzetti* and that of Saint-Gaudens as well, to model some figures first in the nude before clothing them. In the knickered boy of the later sketch, the sculptor embued the piece with unattractive costume elements and a personification usually lacking in his maquettes and their derivations.

70. Abraham Lincoln Memorial

(for Lincoln, Nebraska). 1910. Plaster. Height 14½ inches (36.8 cm.). Chesterwood, Stockbridge, Massachusetts, a Property of the National Trust for Historic Preservation, 69.38.1050

The Nebraska legislature formed a committee in 1903 and gathered funds to honor Abraham Lincoln, but not until 1908 did an eight-man group seek a sculptor. The commission fell to Daniel Chester French and architect Henry Bacon, the sculptor's frequent partner in such works. By 1910 French began a series of sketches. He commented in 1909 that his usual method with commissions was to make a group of ten-inch sketches in clay, with the one that "hit upon that the sculptor believes to meet the demands of the case" being cast in plaster for patron's approval. French was anxious to get his clay pieces cast quickly in plaster, *bozzetti* being no exception when certain successful ones were to be saved. He stated in 1889: " . . . I should much prefer to get it cast [in plaster] at once. After a clay model is finished it deteriorates, through accidents and the constant wear that its daily sprinklings [of water] make upon it" (Letter, Daniel Chester French to Franklin B. Sanborn, December 28, 1889, Archives, Concord Free Public Library, Concord, Massachusetts). In the autumn of 1910, French's sketch was shown to the Nebraska committee. Its contemplative, introspective character seems accentuated by the plain treatment of surfaces. The tilted head is modeled carefully, for a correct resemblance was expected even in the *bozzetto*.

70

69

71. Ralph Waldo Emerson

1911. Plaster. Height 12⅝ inches (32.2 cm.).
Inscribed right side: Aug 17 1911 DCF.
Chesterwood, Stockbridge, Massachusetts, a
Property of the National Trust for Historic
Preservation, 69.38.100

The idea for a seated version of the Concord
philosopher was first considered in 1891, but the
maquette was not completed until 1911 at
Chesterwood. By April 1913 the enlargement in
clay was finished, ready for the marble carvers
that would produce the massive portrait now in
the Concord, Massachusetts, public library.
French's inspiration came, perhaps, from
Houdon's *Voltaire*, a seated figure the American
artist must have known from his European trips
and from book illustrations. For the accurate
portrayal of Emerson's features, the sculptor
relied on his earlier portrait bust (1879). The
sketch's use of Emerson's flowing robe,
"Gaberlunzey," removes the figure from his
chronological place, inserting the New
Englander into a timelessness becoming to his
Transcendental philosophy.

72. Spirit of the Waters

(for *Spencer Trask Memorial*, Saratoga Springs,
New York). 1913. Plaster. Height 11¼ inches
(28.5 cm.). Inscribed on back: D.C. French /
1913 ©. Chesterwood, Stockbridge,
Massachusetts, a Property of the National Trust
for Historic Preservation, 69.38.9

71

72

73

73. Spirit of Life

(for *Spencer Trask Memorial*, Saratoga Springs, New York). 1913. Plaster. Height 15⅝ inches (39.6 cm.). Inscribed on back: DCF / Dec 1913. Chesterwood, Stockbridge, Massachusetts, a Property of the National Trust for Historic Preservation, 69.38.211

The angel form, a winged figure of grace and sadness, appeared throughout French's long years of work. Spencer Trask's monument for Congress Park, Saratoga Springs, New York, combined the talents of French and Henry Bacon, in a setting unusually elaborate and architectural. By the summer of 1913, French modeled a sketch called *Spirit of the Waters*, a half-draped female with outstretched arms and drooping wings. The *bozzetto*, smoothed in most areas, was a typically complete statement,

the mood of downcast blessing evident even in the eight-inch sketch. Later in 1913, French created a female figure, *Spirit of Life*, its wings modified and reduced. The drapery was more swirling and energetic and with a "spirit of buoyancy and life which you expressed a wish to have represented," he wrote to Mrs. Spencer Trask (Letter, Daniel Chester French to Katrina Trask, January 24, 1914, Daniel Chester French Papers, Library of Congress).

Unfinished as French thought the maquette was that he sent to Mrs. Trask, the vigorous rendering and athletic posture of the figure was unlike anything French had done before, and its effect must have captivated the patron. And from this *bozzetto* the finished enlargement in bronze resulted. The moods expressed by the two sketches were contrasting to a degree unknown in French's oeuvre.

74. Brooklyn

(for Manhattan Bridge, New York). 1914. Plaster. Height 9 inches (23 cm.). Chesterwood, Stockbridge, Massachusetts, a Property of the National Trust for Historic Preservation, 69.38.76

74

75

75. Manhattan

(for Manhattan Bridge, New York). 1914.
Plaster. Height 9⅛ inches (23.2 cm.). Inscribed
at left: DCF / June / 1914. Chesterwood,
Stockbridge, Massachusetts, a Property of the
National Trust for Historic Preservation,
69.38.80

At the Brooklyn side of the Manhattan bridge,
architects Thomas Hastings and John Carrère
proposed two monumental pylons, and French
received the award to execute two statuary
groups for their decoration. The subjects for
the groups, the boroughs of Brooklyn and
Manhattan, were developed first as *bozzetti* to
determine positions of bodies, placement of
attributes, and character or mood. Just ten years
earlier, French had modeled maquettes for the
United States Customs House, and a similar
challenge to combine symbolism and grandeur
in statuary groups appeared again. Slight shifts
in pose, along with changes in attributes, were
made in modeling the working model in clay.
Apparently the two *bozzetti*, boldly conceived
but perhaps considered too rough for the New
York Art Commission, were not submitted for
approval, as the working models better served
this purpose.

76. The Genius of Creation

(for Panama-Pacific Exposition, San Francisco).
c. 1914-5. Plaster. Height 12 inches (30.5 cm.).
Chesterwood, Stockbridge, Massachusetts, a
Property of the National Trust for Historic
Preservation, 69.38.1063

77. The Genius of Creation

(for Panama-Pacific Exposition, San Francisco).
1913. Clay. Height 20 ½ inches (52 cm.)
Inscribed, back: DC FRENCH OCT 1913.
Chesterwood, Stockbridge, Massachusetts, a
Property of the National Trust for Historic
Preservation, 69.38.1060

In 1875, working in the Florence studio of
Thomas Ball, the twenty-five-year-old French
developed his clay-modeling skills and formed
the practice that persisted throughout his life of
producing a sketch as the first and basic step in
the development of a sculpture. Ball cautioned
French in 1877: "I should be careful how I made
any very great change in the large. I am more
and more convinced every day, that the closer
we adhere to our small models, if they have
been studied carefully, the more grand and
broad our large work will be" (Letter, Thomas
Ball to Daniel Chester French, April 26, 1877,
Wendell Collection, Houghton Library,
Harvard University). *The Genius of Creation*
sketch evolved into the monument erected in
the Court of Honor in the Panama-Pacific
Exposition at San Francisco, 1915. One of
French's few excursions into Biblical narrative
or characters, the hovering figure symbolizing
the Creator raises protecting arms over Adam
and Eve, placed either side of the central plinth.
The snake was not included in either *bozzetto*,
but was included in final models. Although
both sketches may have been considered
concurrently as design options, it is likely that
the maquette without the Adam and Eve figures
is a discarded, earlier exercise. Both sketches are
reminiscent of the angel modeled as a first
sketch for the Spencer Trask Memorial in 1913.

76

77

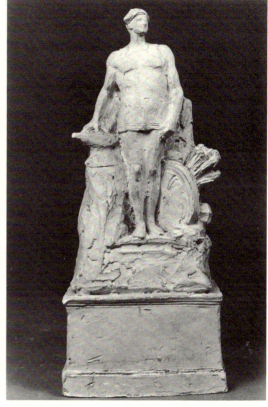

78

78. Industry

1916. Plaster. Height 8⅝ inches (21.9 cm.).
Chesterwood, Stockbridge, Massachusetts, a
Property of the National Trust for Historic
Preservation, 69.38.4

Anvil, wheel, and a tunic-clad male are
elements representing *Industry* in this plaster
cast of a briskly wrought clay sketch. Unlike
MacMonnies' *bozzetti* with their rough,
unpolished surfaces and discernible pellets of
clay, French's surfaces usually were smoothed,
especially in the modeled human form.

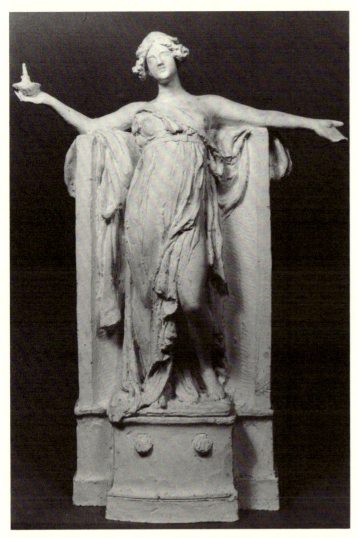 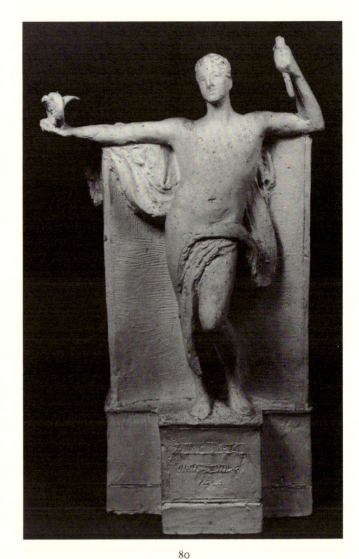

79 80

79. Williams Memorial (Spirit of Achievement) (Woman)

c. 1916. Plaster. Height 12¾ inches (32.3 cm.). Chesterwood, Stockbridge, Massachusetts, a property of the National Trust for Historic Preservation, 69.38.1102

80. Williams Memorial (Spirit of Achievement) (Man)

1915. Plaster. Height 10¾ inches (27.3 cm.). Inscribed right side: DCF / 1915. Chesterwood Stockbridge, Massachusetts, a property of the National Trust for Historic Preservation, 69.38.1104

Bozzetti preceding final sculptures, even for different commissions, were likely to have a kinship or similar appearance. As *bozzetti* are less detailed and more abstract, similarities between clay sketches may seem to exist where no relationship was intended. French's *Spirit of Achievement (Woman)* resembles the Spencer Trask Memorial's *Spirit of Life* in its outspread arms, draped figure with bent knee, and Nike-

like pose. Even the curved architectural background echoes the Trask niche behind the bronze. Tool marks are noticeable throughout both the male and female examples of *Spirit of Achievement*, with both evidencing the *contraposto* in so many of French's standing figures. The symbolism intended in the titles of two works seems lost in the *bozzetti*.

81. Samuel F. Dupont Memorial (Sea, Wind, Sky)

(for Dupont Circle, Washington, D.C.). 1917. Plaster. Height 10½ inches (26.7 cm.). Chesterwood, Stockbridge, Massachusetts, a Property of the National Trust for Historic Preservation, 69.38.122

The setting for the Dupont Memorial, the convergence of eight streets in a busy traffic circle in Washington, D.C., prompted a striking design for a fountain to be seen in full round. A three-sided shaft, each side enframing an allegorical figure, was topped by a wide basin from which cascades flowed. From a

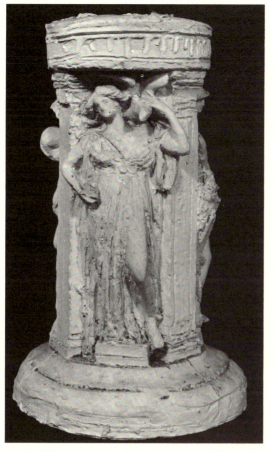

81a

sketch furnished by architect Henry Bacon, French took his lead and began his sketch: "The design for the fountain is a beauty and I am anxious to see it in the round. Can't you make me a drawing at a scale of one and one-half inches to the foot so that I can make a model of it? This would bring the figures about 11″ high which is about the size I like to make my sketches" (Letter, Daniel Chester French to Henry Bacon, June 27, 1917, Daniel Chester French Papers, Library of Congress). *Sea, Wind, and Sky*, three forms decorating the core of the fountain, were modeled summarily, the cuts and strokes of the tools indicating a hastily executed design. But as always with French's maquettes, the artist's touch could be carried through as finished work with little change in format. Bacon's large basin was not indicated in French's *bozzetto*, but the finished presentation model, nearly three times the size of the study, did incorporate it.

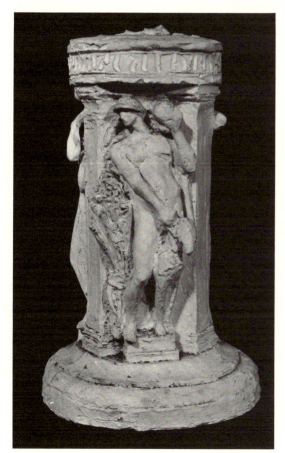

81b

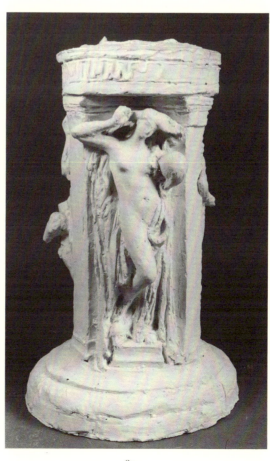

81c

82. Disarmament (Strength Protecting Innocence)

c. 1918. Plaster. Height 10⅛ inches (25.8 cm.). Chesterwood, Stockbridge, Massachusetts, a Property of the National Trust for Historic Preservation, 69.38.90

83. Disarmament (Strength Protecting Innocence)

c. 1918. Plaster. Height 14⅝ inches (37.1 cm.). Chesterwood, Stockbridge, Massachusetts, a Property of the National Trust for Historic Preservation, 69.38.3448

"Absurd though it seems, a good case can be made for turn-of-the-century sculpture as an industry. At this high period of activity, coincident with the neo-imperialism of Teddy

83

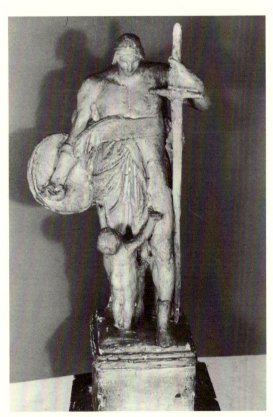

82

Roosevelt, sculptors may have wondered privately, as Mrs. Adams [Adeline Adams] did only in 1923, what would happen if the nation had no more battles to commemorate?" (Whitney 1976, 117). This notion persisted far beyond 1900, of course, for numerous war memorials were created for World Wars I and II, and those beyond. The large-scale public monument dominated French's career, and the sculptor willingly accepted several commissions for memorials to the fallen of World War I, including the New York sculptors' tribute in *Disarmament* or *Strength Protecting Innocence*. For this monument two *bozzetti* exist, both depicting a muscular warrior with two-handed sword and shield towering over an imploring infant.

84

84. Exeter War Memorial

(for Exeter, New Hampshire). c. 1918-20.
Plasticine. Height 8½ inches (21.6 cm.).
Chesterwood, Stockbridge, Massachusetts, a
Property of the National Trust for Historic
Preservation, 69.38.831

85. Exeter War Memorial

(for Exeter, New Hampshire). c. 1918-20.
Plaster. Height 18⅞ inches (48 cm.).
Chesterwood, Stockbridge, Massachusetts, a
Property of the National Trust for Historic
Preservation, 69.38.226

French's birthplace, Exeter, New Hampshire,
commissioned its native son to design a
memorial to its World War I soldiers. Working
in collaboration with architect Henry Bacon,
with whom he had joined so often, French
produced a commemorative group that
undoubtedly gave him some difficulty,
particularly with costume. The writer Adeline
Adams correctly perceived this: "The group
consists of but two figures, a guardian spirit,
amply draped, and a young soldier in uniform.
Probably that last item, the uniform, caused the
sculptor no little vexation of spirit, since it is
hard to harmonize the prosaic particularity of
modern military dress with the poetic license of
imagined drapery. When the whole interest of a
group is concentrated in two figures of
somewhat opposed artistic intention (at least as
to costume), difficulties increase. It was
necessary to show the uniform as it was, and
not as it might have been; in that quarter, the
door to imagination was shut" (Adams 1932,
77-78). French's ability to conceive the entire
monument, architectural background as well as
figures in the small sketch, was demonstrated
frequently as in this rare example in clay.
Developed further as shown in the plaster cast
of a subsequent *bozzetto*, the sculptor refined
his modeling and added more details but
neglected to include the stele that formed the
setting.

85

86

86. Washington Irving Memorial

(for Irvington–On–Hudson, New York). c. 1925. Plaster. Height 15½ inches (39.4 cm.). Inscribed in front: DCF 1925. Chesterwood, Stockbridge, Massachusetts, a Property of the National Trust for Historic Preservation, 69.38.185

Late in French's career, he designed a memorial to the American author, Washington Irving, a work in two parts combining a portrait bust set against a simple slab on which two of Irving's characters, Rip van Winkle and Boabdil, perhaps from *Tales of the Alhambra*, appear. Erected at Irvington-on-Hudson, the memorial is a pedestrian, bland attempt at marrying two sculptural approaches. This is a rare instance of French's failure to model a vibrant, expressive sketch.

87. Andromeda

1929. Plaster. Height 10¾ inches (27.2 cm.). Inscribed at right: DCF / 1929. Chesterwood, Stockbridge, Massachusetts, a Property of the National Trust for Historic Preservation, 69.38.269

French created an ideal sculpture at the very end of his life, forming the clay sketch in the summer of 1929 and reported in his account book. He wrote his nephew: "You may be amused if I tell you that I am contemplating the creation of a nude female figure of heroic size, not an order, but just for fun" (Letter, Daniel Chester French to Henry Hollis, November 27, 1929, Daniel Chester French papers, Library of Congress). The marble enlargement (Chesterwood), carved by the Piccirilli brothers, was the last work on which French worked.

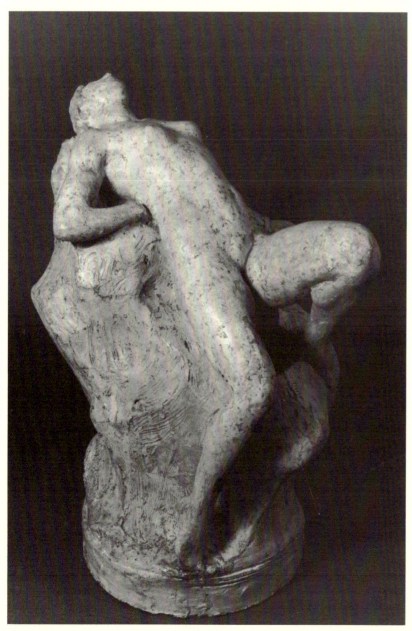

87

88

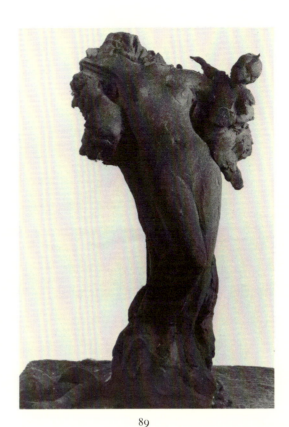

89

90

88. Daniel Webster

1930. Clay. Height 9¼ inches (23.5 cm.). Chesterwood, Stockbridge, Massachusetts, a Property of the National Trust for Historic Preservation, 69.38.829

This broadly worked sketch in clay is an original sculpture, slightly damaged, that illustrates the use of this modeling material and the typical small scale employed for first recordings of plastic ideas. The nail protruding from the head may be part of the supporting armature.

89. Mother and Child

c. 1930. Plasticine. Height 11 inches (27.9 cm.). Chesterwood, Stockbridge, Massachusetts, a Property of the National Trust for Historic Preservation, 69.38.830

Photographed on French's work stand with bits of clay strewn around its base, the genesis of this sculpture is vividly expressed in spite of its incompleteness, the hastily formed infant, and the rough strata of planes behind the sinuous female. This *bozzetto* is one of French's most telling illustrations of his modeling process and a rare example preserved in clay.

90. George Washington

1931. Clay. Height 16 inches (40.5 cm.). Chesterwood, Stockbridge, Massachusetts, a Property of the National Trust for Historic Preservation, 69.38.832

Portions of the armature poke through points in this sketch, a costume study, essentially, for the sculpture lacks the individuality and expressiveness of a *bozzetto* for a specific commission.

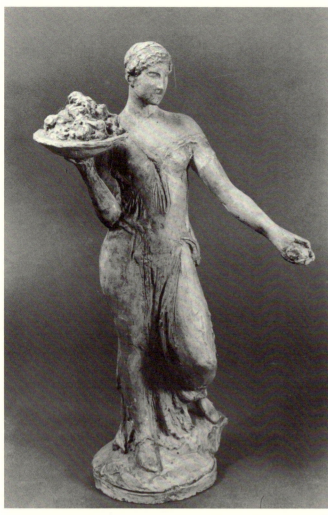

91

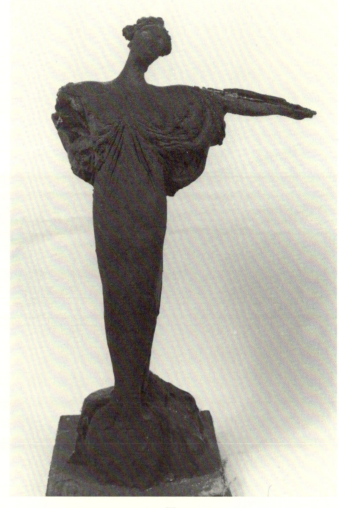

92

91. Allegorical Figure

1931. Plaster. Height 10⅜ inches (26.4 cm.).
Chesterwood, Stockbridge, Massachusetts, a
Property of the National Trust for Historic
Preservation, 69.38.178

Perhaps the sketch personifies Pomona or
another mythological character associated with
a fruitful harvest, Abundance, or the like, but
its relationship to any monument by French is
unknown. The figure's stance, with weight on
one leg, abstracted features, and smoothed
surface treatment are typical of French's
bozzetti.

92. Female Figure

Clay. Height 9½ inches (24 cm.). Chesterwood,
Stockbridge, Massachusetts, a Property of the
National Trust for Historic Preservation,
69.38.828

An incomplete sketch for an unknown
sculpture, this work has an *art nouveau* character
to it unlike anything in French's work. The
attenuated neck, barely indicated drapery, lithe
look of the body and the unfinished portions
are appealing aspects of a modernism never
fully explored by French, yet suggested here in
this imaginative *bozzetto*.

93. Knowledge

Plaster. Height 9½ inches (24.1 cm.). Inscribed on reverse: D.C. French ©. Chesterwood, Stockbridge, Massachusetts, a Property of the National Trust for Historic Preservation, 69.38.205

Reminiscent of one of Michelangelo's *Prophets* for the Sistine Chapel ceiling, French's *bozzetto* has a similar attitude evoking quiet resolve, meditation, and strength. Planes and volumes are broadly worked, yet all elements are properly suggestive, not too abstracted, for the final model. In the damaged proper left arm, a portion of the armature is exposed.

94. English High School Group (Spirit of Service to Mankind).

Plaster. Height 12⅞ inches (32.6 cm.). Chesterwood, Stockbridge, Massachusetts, a Property of the National Trust for Historic Preservation, 69.38.212

Much of the beauty of a *bozzetto* is due to its timeless, undated look, largely due to the abstraction that could place it in several centuries, forging a link with Baroque and even classical sculptors of centuries before. French was less at ease with commissions requiring contemporary dress rather than those that required togas and chitons to drape his allegorical figures. Clearly more attention and inspiration have been fused in the female figure with tablet, while the boy linking hands adds a self-conscious, awkward element to this preliminary sketch.

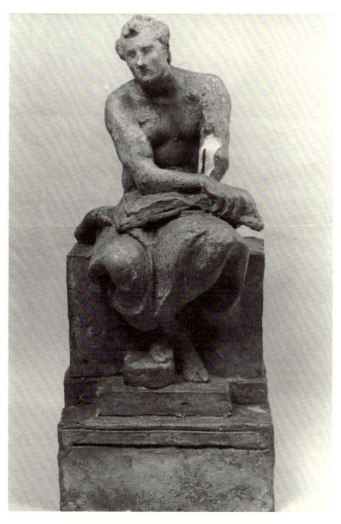

93

94

95

96

95. Seated Female (Alma Mater?)

Plaster, painted. Height 8¼ inches (20.9 cm.). Signed on base: D.C. French. Chesterwood, Stockbridge, Massachusetts, a Property of the National Trust for Historic Preservation, 69.38.15

In French's revived classicism, so popular in the late nineteenth century in American art, certain Greek or Roman forms appear in his sculpture again and again. More than once did French employ the *klismos* chair with its rounded back and sabre legs (see sketches for *Manhattan* and finished bronze of *Alma Mater*). This *bozzetto*, a rare example of applied color in French's sculpture, may have been a rejected sketch for •one of these commissions, although missing attributes make it difficult to decipher its iconography. In this example, although the back of the chair is disportionately large, the light, shadow, and pose are masterfully handled.

96. Male Figure

Plaster. Height 2⅜ inches (6 cm.). Chesterwood, Stockbridge, Massachusetts, a Property of the National Trust for Historic Preservation, 69.38.1107

A sketch for an unknown project, the roughly modeled seated figure is akin to several examples of male and female figures posed on a block and with one leg raised higher by a small footstool, such as *Sculpture, Knowledge,* or *Manhattan.*

97. Bust of a Man

Plaster. Height 1⅜ inches (3.4 cm.). Chesterwood, Stockbridge, Massachusetts, a Property of the National Trust for Historic Preservation, 69.38.1108

Did Daniel Chester French ever encounter Honoré Daumier's small caricatures of members of the French Legislature? Probably not, but a curious similarity exists between the depictions of corrupt, foolish legislators and French's ghostlike man with gaping eye sockets. Its use as a *bozzetto* is unknown.

97

Leo Friedlander 1888-1966

Born to immigrant parents. Studied at the Art Students League, New York, beginning at age twelve. Apprenticed to a firm manufacturing ornamental details for building industry. Worked at Klee Brothers as modeler until 1908, moving to Paris and Brussels for study. Returned to New York, 1911, receiving commission for decoration of Paul Cret's memorial arch at Valley Forge, Pennsylvania. Won Prix de Rome, 1913, returning home after study, 1917. Most important commission was received in 1929 for colossal equestrian groups at entrance to Arlington Memorial Bridge, Washington, D.C. (finally dedicated in 1951). Served as President, National Sculpture Society, 1954-57.

98. Valor

1931. Painted plaster. Height 13½ inches (34.3 cm.). Private Collection

Friedlander was commissioned in 1929 by McKim, Mead and White, architects of the Arlington Memorial Bridge, to sculpt a pair of monumental equestrian groups to flank the entrance at the District of Columbia side of the bridge. The theme was *The Arts of War*, with *Valor* and *Sacrifice* selected as specific subjects for the two units. *Valor* was modeled originally in 1916, when Friedlander was a student in Rome. Reflecting the world of classicism and antiquity around him, the sculptor modeled his *bozzetti* with a "bigness of conception and style that defies the small proportions of the actual works. Most of his figures are closed – arms held in to the torso, thighs compressed, chins pulled down, drapery sometimes filling open areas – creating weighty, monumental forms" (Rosenkranz 1984, 8).

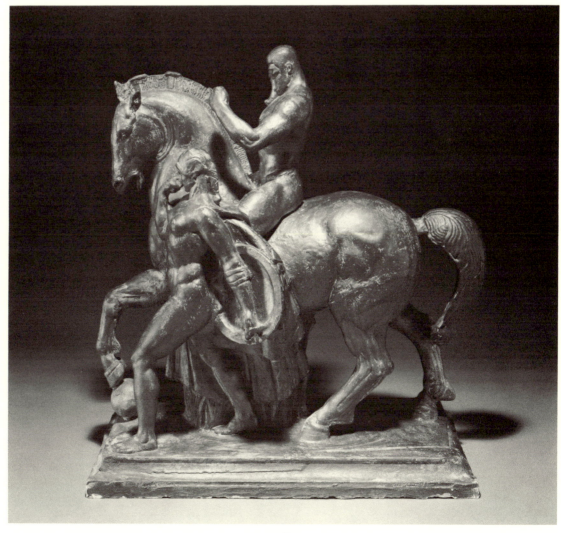

98

99. George Rogers Clark Memorial

(left side, right side) (for State Capitol, Salem, Oregon). c. 1932. Painted plaster. Height 16¾ inches (42.5 cm.). Inscribed, obverse: WESTWARD THE STAR OF EMPIRE TAKES ITS WAY. Inscribed, reverse: HAVE THRUST OUR FRONTIERS TO THE. The Mitchell Wolfson Jr. Collection of Decorative and Propaganda Arts, Miami, Florida

The monumentality of most of Friedlander's works, figures larger than life and blocked out in stone or bronze to show massive silhouettes, is illustrated in his *bozzetto* for the Clark Memorial at the Oregon State Capitol. Always sensitive to the demands of architecture and related sculpture, Friedlander worked in close harmony with architects throughout his long career. His flat, planar style persisted in all his sculpture.

100. Abraham Lincoln

c. 1932. Bronze. Height 15½ inches (39.4 cm.). Marked: Kunst F'dry NY. Museum of Fine Arts, Boston, Massachusetts

This sparse, expressive *bozzetto* for a proposed monument intended to reach a height of sixty feet was never realized in final form for Springfield, Illinois. Friedlander's few extant sketches are without the roughened, sometimes unarticulated surfaces of numerous *bozzetti* by Friedlander's precursors and contemporaries, but are finely finished and smoothed, easily translatable into larger versions in metal or stone. In the 1930s the sculptor directed his efforts toward monumental pieces, commissions flowed in, and he found his *métier* thereafter in grand-scale monoliths.

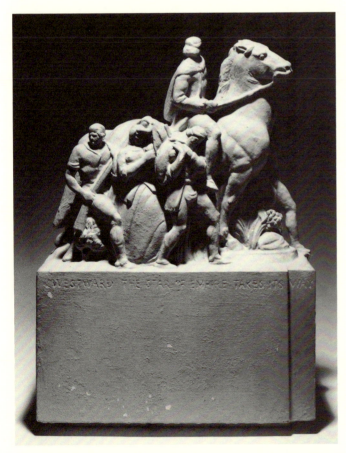

99a

99b

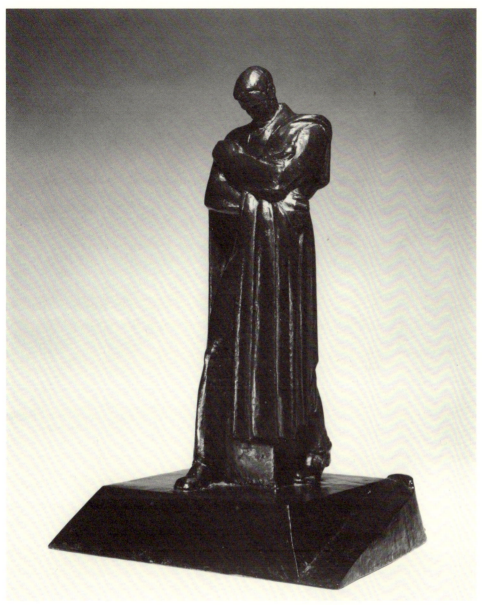

100

101. George Eastman Memorial

(Fragment) (for Rochester, New York?). Plaster.
Height 12 inches (30.5 cm.).
Conner · Rosenkranz, New York

Manship, Jennewein, and Friedlander shared a
neoclassical vernacular. Highly stylized, this
smoothly muscled patriarch exhibits the tenor
and visual effect Friedlander sought in his
sketches as well as finished sculpture.

101

Charles Grafly 1862-1929

Born in Philadelphia. Apprenticed as stonecutter at age seventeen, he later studied with Thomas Eakins and Thomas Anshutz at the Pennsylvania Academy of the Fine Arts, 1884-88. He studied four years in Paris, 1888-92, at Ecole des Beaux-Arts and Académie Julian with Chapu. Produced two entries accepted by *Salon*, 1890. Taught in Philadelphia and Boston after 1917. Renowned for his portraits, he was a major force in impressionistic modeling and symbolism in sculpture.

103

102

102. Woman with Skull

c. 1885-90. Plaster. Height 6 inches (15.2 cm.). Charles Grafly Collection, Wichita State University Endowment Association Art Collection, Edwin A. Ulrich Museum of Art

Grafly's ideal work of the 1890s often dealt with emotive, even morbid subjects, and this early study from pre-Paris student days foretells such direction. The sketch is awkwardly modeled with some proportions handled inadequately. It is clearly a student work.

103. Mother and Child

c. 1885-90. Clay. Height 9 inches (22.8 cm.). Charles Grafly Collection, Wichita State University Endowment Association Art Collection, Edwin A. Ulrich Museum of Art

This sketch probably dates from student days at the Pennsylvania Academy of the Fine Arts, or it may be a rare survivor from his first stay in Paris. The blocky execution and cut surfaces suggest a Philadelphia origin, not quite like the technique learned from the French Academicians. Also, parts are modeled incompletely or as meaningless solids and voids.

104. Cain

c. 1888-92. Plaster. Height 8⅜ inches (21.2 cm.). Inscribed: Cain. Charles Grafly Collection, Wichita State University Endowment Association Art Collection, Edwin A. Ulrich Museum of Art

At least two versions of Cain have survived depicting the remorseful Biblical murderer of Abel. Such abstracted modelings in flowing, expressive lines typified Grafly's earliest known sketches, curiously more abstract than works from his later years, reversing the usual progress from academic realism to abstraction frequently encountered in the maturing process in artists.

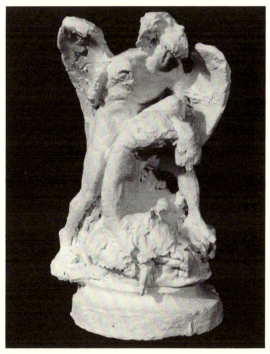

106. Daedalus and Icarus

1890. Clay. Height 9½ inches (24.1 cm.).
Inscribed: DEDALVS ET ICARVS. Charles
Grafly Collection, Wichita State University
Endowment Association Art Collection,
Edwin A. Ulrich Museum of Art

Students at the academies in Paris learned to
model clay by practice and repetition, working
from casts and models, criticized (but not
frequently) by their teachers who assigned the
subjects and judged the results. Saturdays at the
Académie Julian produced a parade of small
clay sketches, called *ésquisses*, made the
preceding week. These studies, after a critique,

105

105. L'Age de Fer

c. 1888-92. Clay. Height 10⅛ inches (25.6 cm.).
Inscribed: L'AGE de FER. Charles Grafly
Collection, Wichita State University
Endowment Association Art Collection,
Edwin A. Ulrich Museum of Art

Perhaps an *ésquisse* assigned by the instructor
at the Académie Julian, the sketch is modeled
with fluidity, attention to correct anatomy, and
bears the print of Grafly's already maturing
impressionistic modeling technique.

106

were returned to the clay bin. Thus, their
destruction at the end of the assignment
accounts for the relative lack of sketches or
bozzetti to represent an artist's early production.
It may also suggest the paucity of *bozzetti* from
an artist's career at any stage, due to the
ingrained habit of discarding first expressions as
the work developed. Grafly's diary for January
12, 1890, noted that he worked in his studio all
day to "make a new ésquisse of Daedalus and
Icarus" (Simpson 1974, 133). The mythological
subject probably was assigned by Henri-Michel
Chapu, Grafly's instructor at Julian's, and no
doubt a continuation of the theme explored a
year earlier in the bust of *Daedalus*

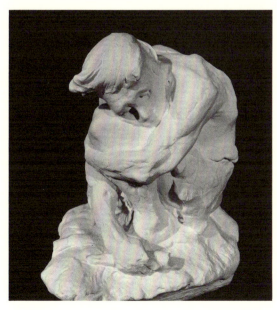

104

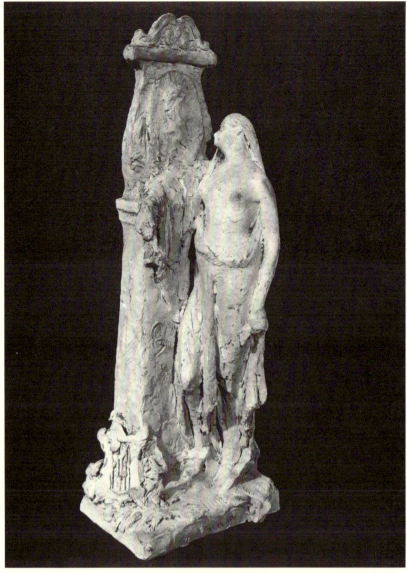

107

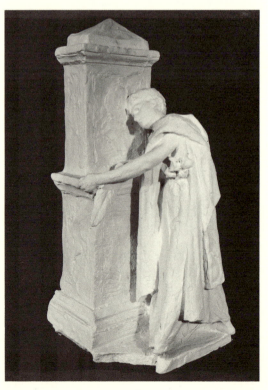

108

(Pennsylvania Academy of the Fine Arts). The smoothed, somewhat ill-defined parts of this sketch are typical of Grafly's sketches from his student days.

107. Woman at a Monument

1890. Clay. Height 15⅛ inches (38.4 cm.). Signed: Grafly February 1890. Charles Grafly Collection, Wichita State University Endowment Association Art Collection, Edwin A. Ulrich Museum of Art

108. Tomb Memorial

c. 1890. Plaster. Height 19 inches (48.2 cm.). Charles Grafly Collection, Wichita State University Endowment Association Art Collection, Edwin A. Ulrich Museum of Art

Grafly's diary entries in 1889-90 recorded his work on assignments from his teacher, Chapu. These two exercises seem to identify with these entries, the first evidently criticized by the master: "The motif was good but the upper part of the tomb was too much like a vase . . . not architectural enough" (Simpson 1974, 144). The sculptor sought out inspirational examples of funereal sculpture in Paris, and they abounded in churches and cemeteries, as references and background. His diary indicated that he went "to the Pere Lachaise cemetery for new ideas of monuments," and though he was "not allowed to sketch," he apparently did some drawing or off-hand modeling there (Simpson 1974, 145). Typical of much late nineteenth-century memorial sculpture are the combination of classical elements and grieving mourners, dignified and stoically accepting loss. The more freely modeled of the two illustrates Grafly's invigorated treatment of surface.

109

110

109. Crouching Figure

c. 1890. Clay. Height 4½ inches (11.4 cm.).
Charles Grafly Collection, Wichita State
University Endowment Association Art
Collection, Edwin A. Ulrich Museum of Art

Almost totally abstracted, this undeveloped
sketch is perhaps related to *Cain*. It is one of
Grafly's least detailed studies.

111

110. Frances Sekeles Grafly

c. 1892–1900. Tinted plaster. Height 8½ inches
(21.5 cm.). Charles Grafly Collection, Wichita
State University Endowment Association Art
Collection, Edwin A. Ulrich Museum of Art

The sculptor met his future wife in 1890, and
they were married in 1895, journeying to Paris
for a year's period of study and travel. More
finished than the usual *bozzetto*, the relief may
have been intended for translation into marble
or bronze. Rarely did Grafly sculpt reliefs, and
his competency is not equal to that of Saint-
Gaudens, the undoubted master of the relief
among American sculptors.

111. Two Figures

1896. Clay. Height 11½ inches (29.2 cm.).
Signed: Grafly Paris 1896. Charles Grafly
Collection, Wichita State University
Endowment Association Art Collection,
Edwin A. Ulrich Museum of Art

This sketch probably pertains to an important
work, now destroyed, *The Vulture of War*. This
was a major project modeled in Paris, never
realized but exhibited in part at the Pan-
American Exposition, Buffalo, 1901. Grafly's
modeling is brisk and sure, the rough surface
treatment hinting that it was a study for his
own use only, not a *bozzetto* to be submitted to
commissioners.

112. Woman Watching a Cat

c. 1896. Plaster. Height 9¾ inches (24.8 cm.).
Charles Grafly Collection, Wichita State
University Endowment Association Art
Collection, Edwin A. Ulrich Museum of Art

The essence of form could be quickly captured
by Grafly in sketches, as in this one, with the
surface left rough. Apparently the sculptor
worked the clay in a rather moist consistency,
permitting easy blending of small balls of clay.

113. Stephen Girard Monument

c. 1896. Plaster. Height 19 inches (48.2 cm.).
Charles Grafly Collection, Wichita State
University Endowment Association Art
Collection, Edwin A. Ulrich Museum of Art

Girard (1750-1831), a wealthy Philadelphian,
bequeathed funds to establish a college that
would provide free education for poor white
orphan boys. His philanthropic spirit was
commemorated in a monument, for which
Grafly competed, but the prize went to John
Massey Rhind (1860-1936), who executed a
single figure. In some of Grafly's sketches, the
heads appear to be too large for the bodies, and
the impressionistically treated surfaces
frequently were erased by a smooth treatment.
These two factors are evident in this *bozzetto*.

112

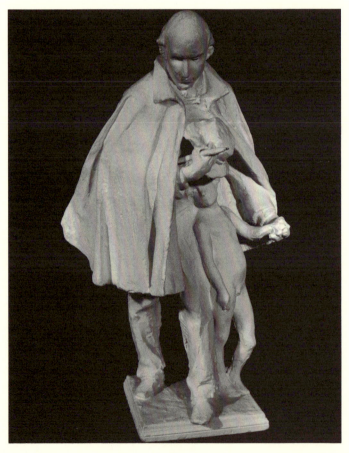

113

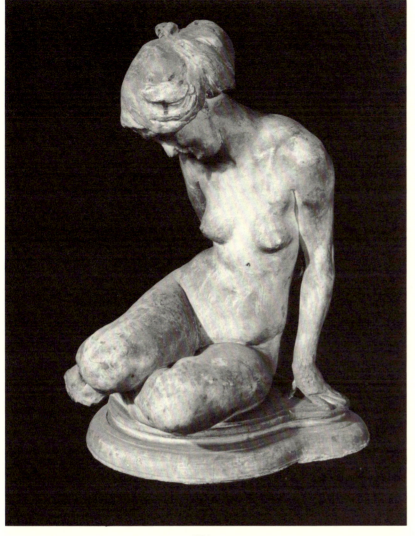

114

114. Seated Woman

c. 1896. Plaster. Height 14 inches (35 cm.). Charles Grafly Collection, Wichita State University Endowment Association Art Collection, Edwin A. Ulrich Museum of Art

115. Two Figures Seated on a Rock

c. 1896–98. Plaster. Height 18 inches (45.8 cm.). Charles Grafly Collection, Wichita State University Endowment Association Art Collection, Edwin A. Ulrich Museum of Art

The poor condition of the sketch with its armatures exposed at several points does not permit an easy reading, but pencil markings on the shoulders of the female figure may indicate it was being readied for translation into marble or bronze. Grafly's habit of elongating, or at least emphasizing, the arms in his sketches of the 1890s is shown here, but the surface treatment is more finished than expected for this period.

116. Sisyphus

1899. Plaster. Height 8 inches (20.3 cm.). Charles Grafly Collection, Wichita State University Endowment Association Art Collection, Edwin A. Ulrich Museum of Art

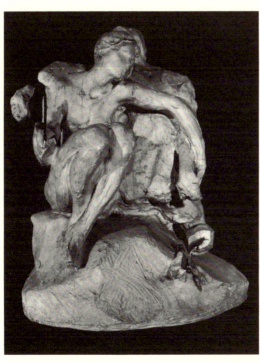

115

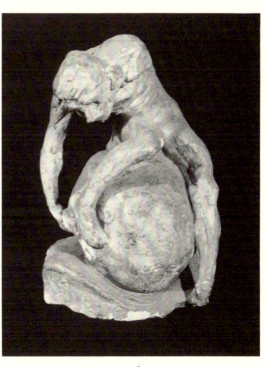

116

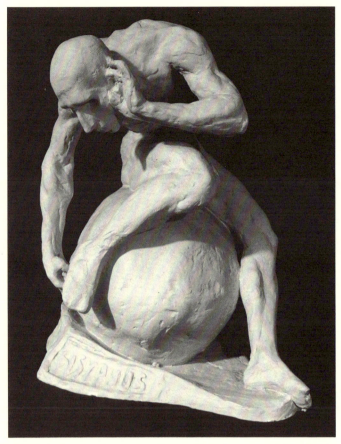

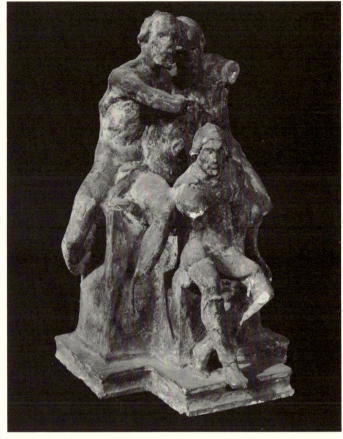

117

118

117. Sisyphus

1899. Plaster. Height 17¾ inches (45 cm.).
Signed: Grafly 1899. Inscribed: SISYPHUS.
Charles Grafly Collection, Wichita State
University Endowment Association Art
Collection, Edwin A. Ulrich Museum of Art

Ovid's *Metamorphoses* related the tale of
Sisyphus, King of Corinth, who angered Zeus
and was condemned to roll a boulder up a hill
forever. Grafly's first sketch of this subject (the
smaller of the two figures illustrated) was
extended in a second version. His modeling in
the smaller sketch, as well as in the twisted
pose, evokes the Baroque and expresses the
strong influence of his Paris schooling.

118. Three Men

1899. Plaster. Height 17¼ inches (43.8 cm.).
Signed: Grafly 1899. Charles Grafly Collection,
Wichita State University Endowment
Association Art Collection, Edwin A. Ulrich
Museum of Art

It is unknown if this *bozzetto* was developed as
part of a specific commission. Its theme seems
to relate to ideal, classical, or mythological
episodes he may have been exploring at this
time, such as the *Symbol of Life* or *Aeneas and
Anchises*, that dealt with old age and youth.
The modeling is smoothed and simplified in
its treatment of anatomical elements, with
portions of the wire armature visible.

119. Fountain Study

(for *Fountain of Man?*, Pan-American Exposition, Buffalo). 1900-01. Plaster. Height 15⅞ inches (40.3 cm.). Charles Grafly. Collection, Wichita State University Endowment Association Art Collection, Edwin A. Ulrich Museum of Art

Tactile, very moist clay in Grafly's talented hands formed this group of four herms, each clasping a plaque, a superb example of the quickly modeled *bozzetto*.

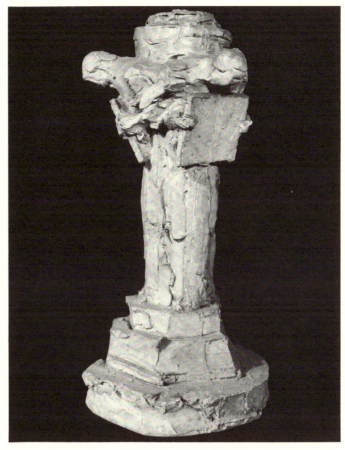

119

120. Man and Woman Wrestling with a Snake

c. 1900-03. Plasticine. Height 12 inches (30.5 cm.). Charles Grafly Collection, Wichita State University Endowment Association Art Collection, Edwin A. Ulrich Museum of Art

Portions of the wire armature protrude from the oily clay, a favorite modeling material of Grafly and his contemporaries. This strange subject, still attached to the bit of board that must have been its only pedestal on the sculptor's modeling stand, was never interpreted further as far as is known. The sketch appeared in a photograph taken in 1903 of Grafly's studio (Simpson 1974, 184).

120

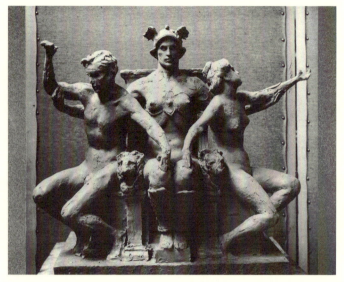

121

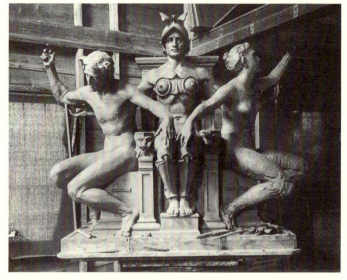

122

121. Electricity Group

(Destroyed)(for Louisiana Purchase Exposition, St. Louis). 1903-04. Clay. Archives photograph, Charles Grafly Collection, Ablah Library, Wichita State University

122. Electricity Group

(Destroyed) (Second Sketch) (for Louisiana Purchase Exposition, St. Louis). 1903-04. Clay. Archives photograph, Charles Grafly Collection, Ablah Library, Wichita State University

123. Electricity Group

(Destroyed) (Second Sketch) (for Louisiana Purchase Exposition, St. Louis). 1903-04. Clay. Archives photograph, Charles Grafly Collection, Ablah Library, Wichita State University

Grafly was commissioned in 1903 by the Louisiana Purchase Exposition in St. Louis to provide sculptural decoration for the overdoor of the main entrance to the Electricity Building. The architect suggested to Grafly the desired image: "the subject is not definitely fixed, but Electricity bestowing gifts to commerce and science or Electricity as life inspiring, or other attributes you see fit . . . " (Simpson 1974, 276). The sculptor's early and small sketch in clay indicates a fully realized concept of Mercury, the central figure in winged helmet beside male and female nudes representing the negative and positive forces, as marked in the second versions. Grafly's enlargement in clay is illustrated in two stages of development, the earliest is possibly a *bozzetto* with a highly finished surface (note also the wads of clay poised on the legs of the two nudes and the modeling tools, armature, and supports on the second enlargement illustrations).

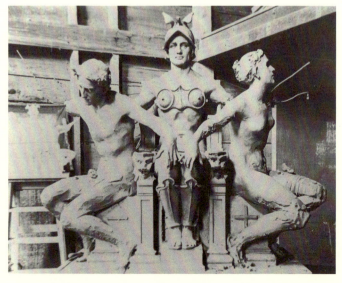

123

124. Figure

(for United States Customs House, New York?). 1903–06. Plaster. Height 24⅞ inches (63.2 cm.). Charles Grafly Collection, Wichita State University Endowment Association Art Collection, Edwin A. Ulrich Museum of Art

Apparently related to the United States Customs House commission, the striding figure in Liberty cap may represent *America*, or it may be a version of *France*. While Grafly's proportions seem too attentuated, the treatment of windblown dress is modeled with special skill. The fitting of the proper right arm, now lost, to the torso is a glimpse of Grafly's hollow-cast method and an indication that sketches of this size were cast in sections.

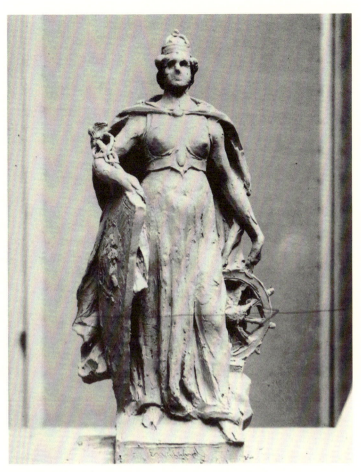

125

124

125. England

(Destroyed) (for United States Customs House, New York). 1903–06. Clay. Inscribed, front of base: England. Archives photograph, Charles Grafly Collection, Ablah Library, Wichita State University

126. England

(for United States Customs House, New York).
1903–06. Plaster. Height 15 inches (38.1 cm.).
Charles Grafly Collection, Wichita State
University Endowment Association Art
Collection, Edwin A. Ulrich Museum of Art

Among the sculptors commissioned to provide
sculptural decoration for this public building in
New York (including Daniel Chester French),
Grafly was assigned by architect Cass Gilbert to
model allegorical figures for the attic portions
of this Beaux-Arts building (Simpson 1974,
285). Images of *England* and *America* were
selected, obviously chosen because of their
world importance in commerce. The nation's
symbols identified each country. The plaster
cast was taken from the lost clay *bozzetto*,
reproducing Grafly's modeling idiosyncrasies in
smoothing pellets or wads of clay into oblong
shapes (note the figure's proper left arm and
proper right hand). The final versions of
England and *France* were carved in marble by the
Piccirilli brothers in 1906.

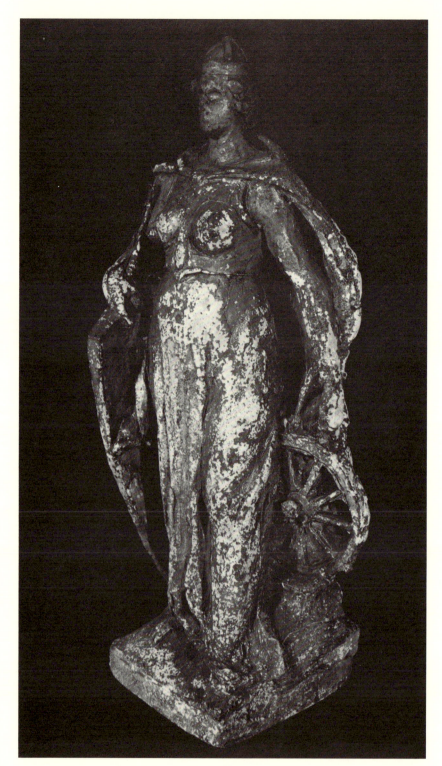

126

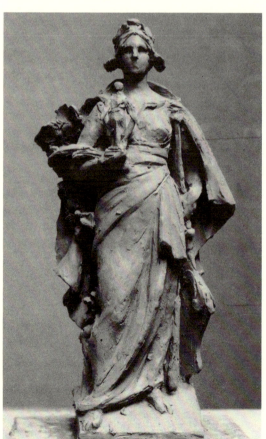

127

127. France

(Destroyed) (for United States Customs House,
New York). 1904–06. Clay. Inscribed front of
base: France. Archives photograph, Charles
Grafly Collection, Ablah Library, Wichita State
University

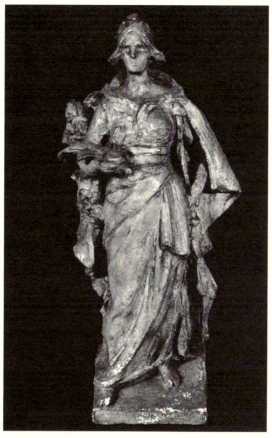

128

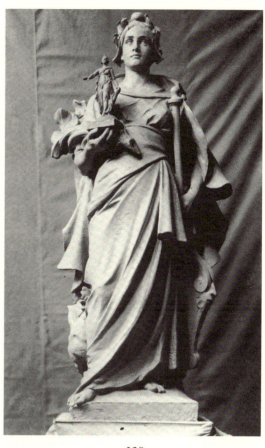

129

128. France

(for United States Customs House, New York).
1904-06. Plaster. Height 16 inches (40.6 cm.).
Charles Grafly Collection, Wichita State
University Endowment Association Art
Collection, Edwin A. Ulrich Museum of Art

129. France

(Destroyed) (for United States Customs House,
New York). 1904-06. Plaster. Archives
photograph, Charles Grafly Collection, Ablah
Library, Wichita State University

Grafly's original commission for decorative
figures of *England* and *America* was changed in
1904 by architect Cass Gilbert, who required
that *France* replace *America*, a modification not
welcomed by the sculptor (Simpson 1974, 289).
The plaster cast duplicated the clay *bozzetto*,
except for the statuette held in the proper right
arm. A crowing cock peeking from behind the
robes, facial details, and other parts are without
detailed modeling eventually realized in the
enlargement or scale model (third illustration).
This group of three illustrations shows a typical
development of sculptor's idea from *bozzetto* in
clay, to plaster cast of that original sculpture, to
slightly enlarged and more finished sketch
derived from the original clay.

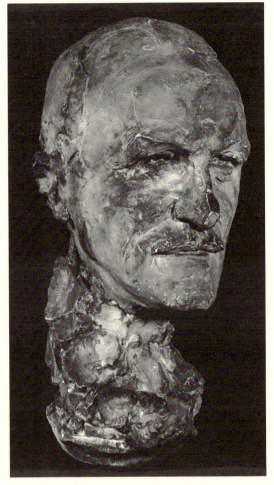

130

130. Dr. Joseph Price (1853-1911)

1906. Plaster. Height 17¼ inches (43.8 cm.).
Charles Grafly Collection, Wichita State
University Endowment Association Art
Collection, Edwin A. Ulrich Museum of Art

Grafly's *bozzetto* is only a few inches smaller
than the finished work in bronze, the modeling
accentuating planes and structure. The loosely
modeled neck illustrates the method Grafly
utilized as a first step in blocking out head and
features.

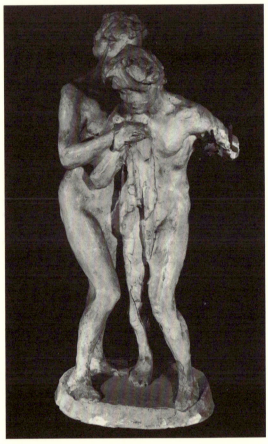

131

131. Two Women

c. 1906. Plaster. Height 26½ inches (67.3 cm.).
Charles Grafly Collection, Wichita State
University Endowment Association Art
Collection, Edwin A. Ulrich Museum of Art

About 1905-06, Grafly embarked on a series of
nude studies, each one quite finished, at least in
surface treatment. They were probably
intended as anatomical and relationship
prompters. Several works of this type exist in
the Wichita State University collection
(Simpson 1974, 314-320).

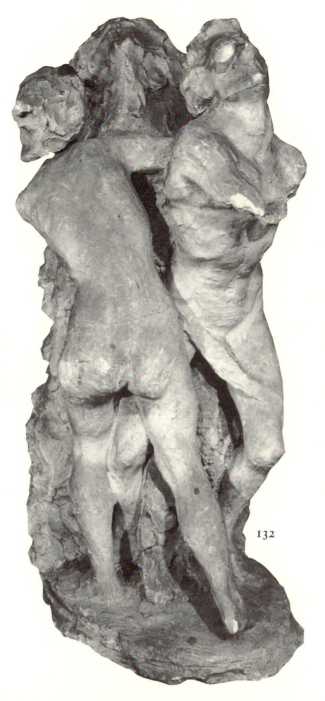

132

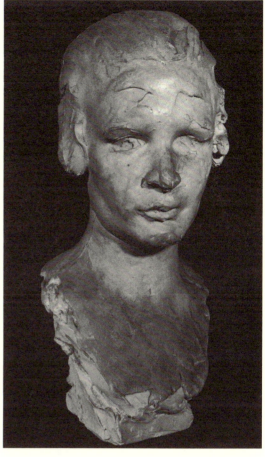

133

133. Head

1913. Plaster. Height 18½ inches (47 cm.).
Charles Grafly Collection, Wichita State
University Endowment Association Art
Collection, Edwin A. Ulrich Museum of Art

132. Two Nudes

c. 1906. Plaster. Height 40 inches (101.6 cm.).
Charles Grafly Collection, Wichita State
University Endowment Association Art
Collection, Edwin A. Ulrich Museum of Art

Now damaged, this sketch is not related to a
specific work, it is thought, but illustrates
Grafly's persistent theme of nudes in grappling,
strained poses. Apparently, these sketches were
anatomical exercizes that might be developed in
future works.

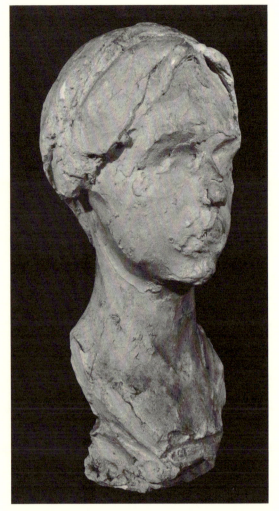

134

134. Head

c. 1913-15. Plaster. Height 17¼ inches (43.8 cm.). Charles Grafly Collection, Wichita State University Endowment Association Art Collection, Edwin A. Ulrich Museum of Art

Both works are demonstration pieces, done to show students how their modeling should block in the general structure before proceeding to handle details. The more finished sketch of the two still bears the mold marks from casting in plaster. One of Grafly's assistants and pupils, George Demetrios, recalled that this work was made from a posed model. The second sketch was marked "Student Demonstration" when unpacked in the Lanesville, Massachusetts, studio of Grafly for shipment to Wichita State University (Simpson 1974, 366).

135. David Duffield Wood Memorial

1913-14. Plaster. Height 16 inches (40.6 cm.). Charles Grafly Collection, Wichita State University Endowment Association Art Collection, Edwin A. Ulrich Museum of Art

Wood (1838-1910) served for forty-six years as organist and choirmaster of St. Stephen's Church, Philadelphia. Grafly was commissioned by the church council in 1913 to execute a memorial relief. This *bozzetto* probably was not presented to the commissioners, however, as it was so undeveloped. Its basic format, even to the placement of lettering, was followed in the marble relief carved from the model. The profile portrait of Wood, fashioned from photographs, is an example of Grafly's abilities to model broadly the planes and structure.

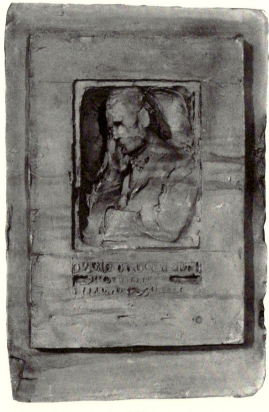

135

136

136. Pioneer Mother Memorial

(Destroyed) (Three sketches) (for Golden Gate Park, San Francisco) 1913-15. Clay. Archives photograph, Charles Grafly Collection, Ablah Library, Wichita State University

A former manager of the Pennsylvania Academy of the Fine Arts, John Trask, an old friend of Grafly, was appointed in 1913 as head of the Fine Arts Department of the Panama-Pacific Exposition to be staged in San Francisco in 1915. Aware of the Pioneer Mother Monument Association's interest in erecting a memorial sculpture to the women who crossed the plains to California in the nineteenth century, Trask promoted Grafly as artist and urged a site near the Fine Arts Building. Grafly's contract required completion of three figures, one and one-half life size, by December 31, 1914 (Simpson 1974, 368). The monument was completed somewhat behind schedule and unveiled in June 1915. Stages in the sculpture's evolution through several early, discarded sketches until the final *bozzetto* was chosen are recorded in a group of archival photographs. The three clay *bozzetti*, each focusing on a central female figure with a baby on each upraised arm, illustrate Grafly's strong architectural commitment with figures tightly bound to a plinth or column. The tiny figure at far left suggests the scale of the final monument.

137

137. Pioneer Mother Memorial

(for Golden Gate Park, San Francisco). 1913-15. Plaster. Height 23½ inches (59 cm.). Charles Grafly Collection, Wichita State University Endowment Association Art Collection, Edwin A. Ulrich Museum of Art

This sketch is closely related to three equally early experiments with the monument's form, a *bozzetto* incorporating bas-reliefs and recondite symbolism. Grafly discarded this format for a straightforward arrangement of three figures, modeled naturalistically.

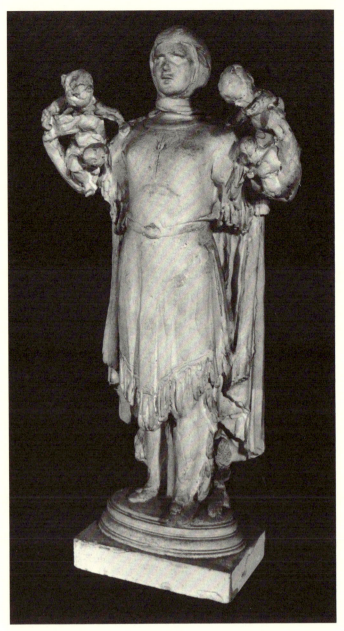

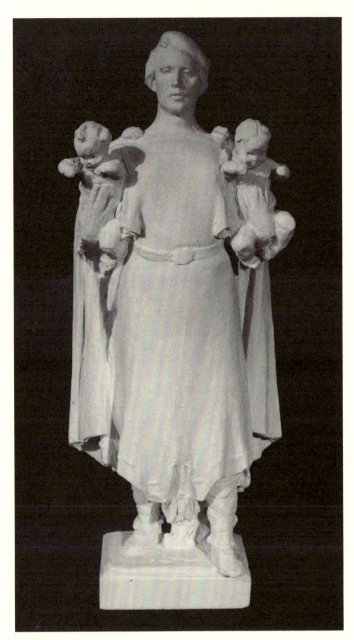

138

139

138. Pioneer Mother Memorial
(for Golden Gate Park, San Francisco). 1913–15.
Plaster. Height 16 inches (40.6 cm.). Charles
Grafly Collection, Wichita State University
Endowment Association Art Collection,
Edwin A. Ulrich Museum of Art

139. Pioneer Mother Memorial
(for Golden Gate Park, San Francisco). 1913–15.
Plaster. Height 15½ inches (39.4 cm.). Charles
Grafly Collection, Wichita State University
Endowment Association Art Collection,
Edwin A. Ulrich Museum of Art

140. Pioneer Mother Memorial

(Destroyed) (for Golden Gate Park, San Francisco). 1913-15. Clay. Archives photograph, Charles Grafly Collection, Ablah Library, Wichita State University

Among Grafly's earliest renderings of the format eventually selected for the memorial's final form, each *bozzetto* is finished in portions and merely suggested in others. This was his modeling practice with many sketches. The third now-lost *bozzetto* shown in an archival photograph illustrates the format and relative positioning of the three figures in the final design. Only the mother's right arm, her costume, and the boy's position would change in the memorial.

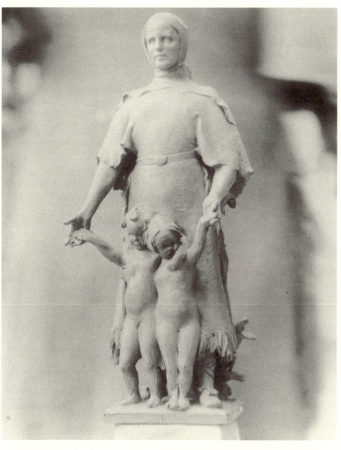

140

141. Pioneer Mother Memorial

(Destroyed) (for Golden Gate Park, San Francisco). 1913-15. Clay. Archives photograph, Charles Grafly Collection, Ablah Library, Wichita State University

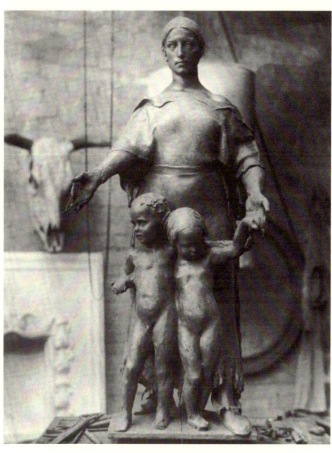

141

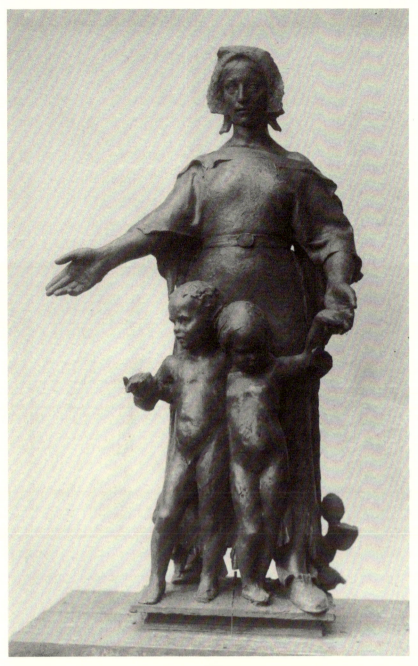

142

142. Pioneer Mother Memorial

(Destroyed) (for Golden Gate Park, San
Francisco). 1913-15. Clay. Archives photograph,
Charles Grafly Collection, Ablah Library,
Wichita State University

Two *bozzetti* in clay, the first photographed in
the studio with tools nearby and showing a
portion of exposed armature in the mother's
right hand, actually may be half-size
enlargements for the sketches for the memorial.
However, both illustrations depict the same
sketch, one incorporating changes such as the
addition of a bonnet, a buckle, and a bit of
cactus.

143. Dorothy Grafly

c. 1915-16. Clay. Height 8 inches (20.3 cm.).
Charles Grafly Collection, Wichita State
University Endowment Association Art
Collection, Edwin A. Ulrich Museum of Art

Perhaps related to a portrait bust of the
sculptor's daughter, thought to be shown in her
twenties, this sketch may have been modeled
from memory rather than from posed sittings
(Simpson 1974, 404).

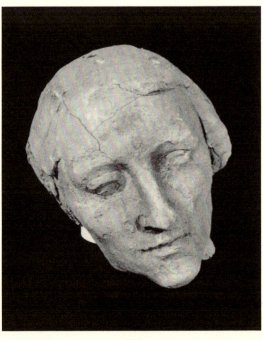

143

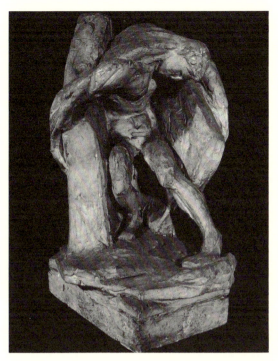

144

144. Allegorical Study

(for *General George G. Meade Memorial*,
Washington, D.C.). 1916. Plaster. Height 22¾
inches (57.8 cm.). Charles Grafly Collection,
Wichita State University Endowment
Association Art Collection, Edwin A. Ulrich
Museum of Art

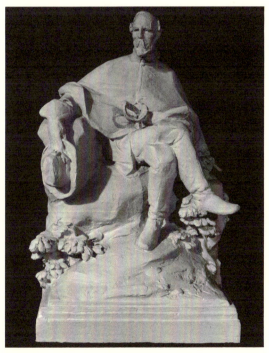

145

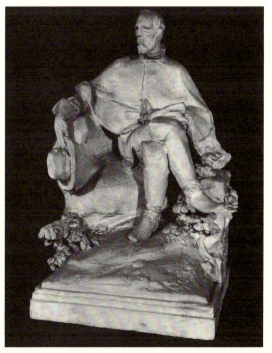

146

145. Seated General Meade

(for *General George G. Meade Memorial*,
Washington, D.C.). 1916. Plaster. Height 18¼
inches (46.3 cm.). Charles Grafly Collection,
Wichita State University Endowment
Association Art Collection, Edwin A. Ulrich
Museum of Art

146. Seated General Meade

(for *General George G. Meade Memorial*,
Washington, D.C.). 1916. Plaster. Height 18½
inches (47 cm.). Charles Grafly Collection,
Wichita State University Endowment
Association Art Collection, Edwin A. Ulrich
Museum of Art

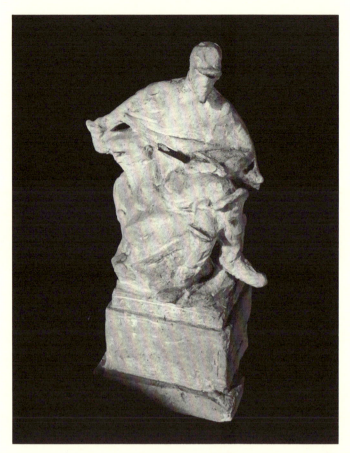

147

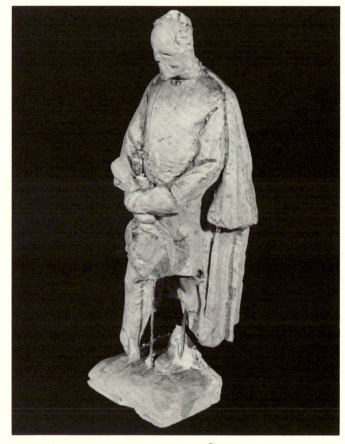

148

147. Seated General Meade

(for *General George G. Meade Memorial*,
Washington, D.C.). 1916. Plaster. Height 8¾
inches (22.3 cm.). Charles Grafly Collection,
Wichita State University Endowment
Association Art Collection, Edwin A. Ulrich
Museum of Art

Grafly accepted a commission in 1915 from the
State of Pennsylvania to memorialize one of the
Civil War's heroes, General George G. Meade
(1815–1872), but little did he realize that
bureaucratic complexities would frustrate him
for a decade. Certain requirements for the
memorial were imposed on the sculptor: the
monument had to be composed in the round as
it was to be seen from all sides, it could not
interfere with other memorials on the
Washington Mall, stone was to be the final
material, and a portrait statue of Meade with
"appropriate symbolic accompaniments" was to
be included (Simpson 1974, 88). In 1919 Grafly's
concept for a circular format, centered on the
General, was approved. But it was not until

1927 that the marble memorial was erected on
the Mall and dedicated. Grafly felt it was his
best work, a successful marriage of allegory,
portraiture, monumentality, and symbolism
(*Ibid.*, 411–412) There exists today a number of
bozzetti that illustrate the peregrinations of his
developing concepts for the work.

Several sketches were submitted to the
committee for approval in 1916. Three of them
were portraits of the General casually seated
with crossed legs and blocked up on a square
base. The most unusual, and Grafly's favorite,
was a nude, sometimes titled *E Pluribus Unum*
(*Ibid.*, 88). The depiction of a struggling male
attempting to pull two slabs together
symbolized Meade and his efforts to unite the
North and South. Obviously it did not meet
the commission's requirement for portraiture.
Also, it was too abstract for its times (or for the
commissioners), and its emotive power was
perplexing. The others, while sensitive
portraits, were too frontally oriented.

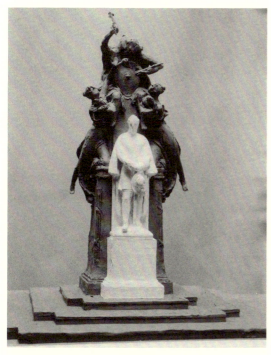

149

148. General Meade, Standing

(for *General George G. Meade Memorial*,
Washington, D.C.). 1916–17. Plaster. Height 9¾
inches (24.7 cm.). Charles Grafly Collection,
Wichita State University Endowment
Association Art Collection, Edwin A. Ulrich
Museum of Art

149. Study

(Destroyed) (for *General George G. Meade
Memorial*, Washington, D.C.). 1916–17. Clay
and Plaster. Archives photograph, Charles
Grafly Collection, Ablah Library, Wichita State
University

150. Study

(for *General George G. Meade Memorial*,
Washington, D.C.). 1916–17. Plaster. Height 23
inches (58.4 cm.). Charles Grafly Collection,
Wichita State University Endowment
Association Art Collection, Edwin A. Ulrich
Museum of Art

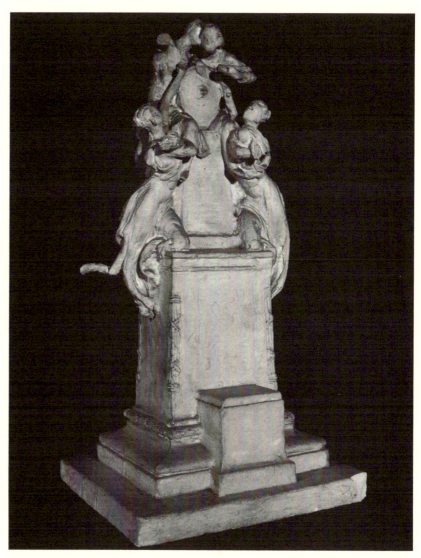

150

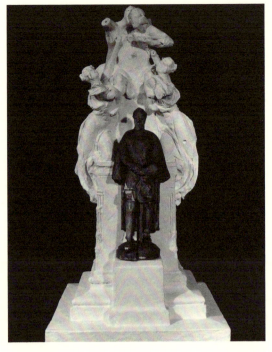

151. Study

(for *General George G. Meade Memorial*, Washington, D.C.). 1916-17. Plaster. Height 23½ inches (59.7 cm.). Charles Grafly Collection, Wichita State University Endowment Association Art Collection, Edwin A. Ulrich Museum of Art

If Grafly were to meet the terms of the commission, he had to sculpt a portrait of General Meade and integrate it into the monument's design. Both seated and standing figures were developed in *bozzetto* form. One sketch employing a standing Meade, pensive and wearing field uniform, was conceived as a two-part sketch: classical, stepped plinth with allegorical figures hovering over a centrally placed figure standing on a pedestal. The small, independent plaster cast of the original *bozzetto* shows that Grafly wanted to use the figure in different settings. The second illustration depicting a now-lost study of the plinth in clay with the portable figure placed in front of it differs from the existing plinth design. Undoubtedly this scheme was discarded because of its unacceptable frontality.

152. Study

(for *General George G. Meade Memorial*, Washington, D.C.). 1917. Plaster. Height 13⅜ inches (34 cm.). Charles Grafly Collection, Wichita State University Endowment Association Art Collection, Edwin A. Ulrich Museum of Art

153

153. Study for Base
(for *General George G. Meade Memorial*,
Washington, D.C.). 1917. Plaster. Height 19¼
inches (48.9 cm.). Charles Grafly Collection,
Wichita State University Endowment
Association Art Collection, Edwin A. Ulrich
Museum of Art

154

154. Study for Cap of Monument
(for *General George G. Meade Memorial*,
Washington, D.C.). 1917. Plaster. Height 10½
inches (26.7 cm.). Charles Grafly Collection,
Wichita State University Endowment
Association Art Collection, Edwin A. Ulrich
Museum of Art

One year after rejections of his first sketches,
Grafly submitted several more *bozzetti*. Using
the cylinder with reliefs and inscriptions raised
above a stepped base, the format was not
acceptable even though the work could be seen
from all sides. The modeled figures and reliefs
seem over-shadowed by the architectural core
and base, and there was no portrait of Meade as
required. The figures are beautifully
understated, making this a distinctive example
of the facile modeling required for *bozzetti*.

**155. General George G. Meade
Memorial**
(Destroyed). 1917-20. Clay and plaster. Archives
photograph, Charles Grafly Collection, Ablah
Library, Wichita State University

155

156

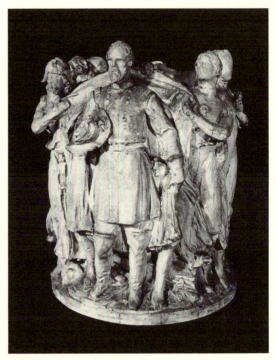

157

156. General George G. Meade Memorial

1917-20. Plaster. Height 20 inches (50.8 cm.). Charles Grafly Collection, Wichita State University Endowment Association Art Collection, Edwin A. Ulrich Museum of Art

157. General George G. Meade Memorial

1917-20. Plaster. Height 10¾ inches (27.3 cm.). Charles Grafly Collection, Wichita State University Endowment Association Art Collection, Edwin A. Ulrich Museum of Art

158. General George G. Meade Memorial

1917-20. Plaster. Height 21½ inches (54.6 cm.). Charles Grafly Collection, Wichita State University Endowment Association Art Collection, Edwin A. Ulrich Museum of Art

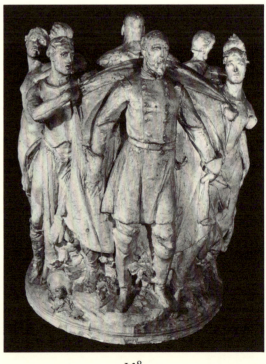

158

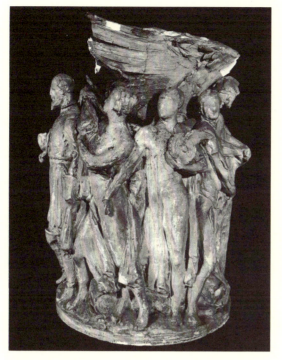

159

160

159. General George G. Meade Memorial

c. 1917–20. Plaster. 25⅛ inches (63.8 cm.).
Charles Grafly Collection, Wichita State
University Endowment Association Art
Collection, Edwin A. Ulrich Museum of Art

160. Wings

(for *General George G. Meade Memorial*,
Washington, D.C.). 1917–20. Plaster. Height 10
inches (25.4 cm.). Charles Grafly Collection,
Wichita State University Endowment
Association Art Collection, Edwin A. Ulrich
Museum of Art

161. Garlands and Fruit

(for *General George G. Meade Memorial*,
Washington, D.C.). 1917–20. Plaster. Height 7¼
inches (18.3 cm.). Charles Grafly Collection,
Wichita State University Endowment
Association Art Collection, Edwin A. Ulrich
Museum of Art

Grafly's resolution of the Meade Memorial
design, blending allegory and portraiture, was
an effective yet conservative statement.
Allegorical figures, the scale of the merging
nudes and battle banners, are combined in an
agitated, action-filled mass. The Meade
Memorial was to serve as the sculptor's career
capstone. The first illustration in this
remarkable group of *bozzetti* shows the now-
lost clay original, together with the stepped
base and a figure at right to demonstrate scale
on the Mall.

161

162

163

162. Head

(for *General George G. Meade Memorial*, Washington, D.C.). 1917-20. Plaster. Height 14¾ inches (37.5 cm.). Charles Grafly Collection, Wichita State University Endowment Association Art Collection, Edwin A. Ulrich Museum of Art

163. Head

(for *General George G. Meade Memorial*, Washington, D.C.). 1917-20. Plaster. Height 15½ inches (39.4 cm.). Charles Grafly Collection, Wichita State University Endowment Association Art Collection, Edwin A. Ulrich Museum of Art

164. Head

(for *General George G. Meade Memorial*, Washington, D.C.). 1917-20. Plaster. Height 8½ inches (21.5 cm.). Charles Grafly Collection, Wichita State University Endowment Association Art Collection, Edwin A. Ulrich Museum of Art

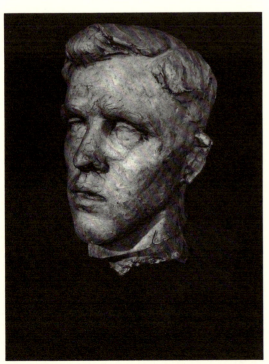

164

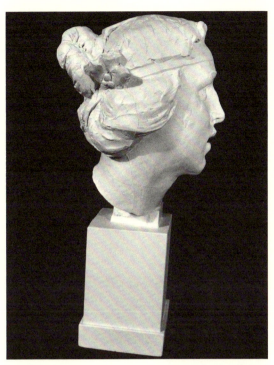

165

166

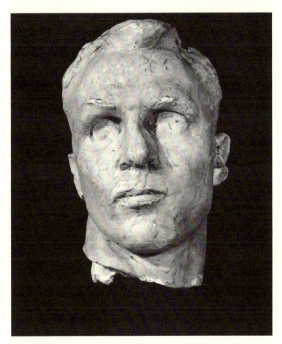
167

165. Head

(for *General George G. Meade Memorial*, Washington, D.C.). 1917-20. Plaster. Height 14⅝ inches (37.1 cm.). Charles Grafly Collection, Wichita State University Endowment Association Art Collection, Edwin A. Ulrich Museum of Art

166. Head

(for *General George G. Meade Memorial*, Washington, D.C.). 1917-20. Plaster. 15½ inches (39.3 cm.). Charles Grafly Collection, Wichita State University Endowment Association Art Collection, Edwin A. Ulrich Museum of Art

167. Head

(for *General George G. Meade Memorial*, Washington, D.C.). 1917-20. Plaster. Height 8¾ inches (22.2 cm.). Charles Grafly Collection, Wichita State University Endowment Association Art Collection, Edwin A. Ulrich Museum of Art

Final form for the monument merged a grouping of male and female allegorical figures huddling with a naturalistic portrait, full-length, of General Meade. Densely packed onto a circular pedestal, the six standing figures were topped with massed flags, an eagle spreading its wings over a shield, and garlands. The figures personified *Chivalry* and *Loyalty*, who hold Meade's cape, and *Military Courage, Energy,* *Fame*, and *Progress*. For each of these nudes, Grafly modeled a number of heads, apparently, for several exist today. For some the sculptor may have used a model, but one pupil recalled that he created the head of *War* (a figure on the opposite side of the monument from Meade's figure) in a few hours without relying on the model (Simpson 1974, 437). In the other heads, Grafly has generalized the features and barely smoothed the pelletized clay.

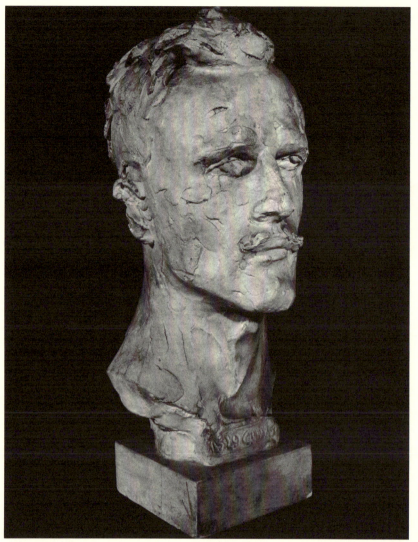

168

168. Student Sidcum

1920. Plaster. Height 17⅝ inches (44.7 cm.).
Inscribed, front: SIDCUM. Charles Grafly
Collection, Wichita State University
Endowment Association Art Collection,
Edwin A. Ulrich Museum of Art

Grafly frequently prepared sketches to instruct
his students, as in this portrait of a pupil who
attended the School of the Museum of Fine
Arts, Boston, where the sculptor taught,
1912-29 (Simpson 1974, 440). Teaching methods
were not precisely those of the Paris Ecole, but
Grafly's helpfulness and insistence on sound
technique were acknowledged by his pupils. He
taught them "to grasp the forms largely and to
work the clay up with the palms of their hands,
not the fingers. He often encouraged the use of
a bat or block to build up the clay and whack it
into shape. He felt that using the fingers too
early led to details before the structure was
established" (*Ibid.*, 102). A student, Gertrude
Lathrop, recalled that Grafly "kept her building
heads without ears, noses or eyes for weeks
because these were 'only decoration'"
(*Ibid.*, 102).

169. General Galusha Pennypacker Memorial

(Destroyed) (Logan Circle, Philadelphia). c.
1921-22. Clay. Archives photograph, Charles
Grafly Collection, Ablah Library, Wichita State
University

169

170

170. General Galusha Pennypacker Memorial

(Destroyed) (Logan Circle, Philadelphia). c. 1921-22. Clay. Archives photograph, Charles Grafly Collection, Ablah Library, Wichita State University

171. General Galusha Pennypacker Memorial

(Destroyed) (Logan Circle, Philadelphia). c. 1921-22. Clay. Archives photograph, Charles Grafly Collection, Ablah Library, Wichita State University

General Pennypacker served as Colonel of the 97th Pennsylvania Regiment and rose to rank of Major General in the Civil War. In 1921, Grafly was asked to model a memorial sculpture to him, and a scale model was approved by the Pennsylvania State Arts Commission, May 1, 1922. The project then lagged until 1926, with no work being done, until his disinterest prompted the assignment of the sculpture to Albert Laissle, his assistant (Simpson 1974, 442). The rare illustrations record three different *bozzetti*, now lost, each one distinguished by a central figure or group and flanking lions or nudes. This format was modified to utilize only the striding male nude in the finished memorial. Grafly's rich and vigorous technique is evident in each work.

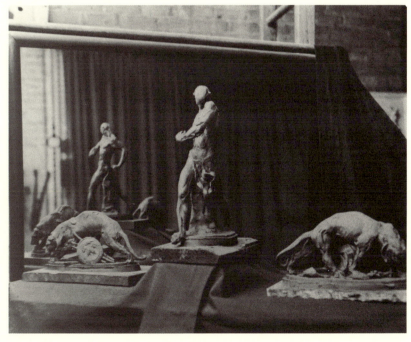

171

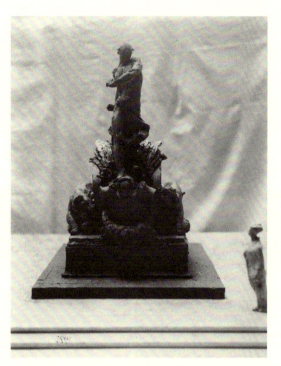

172a

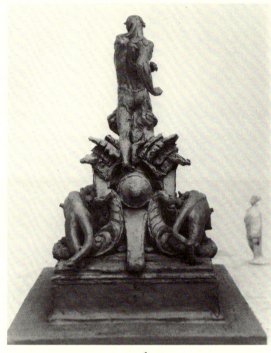

172b

172. General Galusha Pennypacker Memorial

(Destroyed)(Two Views)(Logan Circle, Philadelphia). c. 1921-22. Clay. Archives photograph, Charles Grafly Collection, Ablah Library, Wichita State University

Grafly's clay sketch for the final design of the Pennsylvania memorial, shown here in front and back views, was a tightly arranged triangle of cannon, cornucopia, stalking lions, sheaves or garlands, and a male nude positioned in dramatic *contraposto* above these elements. While portions of the surfaces are smoothed, the sculptor left skin and bones as layers of clay pellets, structuring an anatomy lesson. A tiny spectator to the right in both archival photographs suggests proposed scale.

173. General Galusha Pennypacker Memorial

(Logan Circle, Philadelphia). c. 1921–22. Plaster. Height 21 inches (53.3 cm.). Charles Grafly Collection, Wichita State University Endowment Association Art Collection, Edwin A. Ulrich Museum of Art

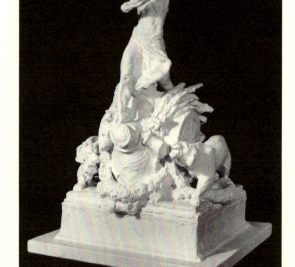

173

174

174. Study

(for *General Galusha Pennypacker Memorial*). c.
1921–22. Plaster. Height 20½ inches (52 cm.).
Charles Grafly Collection, Wichita State
University Endowment Association Art
Collection, Edwin A. Ulrich Museum of Art

The plaster cast of the sketch selected as final
design confirms Grafly's advice to his students
that they discard such studies as they progressed
in developing an idea, for this is the only
existing sculpture of the many sketches that
must have been made and, indeed, are proved
by the archival photographs of now-lost
studies. The second illustration depicts a study
for part of the Memorial and may have been an
exercise or variant.

175

175. Seated Woman

1923. Plaster. Height 8½ inches (21.5 cm.).
Signed: Grafly 4/25/23. Charles Grafly
Collection, Wichita State University
Endowment Association Art Collection,
Edwin A. Ulrich Museum of Art

Dating from the sculptor's last years, this
restrained, rather finished work lacks the
spontaneity inherent in many of Grafly's
bozzetti. Incised lines (note hair and flowers)
were seldom used by Grafly, but they appear in
this work.

176. Fountain Study

Plaster. Height 9½ inches (24.1 cm.). Charles
Grafly Collection, Wichita State University
Endowment Association Art Collection,
Edwin A. Ulrich Museum of Art

Grafly's sculpture seldom was done in low
relief, yet his flattened, classicized figures on
this fountain base demonstrate his mastery of
such subtle forms. This sketch is among the
sculptor's most understated treatments of three-
dimensional form.

176

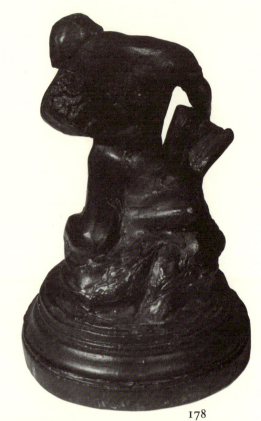

178

178. Seated Man
Painted plaster. Height 7¾ inches (19.2 cm.).
Charles Grafly Collection, Wichita State
University Endowment Association Art
Collection, Edwin A. Ulrich Museum of Art

177

177. Beaver
Plaster. Height 4½ inches (11.4 cm.). Charles
Grafly Collection, Wichita State University
Endowment Association Art Collection,
Edwin A. Ulrich Museum of Art

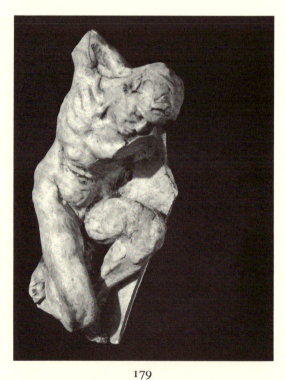

179

179. Relief Fragment
Plaster. Height 10¼ inches (26 cm.). Charles
Grafly Collection, Wichita State University
Endowment Association Art Collection,
Edwin A. Ulrich Museum of Art

Malvina Hoffman 1887-1966

Born in New York City. Studied at Art Students League and in Europe with Rodin, 1910. Returned to United States in 1911 to study anatomy at a medical school, revisiting Paris 1912-14. Fascinated with ballet and its stars, Anna Pavlova posed for several works. In 1930, began extensive worldwide travels for Field Museum, Chicago, preparing sculptures for "Races of Men." Major works were portraits. Won National Sculpture Society Gold Medal, 1966.

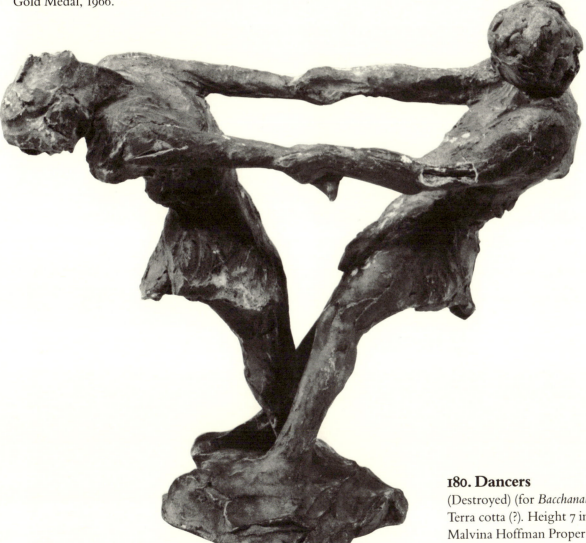

180

180. Dancers

(Destroyed) (for *Bacchanale Frieze*). 1914-15. Terra cotta (?). Height 7 inches (17.3 cm.). Malvina Hoffman Properties. Courtesy Berry-Hill Galleries, New York

Hoffman envisioned the *Bacchanale Frieze* as a series of panels, each panel with paired dancers, forming a total of twenty-five pairs. The frieze was modeled in plasticine with some sketches or studies for it such as this small *bozzetto* formed in full-round. This three-dimensional work is related to the eighteenth group or pair of dancers in the relief (Conner 1984, figure 10). A portion of the armature is exposed in one arm.

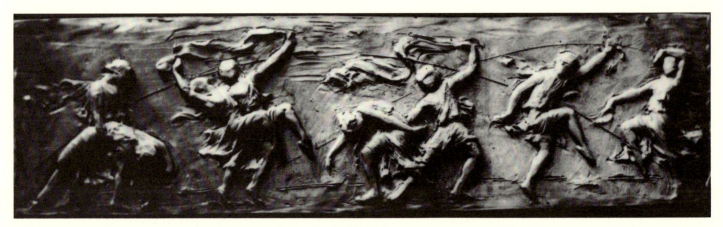

181

181. Study

(Destroyed) (for *Bacchanale Frieze*). 1914-15.
Clay. Malvina Hoffman Properties. Courtesy
Berry-Hill Galleries, New York

In the summer of 1910, an electrifying
performance by Anna Pavlova in London's
Palace Theatre initiated a project by Hoffman
that was completed only six years later. By
February 1911, she evolved a theme of Russian
dancers, modeled several ideas, and noted in her
diary: "A week of Russian dancers – I work
them up" (Conner 1984, quoting Hoffman
diary, February 11, 1911). But it was not until
August 1914 that Hoffman met the great dancer,
arranged through Mr. and Mrs. Otto Kahn.
The sculptor suggested that she would create a
bas-relief depicting Pavlova and Mikhail
Mordkin in *Bacchanale*, a ballet with music by
Glazunov and choreography by Fokine, first
staged in 1909. Hoffman did innumerable
sketches and drawings, attended Pavlova's
rehearsals and performances, and designed
twenty-two groups that would comprise a
frieze. This first sketch, now lost, determined
an arrangement of paired dancers for the frieze,
each group independent from its neighbor but
integrated into a whole. By June 1916, the frieze
was finished but never was cast in bronze. It is
known today only as a finished plaster replica
cast from the clay.

William Morris Hunt 1824-1879

Born in Brattleboro, Vermont. Studied briefly with Henry Kirke Brown in Rome, 1843. Visited France, Italy, and Germany, where he studied in Düsseldorf. Studied painting with French artist Thomas Couture, 1846. Friend and disciple of Barbizon School painters. Worked in Newport, Brattleboro, and the Azores, 1856-1862, before settling in Boston. Highly regarded as portrait painter and initiator of American mural painting.

182. The Flight of Night-Horses of Anahita

c. 1848-50. Plaster, painted. Height 18½ inches (47 cm.). The Metropolitan Museum of Art, gift of Richard Morris Hunt, 1880.12

Only a few American painters explored sculptured form as a means to further their painterly exercises and compositions. Thomas Eakins is the most notable painter of the nineteenth and early twentieth century who modeled in clay or wax to aid in constructing complex compositions through studies or props. William Morris Hunt, an ardent promoter of the Barbizon School in New England and an artist of unfulfilled promise,

made a single venture into sculpture, a study for a large mural he was commissioned to paint for the Assembly Chambers, New York State Capitol, Albany. The theme for the sculpture and the mural was drawn from a Persian poem devoted to the goddess of night, Anahita, that was suggested to Hunt by his scholar-brother Leavitt in 1846-47. In the 1850s-60s Hunt developed and sketched the scene depicting the goddess flying through the clouds, rearing horses in the background, Repose and Sleep disposed on either side. At some date before 1866, when the sculpture was exhibited at the National Academy of Design, Hunt modeled a high-relief study in clay that is now known only in a plaster cast. It is likely that Hunt worked on the relief while studying in Paris, c. 1848-50, when Antoine-Louis Barye was his teacher and before his interest in painting turned him to Millet. In Paris, Hunt no doubt was familiar with French Romantic sculpture, particularly the work of the *animaliers*, Barye pre-eminent among them. The relief was but one part of a group of studies eventually translated into the grand-scale mural for Albany that progressed into the 1870s until 1878, when Hunt was

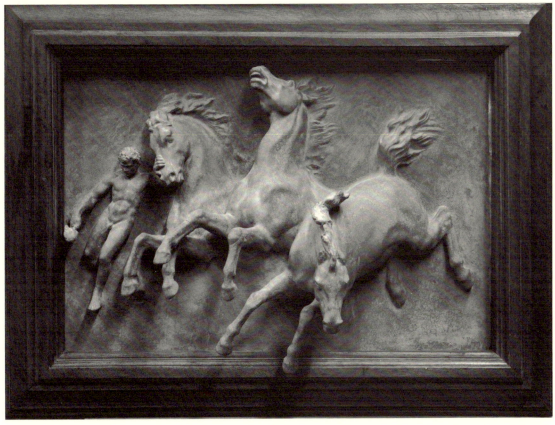

182

commissioned to decorate two lunettes, each measuring sixteen by forty feet, in the Capitol's Assembly Room. The mural was completed by the exhausted Hunt in 1879, only months before his death. At least two plaster casts of Hunt's sketch are known, the illustrated example and one in the Pennsylvania Academy of the Fine Arts. The relief served Hunt as a sculptor's *bozzetto* or sketch might in developmental stages leading to polished marble or sleek bronze, for it assisted his conceptualization of painted forms on a flat wall.

Anna Hyatt Huntington

1876-1973

Born in Cambridge, Massachusetts. Studied with Henry H. Kitson, Boston. First exhibition consisted of forty animal sculptures, beginning long career as most important American *animalier*. Studied with Hermon A. MacNeil and Gutzon Borglum after 1902, Paris-based after 1907. Married philanthropist Archer M. Huntington, 1923, and, with him, founded Brookgreen Gardens, South Carolina, one of America's most extensive sculpture collections, 1923.

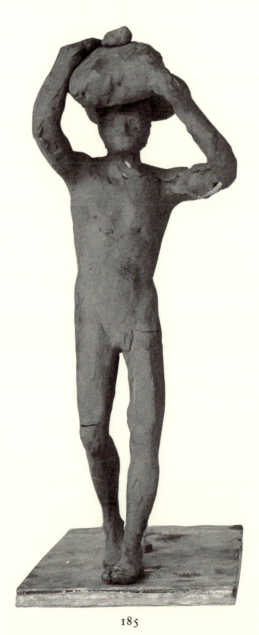

185

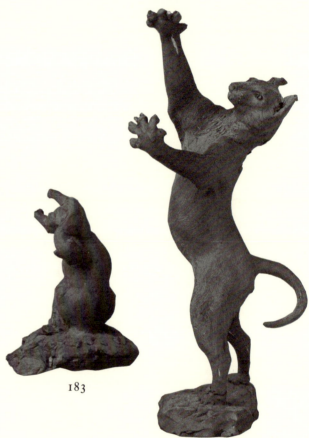

183

184

183. Animal Biting Its Back
Clay. Height 6 inches (15.2 cm.). Courtesy of the Syracuse University Art Collections, SUAC 74.40

184. Model (Cat)
(for *Fly Time*). 1964. Clay. Height 14⅝ inches (37.1 cm.). Courtesy of the Syracuse University Art Collections, SUAC 74.39

185. Male Figure Carrying Sack
Clay. Height 13¾ inches (35 cm.). Courtesy of the Syracuse University Art Collections, SUAC 74.41

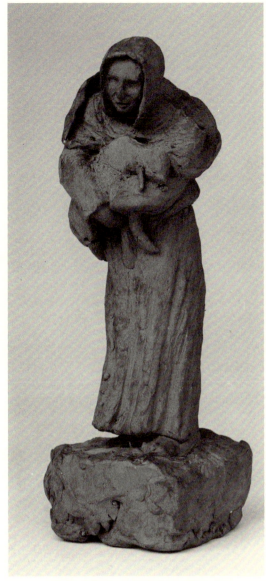

186

186. Mendicant Friar Holding a Lamb
1963. Clay. Height 12¼ inches (31.1 cm.).
Courtesy of the Syracuse University Art
Collections, SUAC 74.36

187. Bear Against Tree
Clay. Height 11½ inches (29.2 cm.). Courtesy of
the Syracuse University Art Collections,
SUAC 74.37

Although animal subjects dominated
Huntington's work in her long career, she
executed several notable public monuments and
cast many of her sculptures in a novel medium,
aluminum. A small number of Huntington's
bozzetti in clay are extant, preserving examples
in this rare material of modeled originals. The
surfaces of each sketch are smoothed over an
armature, with surface texture approximating
the finish achieved in the bronze cast. The
technique of the Ecole formed the basis of the
sculptor's training. Huntington's *bozzetti* and
finished bronzes frequently illustrated active,
sprightly animals, less lofty subjects than
expressed in her monumental statues. Her
modeling technique was curiously static and
insensitive to tactile qualities.

187

C. Paul Jennewein 1890-1978

188

Born in Stuttgart, Germany. Emigrated to America in 1907. Apprenticed to architectural firm in New York City and studied at Art Students League, 1908-11. European travel prior to receiving Prix de Rome and study at American Academy in Rome, 1916-20. New York studio after 1920, numerous commissions including pediment sculpture for Philadelphia Museum of Art, Arlington Memorial Bridge, Rockefeller Center and various war memorials. Highly stylized classicism derived from ancient Greco-Roman sculpture and vase painting with surfaces polished, simplified. Served as President of National Sculpture Society and Brookgreen Gardens.

188. Dudley Memorial Gate

(Destroyed) (Harvard University, Cambridge, Massachusetts). 1912. Clay. Archives photograph, Tampa Museum, Tampa, Florida

Jennewein received a commission for a memorial gateway while working in Kingston, New York, on another project. The relief derived from this sketch was executed but the finished work was removed in 1948 from its site and is now lost (Howarth 1980, 10). The figure and its compact surround illustrate his mastery of modeling in relief, certainly a requirement as an employee of Buhler and Lauter, for whom the sculptor worked, 1907-09, creating architectural decorations.

189. Despair

c. 1918-20. Painted clay. Height 7½ inches (19 cm.). Tampa Museum, bequest of C. Paul Jennewein

A *bozzetto* for an unknown sculpture, its modeling technique illustrates Jennewein's dependence on traditional methods as taught by the American Academy in Rome and, indeed, by all major academies in Europe and America.

189

190

190. First Step

1919. Clay. Height 8½ inches (21.6 cm.). Tampa Museum, bequest of C. Paul Jennewein

Modeled in Rome during his studies at the American Academy, this sculpture is thought to have represented his wife Gina and daughter Mimi in this study (Howarth 1980, 18). However, as the bronze (Janis Conner-Joel Rosenkranz Collection, New York) derived from this sketch shows, the model for the infant is a male, suggesting that Jennewein's son, Paolo, born November 2, 1918, was the inspiration if not the model. The finished bronze was not developed and cast until the autumn of 1920, probably by his foundry in Rome (*Ibid.,* 18). The work is reminiscent of small bronzes from the Italian Renaissance.

191. Relief

(Destroyed) (for Cunard Building, New York). 1920. Clay. Archives photograph, Tampa Museum, Tampa, Florida

192. Relief

(Destroyed) (for Cunard Building, New York). 1920. Clay. Archives photograph, Tampa Museum, Tampa, Florida

Jennewein's return to New York after study in Rome was a hardship economically at first, but commissions soon made life easier. For the new Cunard Building in Manhattan he was asked to sculpt four ceiling reliefs, two panels with fighting sea monsters, and four spandrels of tritons (Howarth 1980, 18). The finished panels

191

192

were to be four by five feet, and the sculptor was paid $2,450 for his work. Joyful putti are depicted rather than the sea monsters the commission required, so the two reliefs may be initial sketches that were unrealized.

193. Plymouth Maid
(Destroyed)(for *Pilgrim's Memorial Fountain*, Plymouth, Massachusetts). 1921. Clay and plaster. Archives photograph, Tampa Museum, Tampa, Florida

In July 1921, Jennewein and the architectural firm of McKim, Mead and White were commissioned by the Daughters of the American Revolution to create a memorial to the heroic women of the Mayflower. After years of delay in signing an agreement, the sculptor finally was asked to prepare studies and models in plaster at three inches to one foot scale, with a full-size model eventually to result in Tennessee marble for $8,150 (Howarth 1980, 20). Jennewein's delicate figure placed against the chaste background provided by the monument's architect is one of his least stylized, more naturalistic examples of modeling at this point in his career.

194. Soldiers and Sailors Memorial
(Destroyed) (for Barre, Vermont). 1921-22. Plaster. Archives photograph, Tampa Museum, Tampa, Florida

The city of Barre held a competition in 1921 to award the contract with $60,000 for the project

193

194

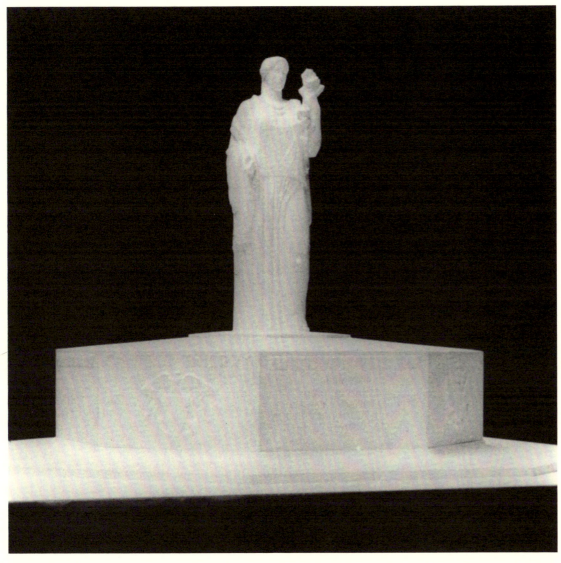

195

to commemorate World War I servicemen. Sixteen models were submitted, and Jennewein was selected, with the contract being awarded January 31, 1922. Among the studies required by the agreement, Jennewein's thirteen-inch *bozzetto* (probably the one illustrated here) was translated into a highly stylized kneeling warrior with sword and shield. A separate plaster cast of the *bozzetto* of the central figure once existed (Howarth 1980, 85), and presumably it was incorporated in the larger study, complete with exedra and stepped base.

195. Soldiers and Sailors Memorial

(Destroyed) (for Providence, Rhode Island). 1927-29. Plaster. Archives photograph, Tampa Museum, Tampa, Florida

In the autumn of 1927, Jennewein joined Philadelphia architect Paul Cret in designing a memorial comprised of a symbolic figure surmounting a fluted column with a frieze of Virtues around its base. The commission called

for a plaster model, ¾ inches to one foot in scale, to be prepared from drawings supplied by Cret. Jennewein's initial design, totally unlike the final version of the monument, shows a chiton-clad neoclassical figure standing on a six-sided drum. His modeling and Cret's scheme must have been accepted by December 1927, for in that month a contract for $26,000 was awarded requiring half-size and full-size models and Jennewein's supervision of the carved figure and relief.

Isidore Konti 1862–1938

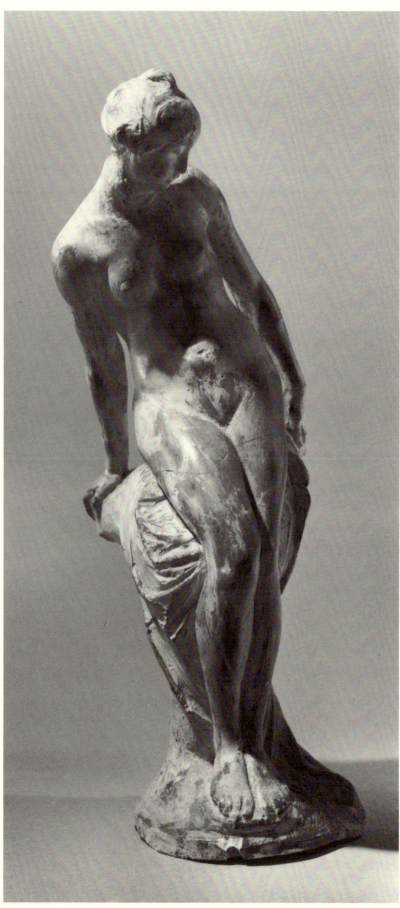

196

Born in Vienna. Studied in that city and Rome before emigrating to America, 1891. Hired to assist with decorative sculpture at the Columbian Exposition, he became Karl Bitter's assistant. Sculpted figures for the Dewey Arch, New York, and for the Pan-American Exposition, 1901. Worked in Buffalo, St. Louis, Cleveland and elsewhere. By 1908, he had taken on Paul Manship as his studio assistant. His architectural and ornamental sculpture reflected the Beaux-Arts style that dominated his career.

196. The Brook
1901. Plaster. Height 10½ inches (26.6 cm.).
Mrs. Erik Kaeyer

The centerpiece for a fountain, this languid nude was greatly enlarged and cast in plaster before its first public display at the National Sculpture Society, 1902 (now in the Hudson River Museum, Yonkers, New York). It appealed to Samuel Untermeyer, who commissioned it in marble for his Yonkers estate, "Greystone" (Madigan 1974, 18). The *bozzetto* was defined by Lorado Taft as the "veritable embodiment of sinuous grace. Carefully studying from nature, the artist had nevertheless the exceeding good taste to 'cover his tracks,' eliminating the offensive realism, all accidents of the individual body, and permitting the figure to stand for just what it is, a beautifully sculptured form" (Taft 1924, 464).

197. Hudson–Fulton Monument

1924. Plaster. Height 24 inches (61 cm.). Collection of The Hudson River Museum, Gift of Mr. Isidore Konti, 1926

Konti's sculpture was perfectly suited to the grand installations and panoramic settings of expositions and world's fairs. His representation in such major public spectacles as the Columbian, Pan-American, and Louisiana Purchase Expositions testifies to this compatibility of sculptural style with the intended monumental scale. The *Hudson-Fulton Monument* in Yonkers, combining in this *bozzetto* a central plinth, personification of navigator on its summit, and portraits of Henry Hudson and Robert Fulton, typifies much of the work commissioned from Beaux-Arts-trained sculptors in the late nineteenth and early twentieth centuries. The modeling is competent; concept and format are uninspired.

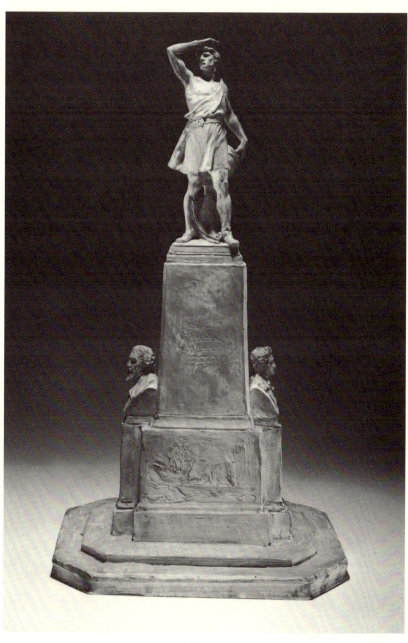

197

Jacques Lipchitz 1891-1972

198

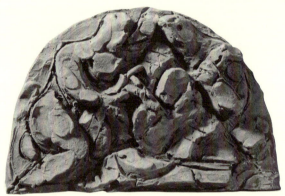

199

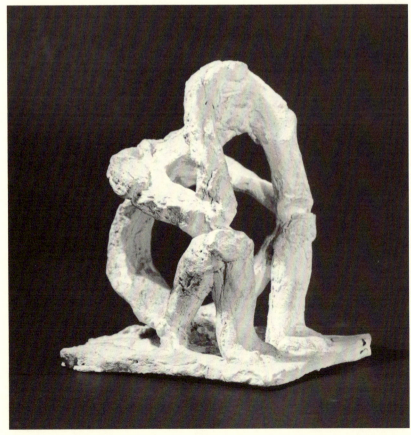

200

Born in Lithuania. Resided in Paris from his teens to World War II when he emigrated to the United States. Trained in the Ecole des Beaux-Arts, the Académie Julian, and the Académie Colarossi, acquiring traditional training and absorbing academic influences. Early explorer of Cubism, he developed in sculpture what Picasso, Gris, and Braque expressed in paint. Cubism's formal analysis in his sculpture paled in the 1920s. Biblical subjects, women, and myths figure in his sculpture by 1941 when he began anew in New York. Final home in Hastings-on-Hudson, New York, by 1950.

198 Reclining Woman
1921. Plaster. Height 2⅜ inches (6 cm.).
University of Arizona Museum of Art

A tiny *bozzetto* for a larger scale garden sculpture for Coco Chanel's house in Paris, the work was never realized in final form. The projected sculpture was part of a commission that included fireplace andirons, also modeled in 1921. The rounded, flaring shapes of *Reclining Woman* contrast sharply with the rectilinear base.

199. Figures with Musical Instruments
1923. Plaster. Height 5⅜ inches (13.5 cm.).
University of Arizona Museum of Art

One of Lipchitz's rare sketches designed for an architectural setting, this *bozzetto* for a lunette was one of two reliefs commissioned by Dr. Albert Barnes for his house-museum in Merion, Pennsylvania (Bermingham 1982, 6). Although this richly shadowed work is contemporary with the sculptor's fruitful Cubist period, it lacks the clearly defined and structural appearances of the obviously Cubist sculptures.

200. Man Leaning on His Elbows
1925. Plaster. Height 4⁵⁄₁₆ inches (11.5 cm.).
University of Arizona Museum of Art

In the 1920s, Lipchitz experimented with sculptured forms that reversed solid and void, rethinking space and mass extending his explorations in Cubist theory and dependence on volumes. Lipchitz retained throughout his long career the methods of the nineteenth-

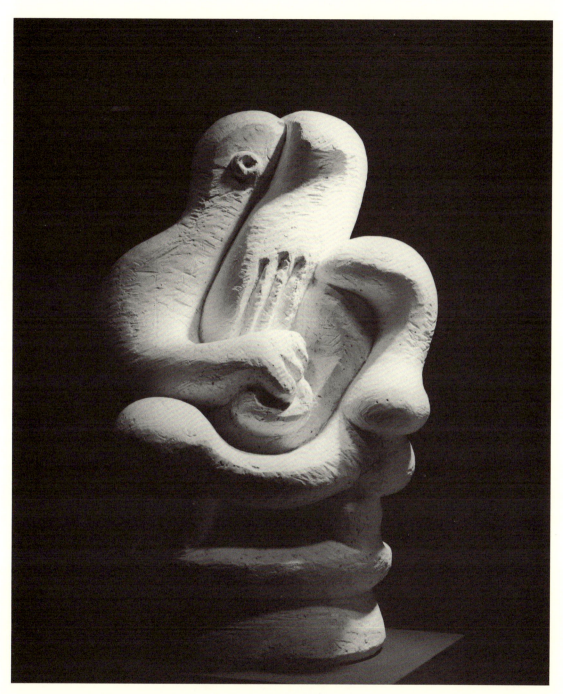

201

century sculptors, beginning every project with sketches in clay. In 1925, not yet at his career's half-way point, he spoke fondly of such models in clay: "I love these little maquettes. They are so fresh and warm in feeling, not worked out and cooled off. Here I can see my natural capacities" (Bermingham 1982, 3).

201. Man with Guitar

(Variation). 1925. Plaster. Height 18⅛ inches (46 cm.). University of Arizona Museum of Art

"Lipchitz stated repeatedly during his lifetime that he was always a Cubist" (Bermingham 1982, 7). His arrival in Paris, 1909, thrust him into a coterie of inventive visionaries, and by 1916 he was represented by the dealer most involved with the Cubists, Léonce Rosenberg. Harlequins, bathers, figures with musical instruments all were attractive subjects to Lipchitz. His series of seated figures began in 1918. In this sketch one part merges with another, with the rounded forms showing prominent file marks on the plaster.

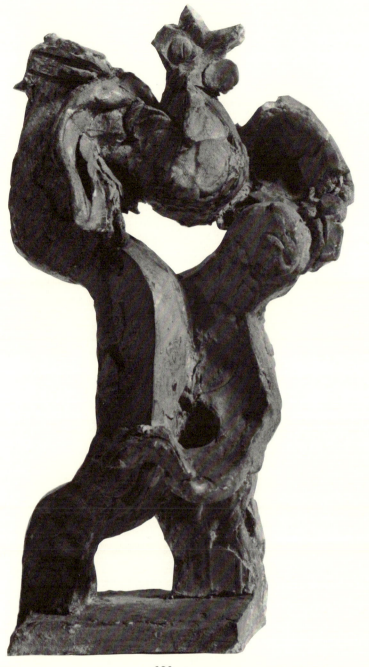

202

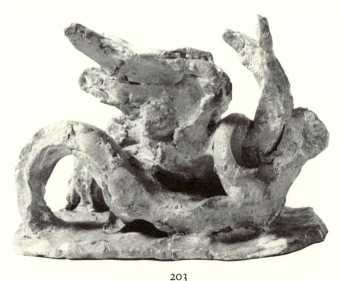

203

202. Sacrifice

c. 1925. Clay. Height 7½ inches (19 cm.).
University of Arizona Museum of Art

Lipchitz's persistent interest throughout his life
in Biblical or religious subjects first was evident
about 1925. Literal translation of titles in his
religious works, as well as in other sketches,
often is difficult with many examples, for the
sculptor sought expressive interpretation of
eternal themes.

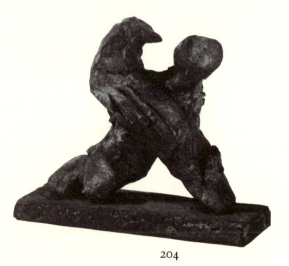

204

203. Birds

1928. Clay. Height 2½ inches (6.2 cm.).
University of Arizona Museum of Art

204. Leda and the Swan

1929. Plaster. Height 4⅜ inches (11 cm.).
University of Arizona Museum of Art

Classical myths provided Lipchitz with rich
material for sketches and developed works.
This example is among the earliest *bozzetti* of
mythological subject matter. The swan
grappling with the impregnated Leda is treated
more realistically (feathers, wings, neck) than
the female form beneath it, illustrating that care
for contrasts so beautifully shown in many of
his sculptures.

205. Woman Leaning on a Column

1929. Clay. Height 10¹⁄₁₆ inches (25.5 cm.).
University of Arizona Museum of Art

Wads of clay, thumbprinted and left without file marks or smooth contours formed by modeling sticks and fingers, are seen more often than not in Lipchitz's sketches. His technique, obviously dependent on the teaching of the Ecole, enhanced abstracted subjects.

206. Man with Clarinet

1929. Plaster. Height 6½ inches (16.5 cm.).
University of Arizona Museum of Art

The letter S forms a human figure, one of the musicians so often the subject in Cubist period sculptures of the 1920s. Lipchitz referred to it as "the first idea for a number of themes such as the return of the Prodigal Son" (Bermingham 1982, 53).

205

206

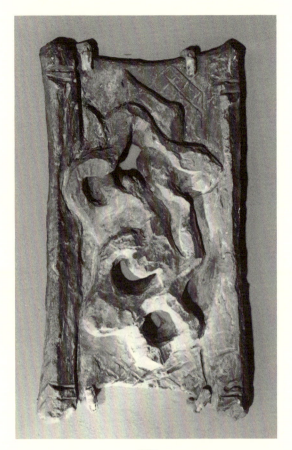

207

207. Couple in Hammock

1929. Plaster. Height 7¹¹⁄₁₆ inches (19.5 cm.).
University of Arizona Museum of Art

Most of Lipchitz's *bozzetti* (and the finished
sculptures derived from them) were devoid of
surface texture made by incised lines.
Occasional cross-hatching, as seen in this low
relief, suggests the mesh of the hammock
supporting the couple.

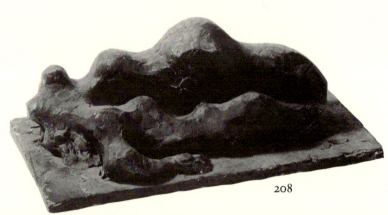

208

208. Reclining Woman

1929. Terra cotta. Height 4¹⁵⁄₁₆ inches (12.5 cm.).
University of Arizona Museum of Art

Lipchitz's sketches occasionally possess a
monumentality that their small size belies, as in
this rare *bozzetto* in terra cotta.

209. Return of the Prodigal Son

1930. Clay. Height 8¼ inches (21 cm.).
University of Arizona Museum of Art

This sketch, modeled one year after *Man with
Clarinet*, repeats the dominant S-curve shape of
the earlier work, but it is totally non-objective.

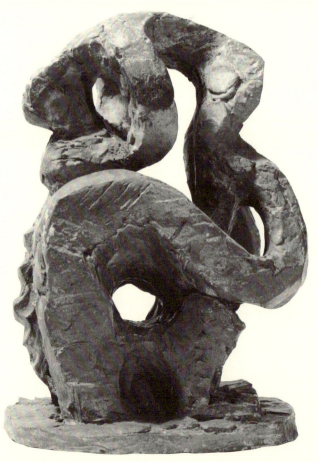

209

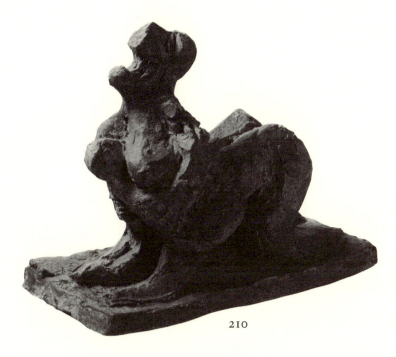

210

210. Woman and Child

1930. Plaster. Height 5⁵⁄₁₆ inches (13.5 cm.).
University of Arizona Museum of Art

Legs, breasts, the child clutched to a reclining
mother are recognizable elements in this earliest
surviving sketch of the mother-child theme in
Lipchitz's oeuvre.

211. Jacob and the Angel

1931. Clay. Height 9¹⁄₁₆ inches (23 cm.).
University of Arizona Museum of Art

Lipchitz retained his impressions of Paul Gauguin's
painting of the same title, a canvas seen as a
student in Paris. The Bible story in Genesis
32:23–32 of the struggle between Jacob, named
Israel by his antagonist, was the subject of
many sketches after 1931 (Bermingham 1982, 26).

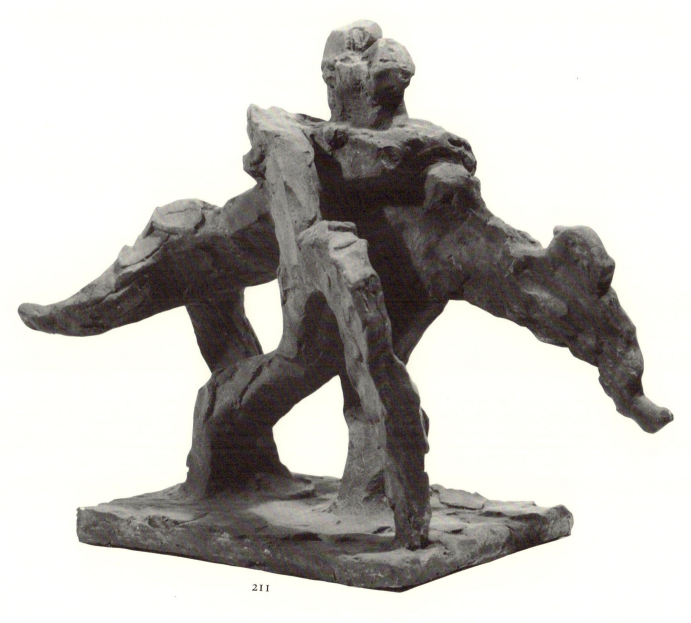

211

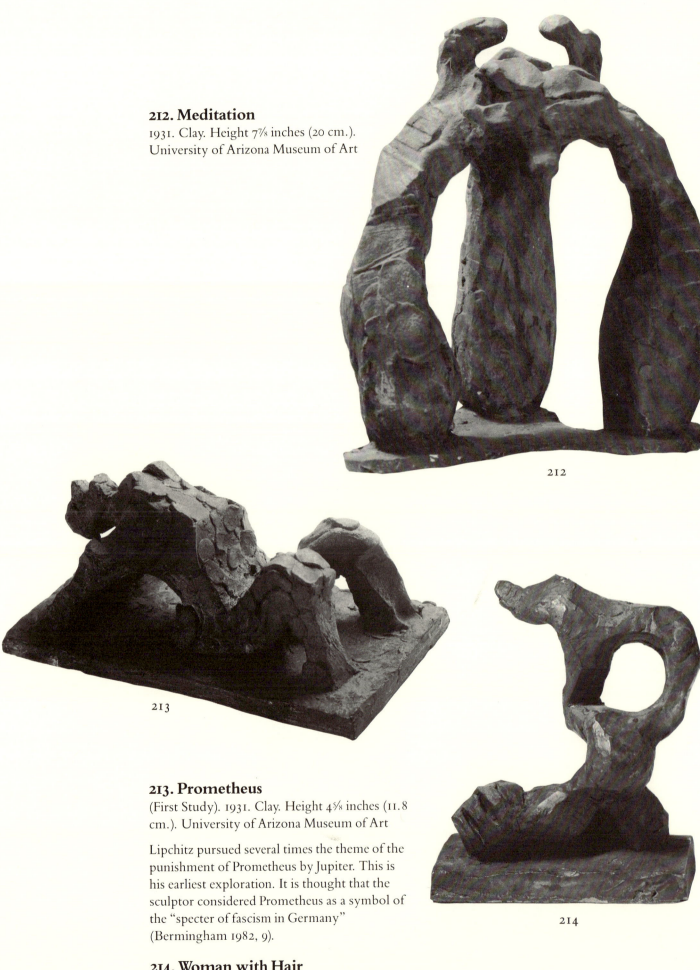

212. Meditation

1931. Clay. Height 7⅞ inches (20 cm.).
University of Arizona Museum of Art

212

213

213. Prometheus

(First Study). 1931. Clay. Height 4⅝ inches (11.8
cm.). University of Arizona Museum of Art

Lipchitz pursued several times the theme of the
punishment of Prometheus by Jupiter. This is
his earliest exploration. It is thought that the
sculptor considered Prometheus as a symbol of
the "specter of fascism in Germany"
(Bermingham 1982, 9).

214. Woman with Hair

1932. Terra cotta. Height 5⅞ inches (10.5 cm.).
University of Arizona Museum of Art

214

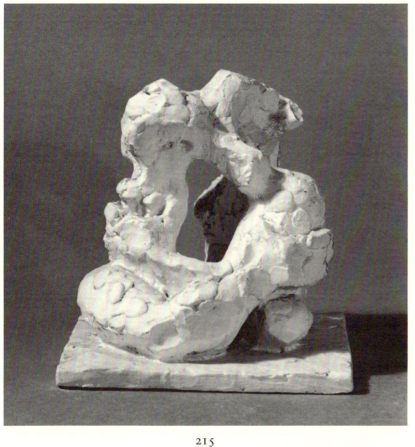

215

216

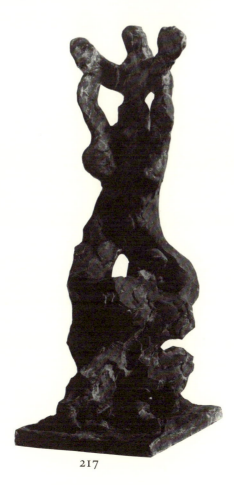

217

215. Head and Crossed Arms
1931. Plaster. Height 6⁵⁄₁₆ inches (16 cm.).
University of Arizona Museum of Art

216. The Potter
(Variation). 1931. Terra cotta. Height 13 inches
(33 cm.). University of Arizona Museum of Art

Lipchitz worked infrequently in bas-relief. His
Cubist period sculptures are flatter and more
considerate of planes than his fully rounded
sketches of the 1930s.

217. Rescue of the Child
1933. Terra cotta. Height 12¾ inches (32.5 cm.).
University of Arizona Museum of Art

Flame-like in form, Lipchitz's *bozzetto* is the
first sketch in a series of several devoted to the
rescue theme (Bermingham 1982, 37). It is
perhaps related to the sculptor's strong affection
for his mother, coupled with his response to
fascism at this time.

218. Leaning Head on Hands
1933. Terra cotta. Height 7¼ inches (18.2 cm.).
University of Arizona Museum of Art

219. Bull and Condor
1933. Terra cotta. Height 14¾ inches (37.5 cm.).
University of Arizona Museum of Art

The fighting bull long has been a favorite
symbol of artists, from the wall murals at
Knossos to the prints of Picasso. In 1933
Lipchitz began a series of studies in clay and
drawing media of the bull locked in combat
with a huge condor. Surface modulations are
heightened by the sculptor's use of flattened
pellets of clay, deeply incised outlines, and
incised lines in the flat background.

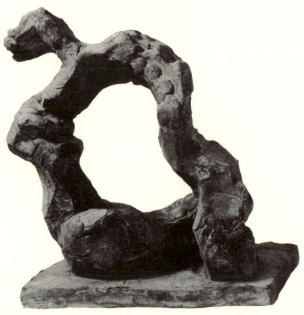

218

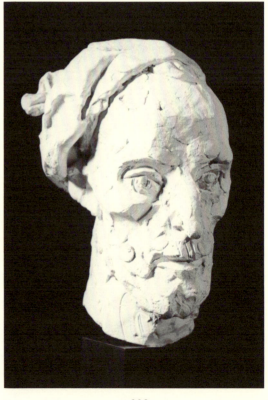

219

220. Head of Géricault
1933. Plaster. Height 14³⁄₁₆ inches (36 cm.).
University of Arizona Museum of Art

Executed in homage to the French painter
Théodore Géricault (1791-1824), this
impassioned rendering was based on portraits,
documents, and the death mask "to make the
portrait as realistic as possible" (Bermingham
1982, 43). Roughly attached, unsmoothed blobs
of clay show structure and form in this head.

220

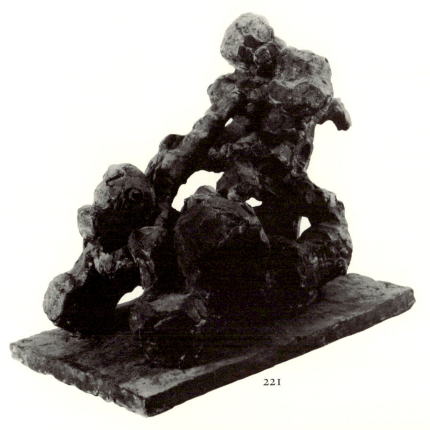

221

221. David and Goliath

1933. Plaster. Height 10 inches (25.6 cm.).
University of Arizona Museum of Art

Lipchitz's sculpture frequently compared
religious subjects with current political issues,
using Old Testament stories as vehicles for his
personal statements. Four sketches, at least,
dealt with the triumph of the young Israelite
over the Philistine warrior. After creating these
in 1933, Lipchitz stated the subject "was
specifically related to my hatred of fascism and
my conviction that the David of freedom
would triumph over the Goliath of oppression"
(Bermingham 1982, 27).

222. Prometheus Strangling the Vulture

1933. Plaster. Height 8⅝ inches (22 cm.).
University of Arizona Museum of Art

The Prometheus theme recurred often in the
sculptor's career after 1931. This sketch dates

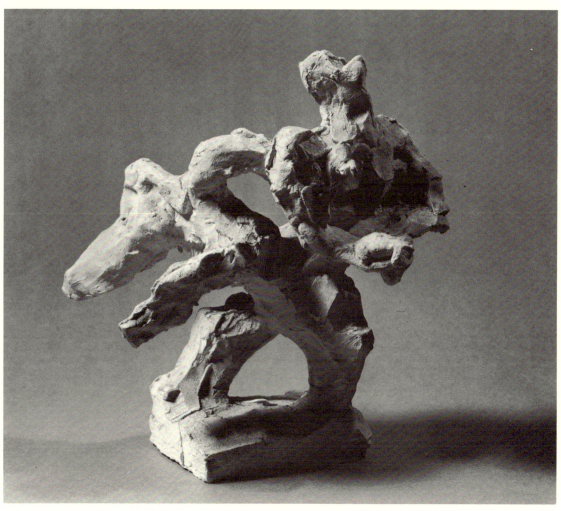

222

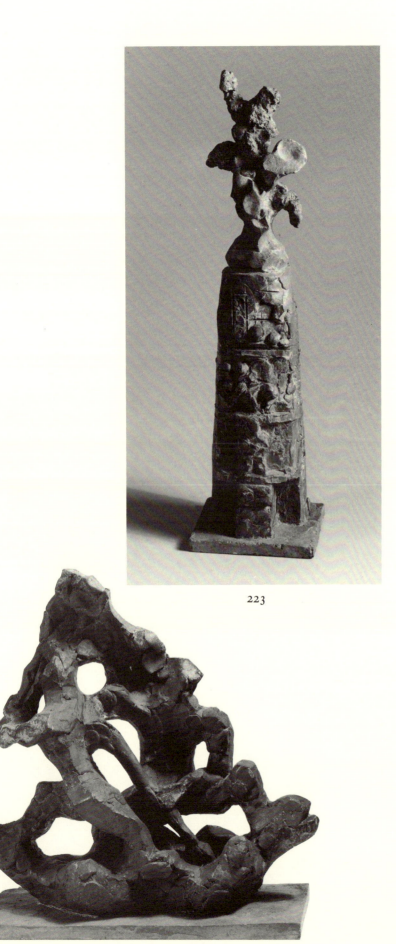

223

from 1933 and represents in strongly abstracted forms the mythical Prometheus dispatching the evil bird. Planes were cut away from the forms in some places, pellets of clay are discerned in others, creating a virtuoso example of Lipchitz's modeling technique. The sketch was later developed for exhibition at the World's Fair in Paris, 1936-38.

223. Study for a Monument
1934. Terra cotta. Height 12⅜ inches (31.5 cm.). University of Arizona Museum of Art

Vertical emphasis and suggested monumentality are illustrated in this work, one of several involving themes suitable for public monuments. Such *bozzetti* are among the earliest totally abstract statements by a major sculptor. While academic ideals were still ascendent in the world and most public memorials were expected to be naturalistically rendered, or at least evidence a modified realism, Lipchitz's explorations of abstractions in the 1930s and before were inventive and provocative.

224. Towards a New World
1934. Terra cotta. Height 8⅝ inches (22 cm.). University of Arizona Museum of Art

While the title has little relationship to the form of the sketch, such models were expressions of Lipchitz's interest in "themes with a more universal suitability" in the 1930s (Bermingham 1982, 14). Seldom were such *bozzetti* realized in finished bronze, however.

224

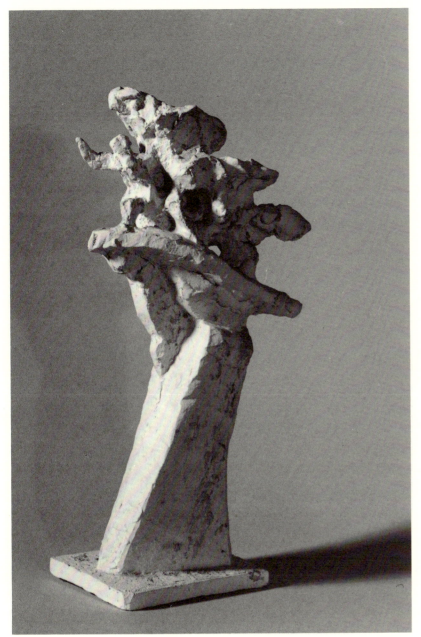

225

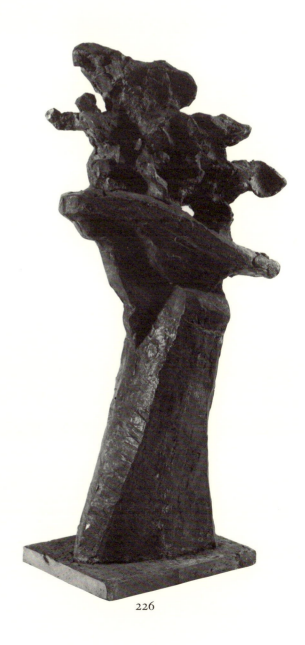

226

225. Study for a Bridge Monument
1936. Plaster. Height 15⅝ inches (39.7 cm.).
University of Arizona Museum of Art

The dramatic thrust of the sketch in the angled
support seems related to Russian Constructivist
works, at least to some of the structures created
by Tatlin decades earlier.

226. Study for a Statue
1936 (?). Terra cotta. Height 15⅞₁₆ inches (39.5
cm.). University of Arizona Museum of Art

This sketch appears to be a variant of the *Study
for a Bridge Monument* (Bermingham 1982, 15).

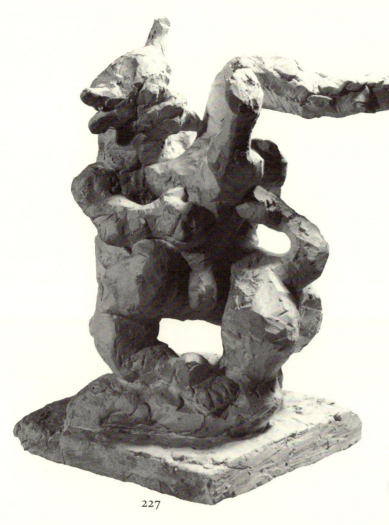

227. Rape of Europa

(Variation). c. 1939. Plaster. Height 13³/₁₆ inches (33.5 cm.). University of Arizona Museum of Art

Bull and maiden were given expressive form in Lipchitz's sketch for this theme from classical mythology. The two figures locked on a flat plinth were strongly fashioned by fingers and tools, and no attempt has been made to establish more than a blocked-out form.

227

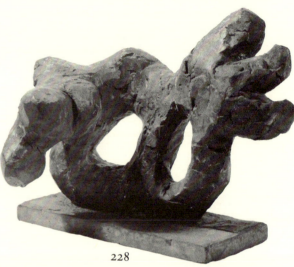

228

228. Benediction

1942. Terra cotta. Height 6¼ inches (17 cm.). University of Arizona Museum of Art

Lipchitz's amorphous forms bore titles often requiring the sculptor's explanations or identification of the influences that prompted the works. *Benediction* derives from his sadness over the Nazi occupation of Paris and was modeled in his studio on Twenty-third Street, New York. It was Lipchitz's hope "to make a sculpture like a lullaby" (Bermingham 1982, 28).

229. Prometheus Strangling the Vulture

1948. Plaster. Height 21¼ inches (54 cm.). University of Arizona Museum of Art

The sculptor's first commission after arriving in the United States in 1944 was a wall decoration for a ministry building in Rio de Janeiro. Developed from the same subject modeled for the World's Fair in Paris, 1936, the South American sculpture when finally cast was dwarfed by its setting.

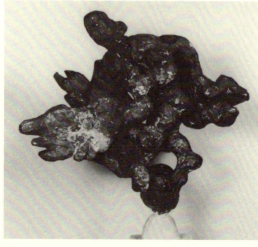

229

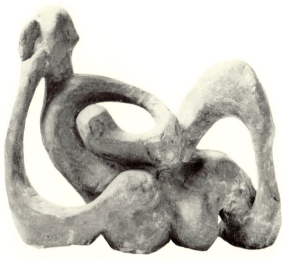

230

230. Hagar

1948. Clay on plaster base. Height 5⅞ inches (15 cm.). University of Arizona Museum of Art

One of the most sinuous, flowing sketches produced by Lipchitz, this work suggests the biblical mother and child as interlocking, reclining forms. A later bronze related to this *bozzetto*, recalled Lipchitz, was intended as "a prayer for brotherhood between Jews and the Arabs" (Bermingham 1982, 29).

231. Biblical Scene

1949. Plaster. Height 20⅝ inches (52.3 cm.). University of Arizona Museum of Art

One of Lipchitz's most complex arrangements of human and animal forms, the act of sacrifice, is clearly defined by the man and sacrificial goat surmounting the sketch. It is an elongated, towering piece to be enlarged in monumental scale. An enlarged, later model was destroyed in the 1952 fire in Lipchitz's New York studio (Bermingham 1982, 30).

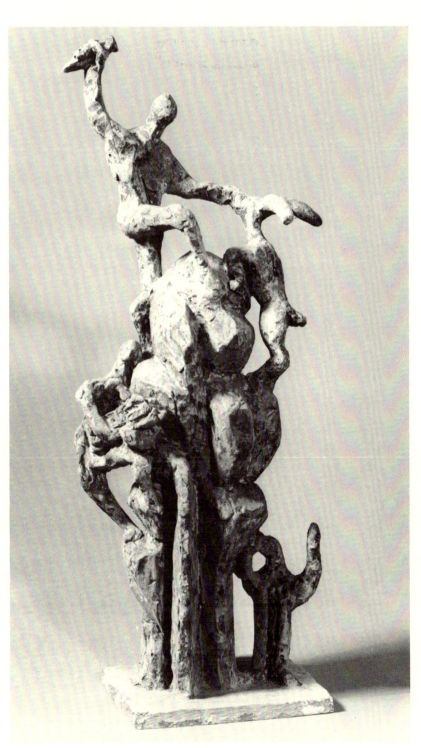

231

232. Study

Plaster. Height 6⅞ inches (17.5 cm.). University of Arizona Museum of Art

Probably dating from the late 1930s, the sketch is a curious melding of angled, architectonic support with an amorphous form capping the topmost point. At least one other sketch (Bermingham 1982, 17) parallels the design of this strong work.

233. Head and Hands

Terra cotta. Height 6¼ inches (15.9 cm.). University of Arizona Museum of Art

An undated study, this small work has an affinity with certain sketches dating from the 1930s. The head's eyes and hand's fingers are abstracted yet still recognizable elements identified by the title.

234. Study for a Composition

Plaster. Height 9½ inches (24 cm.). University of Arizona Museum of Art

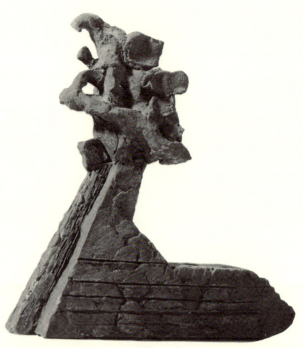

232

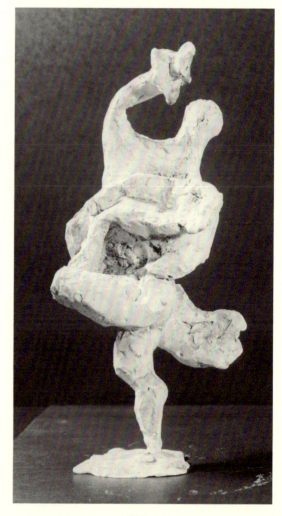

234

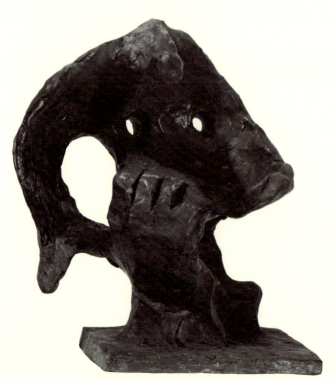

233

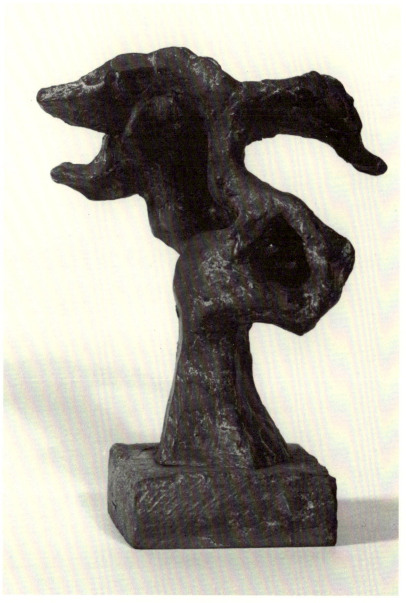

235

235. The Big Eye
Terra cotta. Height 5½ inches (14 cm.).
University of Arizona Museum of Art

236. Standing Figure
Clay. Height 9¼ inches (21 cm.). University of
Arizona Museum of Art

This roughly modeled sketch, not unlike many
works by earlier generations of American
sculptors who were trained in the Ecole's
classes, has an imposing monumentality
suggested even in its diminutive size.

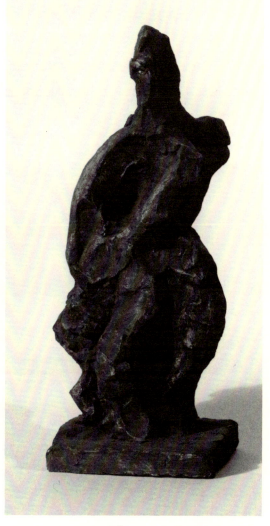

236

Georg John Lober 1892–1961

Born in Chicago. Trained at the National Academy of Design, New York, and the Beaux-Arts Institute of Design. His teachers were the distinguished A. Stirling Calder, Hermon A. MacNeil, Gutzon Borglum, and Evelyn Longman. Winner of numerous medals and prizes and member of the prestigious National Academy of Design and National Sculpture Society. His sophisticated style mirrored Manship's and Jennewein's. He excelled as a medalist.

237. Psyche
1929. Tinted plaster, with pencil notations. Height 9 inches (22.8 cm.).
Conner · Rosenkranz, New York

Still bearing the plaster mold marks, this cast of a *bozzetto* was tinted to resemble terra cotta. The pencil notations indicate dimensions of the projected enlargement. A near life-size bronze (also Conner · Rosenkranz collection) resulted from the sketch.

238

238. Spanish-American War Soldier
c. 1904. Painted plaster. Height 18½ inches (47 cm.). Signed: Georg Lober.
Conner · Rosenkranz, New York

This small study for a memorial to Spanish-American War veterans is colored to resemble the bronze, over life-size monument (location unknown) that probably resulted as a commission. Because of its degree of surface finish and details, other more abstract *bozzetti* probably preceded this sketch.

237

Frederick William MacMonnies 1863-1937

Born in Brooklyn. Studied with Augustus Saint-Gaudens, 1880, and at Art Students League, New York. Studied in Paris after 1884 with Mercié and Falguière. Received numerous prizes and awards for sculpture, beginning in 1884. Sculptor for Columbian Exposition, 1892-93, creating notorious *Bacchante and Infant Faun* same year. Established studio in Paris, 1887, but worked in New York City after World War I, executing numerous large- scale public monuments.

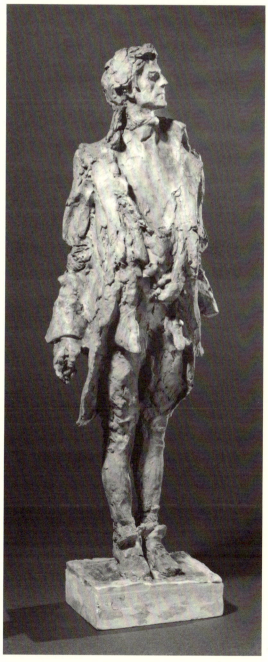

239

239. Nathan Hale

1889-90 (cast 1960). Plaster. Height 20 inches (50.8 cm.). The Art Museum, Princeton University, Museum Purchase, The John Maclean Magie and Gertrude Magie Fund, 77-72

Educated in methods of modeling as taught in the French ateliers and Ecole des Beaux-Arts, specifically the techniques of Falguière with whom he studied, MacMonnies in 1889-90 created one of his best known sculptures while yet relatively unknown. The *bozzetto* for the Revolutionary War martyr is both expressive of the defiant patriot's bravery and fully exploitive of the tactile clay. Although the finished bronze emanating from this sketch was "criticised for its impressionistic treatment of form, a criticism that testifies to the extent to which he had absorbed the Parisian manner of modeling," (Whitney 1976, 53) it is the sketch that realizes the artist's early, and perhaps finest conceptualization of the subject. Lorado Taft suggested that MacMonnies' "sheer dexterity of manipulation" was unequaled (Taft 1924, 332). This sensitive *bozzetto* known by the plaster cast made in 1960 from the original clay, confirms that opinion. It remains one of MacMonnies' greatest achievements, a tour-de-force of modeling by a young, untried artist. Taft perceived this in the sculptor: "Some sculptors, like MacMonnies, seem to possess an intuitive sense of beauty in modeling. Others acquire skill in that direction through laborious and costly experience; while certain ones, possibly men of marked power in other phases of their art, seem to be serenely unconscious of its existence. It is very rare that the work of a beginner possesses this quality; he always begins with literal imitation" (*Ibid.*, 352). In MacMonnies' vigorous *bozzetto*, at least, the "literal imitation" of Hale's appearance never dominated. The sculptor's granddaughter, Marjorie MacMonnies Waller, had plaster casts made in 1960 from clay sketches still preserved in the sculptor's studio. Using the waste-mold process, the clay models were destroyed, with only unique casts remaining. In sketch and final bronze casts, MacMonnies established himself among the leading sculptors of the Beaux-Arts tradition. The life-size statue in bronze was unveiled in City Hall Park, New York, on November 25, 1893, a commission from the

Sons of the Revolution of the State of New York. Reductions of the sculpture were made (Metropolitan Museum of Art) only slightly larger than the *bozzetto*, but highly detailed and finished.

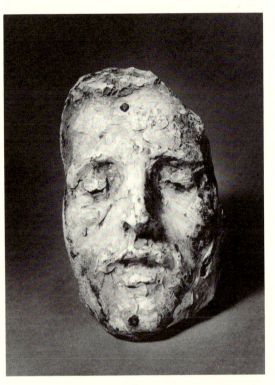

240

240. Study for Face of Nathan Hale

1889-90. Plaster. Height 5⅛ inches (13 cm.). The Art Museum, Princeton University, Museum Purchase, The John Maclean Magie and Gertrude Magie Fund, 77-73

MacMonnies' preparatory work for the Nathan Hale Monument produced this haunting study, a face calmly resigned to the hangman's noose, a structured, exquisite rendering of planes and shadows. In this sketch MacMonnies moved away from the insipidity of Falguière and toward the strength of Rodin, although the latter's influence was not felt until later in the American sculptor's career.

241. Minerva Diffusing the Products of Typographical Art

(for Library of Congress, Washington, D. C.) 1894-96. Plaster. Height 7¾ inches (19.7 cm.). Ira Spanierman, New York

MacMonnies mastered the integration of human forms in architectural settings, as demonstrated in this sketch for a tympanum of the Library of Congress. MacMonnies' modeling technique, learned in Paris and practiced later in his Rue de Sèvres studio, was the most impressionistic among those of late

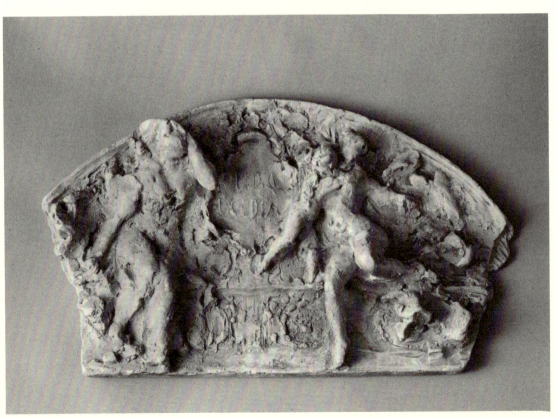

241

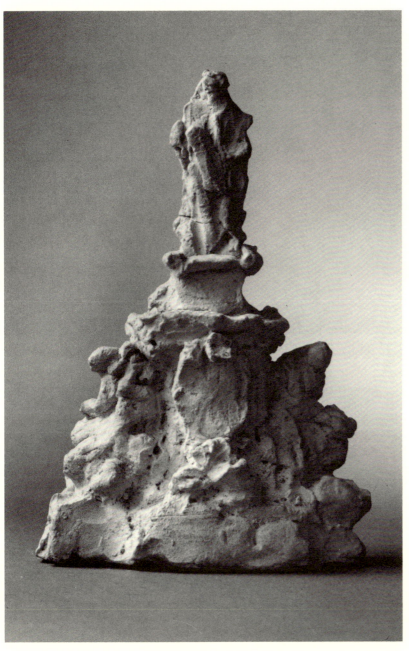

242

243

nineteenth-century American sculptors. The sculptor's sketch was not followed precisely in the finished commission that depicts a centrally seated Minerva with putti distributing books.

242. Shakespeare Fountain (?)

c. 1895. Terra cotta. Height 6⅜ inches (16.3 cm.). Ira Spanierman, New York

Writing about MacMonnies, Lorado Taft stated: "There are no black holes in good sculpture. The caverns must be filled, plausibly or otherwise; not to the brim, of course – else our sculptural mass would become as uninteresting

in form as a worn bar of soap, – but sufficiently to produce luminous shadows within their depths. Especially must their boundaries slope off with easy transition on one side, at least, carrying the light by insensible degrees down into the darks" (Taft 1924, 352). In his early thirties when this imaginative *bozzetto* was modeled, MacMonnies created a large number of sketches, suggesting form rather than explicitly detailed surfaces. Perhaps a rejected sketch for the *Shakespeare Monument*, Library of Congress Rotunda, Washington, D. C., this terra cotta is MacMonnies' most Baroque expression, a small *bozzetto* resembling works of the seventeenth century.

243. Boy with Fish

c. 1895-98. Terra cotta. Height 3½ inches (8.9 cm.). Ira Spanierman, New York

A fountain group by MacMonnies of a joyful cupid clutching a duck, donated by the sculptor to Brooklyn's Prospect Park in 1898, derived from this abstraction. It suggests a format more compact and solid than realized in the final interpretation, with wads of clay roughing out surface as well as internal structure. The bronze group, unfortunately stolen from its site in 1941, descends from cherubic figures by masters of the Italian Renaissance. Andrea del Verrocchio's *Putto with Fish* (Palazzo Vecchio, Florence) is prototypical of MacMonnies' terra cotta, suggesting an inspiration from the *quattrocento* reflected in this work of the 1890s.

244

244. Study for Face

c. 1895–98. Terra cotta. Height 5¾ inches (14.6 cm.). Ira Spanierman, New York

The fat-cheeked *putti* of the della Robbia family, Antonio Rossellino, and Andrea Verrocchio are resurrected in this fragmented face, a study by MacMonnies for the *Boy with Duck* or *Cupid on Ball* (the latter sculpture is known only by an illustration in *Scribner's Magazine*, XVIII, 1895, p. 628). This study may have been part of a full-size clay original and not a fragment remaining from a study or sketch. Its surface treatment is unlike that usually manipulated by MacMonnies in his *bozzetti*.

245. The Hunter

(for *The Pioneer Monument*, Denver). c. 1905–10. Plaster. Height 11 inches (28 cm.). Mr. and Mrs. John W. Mecom, Jr., Houston, Texas

245

246. The Pioneer Mother

(for *The Pioneer Monument*, Denver). c. 1905–10. Plaster. Height 11 inches (28 cm.). Hirschl and Adler Galleries, New York

MacMonnies executed sketches for a sculptured memorial complex, *The Pioneer Monument*, to be erected in Denver, Colorado, that centered on an equestrian of Kit Carson atop a granite

247

shaft. Below Carson's figure were three groups in bronze: *The Hunter, The Pioneer Mother*, and *The Prospector*. Fountain basins and decorative symbols of Colorado's agricultural and mineral wealth completed the elaborate structure. Two *bozzetti* for *The Hunter* and *The Pioneer Mother* are extant, the latter sketch differing in certain portions of the pose from those in the final rendering for the bronze. Both *bozzetti* are pyramidal in their massing of figures, polished

and smoothed to a degree seldom seen in MacMonnies' sketches. The monument was finished in 1910.

247. Edwin Booth Memorial

(Destroyed)(for Gramercy Park, New York). 1907-13. Clay. Archives photograph, The Walter Hampden-Edwin Booth Theatre Collection and Library, The Players, New York

A memorial of the great Shakespearean actor Edwin Booth (1833-1893) was commissioned by The Players but never completed due to conflicts and disagreements between the artist and client. MacMonnies' clay sketch, now destroyed, placed Hamlet, one of Booth's major interpretations, within an over-elaborate proscenium arch and on a graduated plinth. Earlier, in 1894, MacMonnies had modeled a portrait of Shakespeare for the Library of Congress Rotunda, but the final bronze is a straightforward standing figure and does not have the originality of concept or elegance suggested by the Players commission. The memorial's design precludes in date and structure a famous work by Edmund Hellmer, the *Johann Strauss Monument*, City Park, Vienna, 1907-21 (Clark 1986, 18).

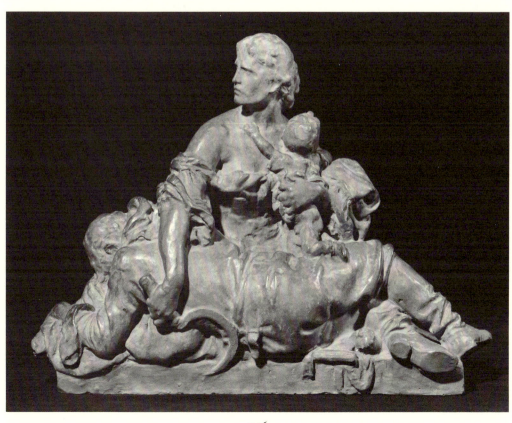

246

248

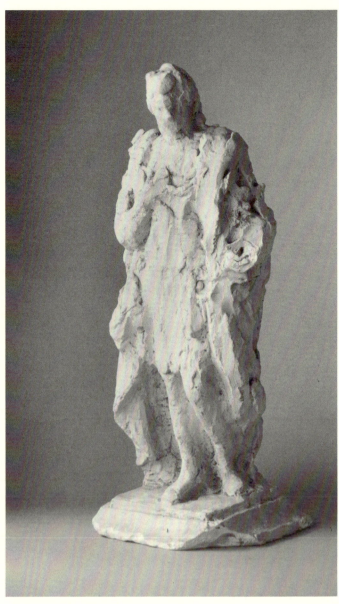

249

248. Hamlet with Skull
(for *Edwin Booth Memorial*, Gramercy Park,
New York). 1907–13. Plaster. Height 14½ inches
(36.8 cm.). Ira Spanierman, New York

249. Hamlet
(for *Edwin Booth Memorial*, Gramercy Park,
New York). 1907–13. Plaster. Height 14½ inches
(36.8 cm.). Ira Spanierman, New York

Both versions must have shown Hamlet
contemplating a skull in his left hand, yet only
one of the *bozzetti* bears that attribute today.
Poised with hand on chest, one leg slightly
bent, a contemplative mood is handsomely
depicted in the freely rendered sketches.

251

251. Fountain

(for Memorial Parkway at Elm Street, Utica, New York). 1908-10. Plaster. Height 6 inches (15.3 cm.). Ira Spanierman, New York

The original *bozzetto* was cast in plaster by the sculptor's daughter long after MacMonnies' death in 1937 and the closing of his studio. Now missing a standing figure on the fountain's central plinth, the sketch is incomplete as seen in this illustration. It is nevertheless a robust demonstration of MacMonnies' distinctly individual modeling technique and rendering of surfaces.

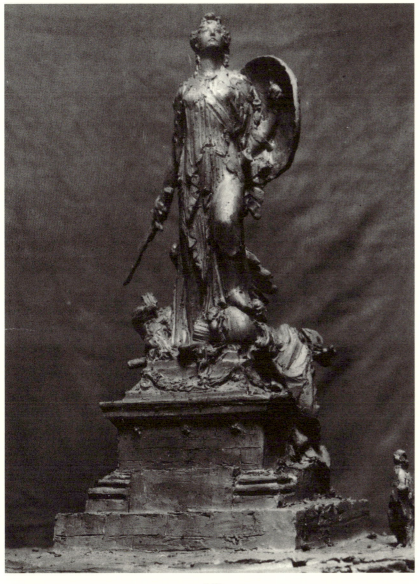

250

250. The Republic

(Destroyed)(First version, Princeton Battle Monument, Princeton, New Jersey). 1908-09. Clay. Archives photograph, Department of Art and Archaeology, Princeton University

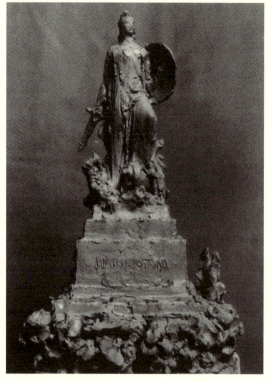

252

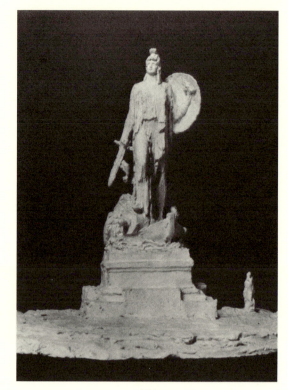

253

252. The Republic
(Destroyed)(Second version, Princeton Battle Monument, Princeton, New Jersey). 1910. Clay. Archives photograph, Department of Art and Archaeology, Princeton University

253. The Republic
(Destroyed)(Third version, Princeton Battle Monument, Princeton, New Jersey). 1910. Plaster. Archives photograph, Department of Art and Archaeology, Princeton University

254. The Republic
(Destroyed)(Fourth version, Princeton Battle Monument, Princeton, New Jersey). 1911. Plaster. Archives photograph, Department of Art and Archaeology, Princeton University

"The result of a collaboration between MacMonnies and the architect Thomas Hastings, the Battle Monument is one of the most ambitious, but least known, examples of Beaux-Arts sculpture in the United States" (Clark 1986, 27). Commemorating a decisive victory fought on the outskirts of Princeton, New Jersey, on January 3, 1777, the Princeton Battle Monument was fraught with indecision and disagreement by artist and commissioners alike before its design was confirmed. By 1907,

the Princeton Battle Monument Commission was formed, and MacMonnies was selected after Saint-Gaudens and Daniel Chester French were passed over. MacMonnies' first submitted sketch, a colossal female figure, was rejected amidst much criticism (Clark 1986, 32). The second version, also a single figure, was discarded along with rejected third and fourth versions employing an armed Victory surmounting a stepped plinth.

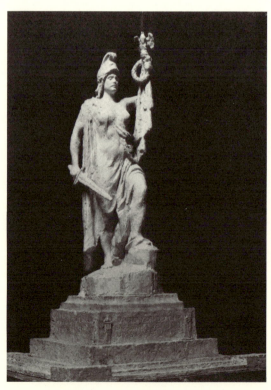

254

255

255. Truth

(for New York Public Library). 1911-12. Plaster.
Height 6½ inches. (16.5 cm.). Ira Spanierman,
New York

256. Truth

(for New York Public Library). 1911-12. Plaster.
Height 14½ inches. (36.9 cm.). Ira Spanierman,
New York

256

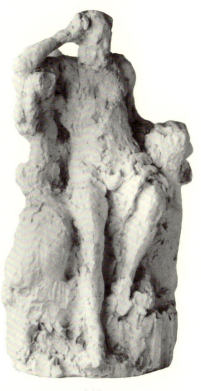

257

257. Truth

(for New York Public Library). 1911-12. Plaster.
Height 16½ inches. (41.9 cm.). Ira Spanierman,
New York

The three extant *bozzetti* for *Truth*, part of the
sculptor's most significant architectural
commission, depict a seated male nude,
probably a philosopher or thinker of classical
Greece. Commissioned in 1911 to provide two
monumental sculptures for niches on the north
and south sides of the main entrance of the New
York Public Library, MacMonnies was enrolled
in the sculpture program for this building along
with such illustrious contemporaries as George
Grey Barnard and Paul Wayland Bartlett
(Lydenberg 1923, 509). MacMonnies
apparently did not decide on the personification
of his figures when he began work on the
sketches, referring to them by several titles: "I
enclose little photos made some days ago.
Group of Truth or Knowledge or Philosophy.
Old man sitting on a stone seat carved into a
sphinx-pieces of ruins about" (Letter, Frederick
MacMonnies to Thomas Hastings, August 12,
1911, New York Public Library Archives). Less
detailed in its modeling is the smallest sketch.
The differences in technique suggest that the
smallest sketch (larger chunks of clay, less

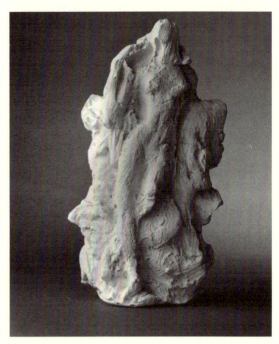

precise tool marks, roughened finger marks) preceded the larger two (smaller pellets of clay, sharper and distinct tool marks, more detailing). In the larger *bozzetti* greater definition is given to the throne-like seat for the philosopher than to facial treatment and anatomy (note the sensitive treatment of pectoralis and gastrocnemius muscles in chest and legs in the mid-size example.)

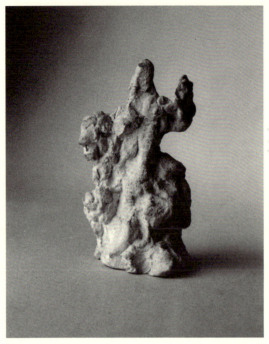

258

258. Beauty
(for New York Public Library). 1911-12. Terra cotta. Height 4½ inches (11.5 cm.). Ira Spanierman, New York

259. Beauty
(for New York Public Library). 1911-12. Plaster. Height 6¾ inches (17.2 cm.). Ira Spanierman, New York

260. Beauty
(for New York Public Library). 1911-12. Plaster. Height 7 inches (17.8 cm.). Ira Spanierman, New York

Among the most abstract of MacMonnies' sketches, the representation of Beauty as a female figure is difficult to identify in the amorphous clay mass in the smallest of three studies remaining from the commission that provided sculptural decoration for the main

entrance of the New York Public Library. The sculptor titled the figure "Beauty – Poetry – Inspiration" in 1911, and described his sketch of it as a "young woman drawing a veil from her eyes, about to mount a pegasus" (Letter, Frederick MacMonnies to Thomas Hastings, August 11, 1911, New York Public Library Archives). The two *bozzetti* in cast plaster position the female figure with a frontal orientation, a requirement of the architectural setting for the final marble. From the flowing lines of *Beauty* and the appearance of tooled marks and cuts, MacMonnies probably worked the clay in his sketches while the material was very moist.

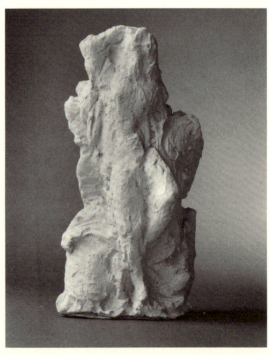

260

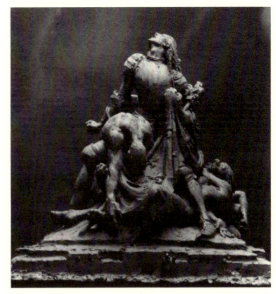

262

261. Princeton Battle Monument

1912-14 (cast 1960). Plaster. Height 14⅛ inches (36 cm.). The Art Museum, Princeton University, Museum Purchase, The John Maclean Magie and Gertrude Magie Fund, 77-74

A relief of exceptional artistry in its abstracted forms, play of light and shadow, and rich plasticity illustrated the theme "Washington Refusing Defeat at the Battle of Princeton." This *bozzetto* is the final concept for the monument in Princeton, New Jersey. Surface effect dominated the briskly modeled relief. The placement of strongly abstracted figures against a background plane incised with horizontal and vertical strokes created a vigorous counterpoint to reliefs by Saint-Gaudens, his mentor, made a decade or two earlier. The finished *Princeton Battle Monument* was dedicated in 1922, a large-scale marble relief incorporated in a severe architectural setting designed by Thomas Hastings. It was placed on Nassau Street on grounds once belonging to the Princeton Inn. MacMonnies perpetuated in the final sculpture the sense of movement, the nervous excitement of the *bozzetto*. Lorado Taft recognized MacMonnies' facility as modeler: "His art is a joyous one, which must find playful and swift expression. He delights in the 'feel' of the clay and handles it like a magician, astonishing even himself with the results" (Taft 1924, 334).

262. Marne Battle Memorial

(Destroyed). c. 1917-20. Clay. The Art Museum, Princeton University

In 1917, MacMonnies began work on his last major commission, a monument to the French soldiers who fought the first battle of the Marne in September, 1913. The sculptor was a logical choice for the American committee, as he was a frequent collaborator with Thomas Hastings, architect of the monument's base, and he had lived primarily in France for most of his career. MacMonnies' initial design was related to early designs for his Princeton Battle monument, a single figure that was replaced by 1920 with a pyramidally shaped massing of fallen warriors capped with a defiant Joan of Arc (Clark 1986, 21). The stone monument at Meaux, France, was not finished until 1932.

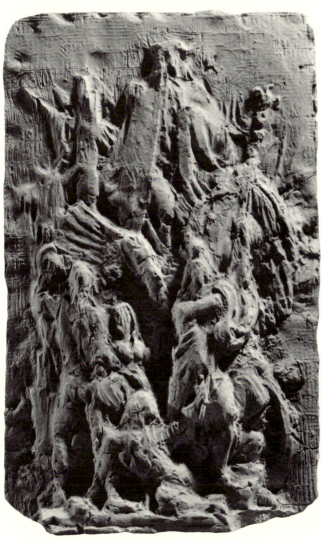

261

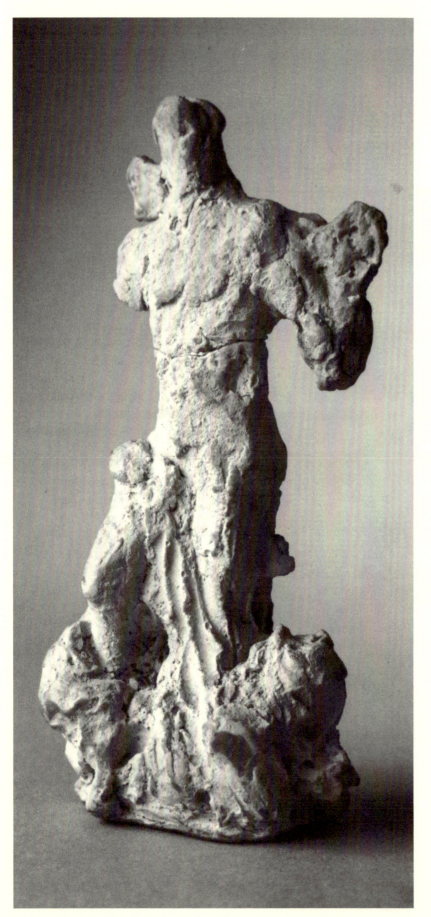

263. Civic Virtue
(for City Hall Park, New York). c. 1922. Terra cotta. Height 5¾ inches (14.6 cm.). Ira Spanierman, New York

264. Civic Virtue
(for City Hall Park, New York). c. 1922. Plaster. Height 13½ inches (34.3 cm.). Ira Spanierman, New York

265. Civic Virtue
(for City Hall Park, New York). c. 1922. Plaster. Height 14¾ inches (37.5 cm.). Ira Spanierman, New York

As the war expanded in Europe and drew the United States ever closer to involvement, MacMonnies returned home in 1915, never to return to his Paris studio. He accepted no sculpture commissions and directed his energies to painting. By the 1920s two commissions for allegorical figures were accepted, however, one for City Hall Park, New York, symbolizing Civic Virtue (Craven 1968, 427). At least three *bozzetti* for the work, a standing Hercules with club standing over a coiling figure, exist. Each is modeled with little surface finish or indication of details, clay pellets retaining their separate outlines in parts of the bodies. Two of the sketches (one with exposed armature in the legs) may derive from an Italian marble sculpture dating from 1540 by Bartolomeo Ammanati (1511-1592), *Victory* (Museo Nazionale, Florence). This sixteenth-century figure intended for the Mario Nari Monument in the Annunziata Church, Florence, reverses the placement of figures, however. In Ammanati's *Victory*, a female with upraised hand stands over a fallen male. MacMonnies' muscular male vanquishing a female was found offensive to women's groups, who demanded in 1926 the removal of the finished sculpture from its original site. It is intriguing to contemplate the possible influence of Italian fifteenth- and sixteenth-century sculpture on MacMonnies' work, such as *Civic Virtue*. As MacMonnies is thought to have made several trips to Italy, there is evidence to support this possibility (Letter, Mary Smart to Millard F. Rogers, May 10, 1985).

263

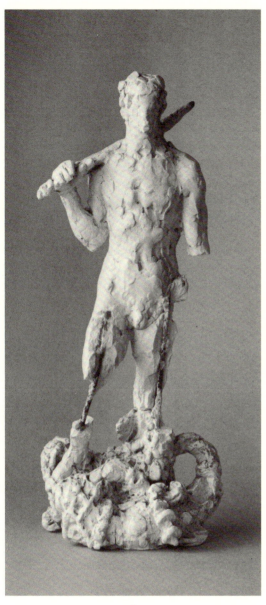

264

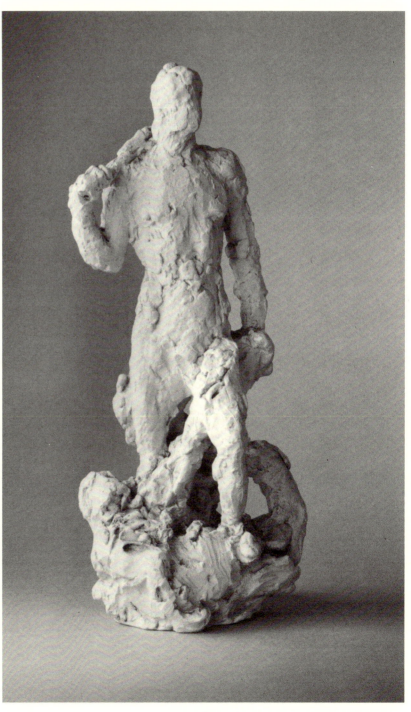

265

Hermon Atkins MacNeil 1866-1947

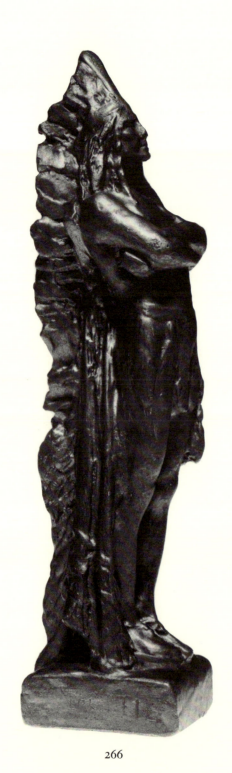

266

Born in Chelsea, Massachusetts. Studied at Boston's Normal Art School for several years and taught at Cornell University, 1885-88. He enrolled in Paris under Henri Chapu and Alexander Falguière, imbibing French modeling techniques. Returning to America in 1891, MacNeil assisted Philip Martiny at the Columbian Exposition, where he remained until 1896. In Chicago he began his lifetime interest in the American Indian as subject matter. Working in Rome, 1896-99, he later re-established a studio in the United States, 1900. Civic commissions, portraits, and medals largely occupied him after 1900 along with expositions in St. Louis, Buffalo, and San Francisco.

266. Standing Indian

c. 1891-95. Colored plaster. Height 10½ inches (26.7 cm.). Signed: MACNEIL. Inscribed under base: MacNeil Sculptor Chicago Illinois. Conner·Rosenkranz, New York

MacNeil, perhaps America's preeminent sculptor of Indian subjects, became interested in the Noble Savage in Chicago after 1891 when he saw Buffalo Bill's Wild West Show. Ever after, the American Indian dominated his oeuvre. He visited this show frequently, made sketches, and relied on these and trips to America's Southwest for subjects for later sculptures. In Chicago he sought to establish an art form truly American in its subject matter (Broder 1974, 87). This sketch is broadly modeled and colored to resemble bronze, though obviously a study for a later, more finished sculpture.

Paul H. Manship 1885-1966

Born in St. Paul, Minnesota. Studied with Solon Borglum and Isidore Konti in New York, 1905, and with Charles Grafly at the Pennsylvania Academy of the Fine Arts, 1906. Won Prix de Rome for study and work at American Academy, Rome, 1909-12. Influenced there by ancient Roman and Greek art, particularly Archaic period sculpture. By 1913, won Barnett Prize from National Academy of Design and elected Academician, 1916. Worked in Paris, 1922-27. Famous *Prometheus Fountain* (1934), Rockefeller Center, New York, typifies Manship's elegant style.

267. Centaur and Mermaid

1909. Electroplated plaster. Height 10½ inches (26.7 cm.). Collection Minnesota Museum of Art, Saint Paul, bequest of the artist, 66.14.77

Manship matured as a sculptor, his style set in a simplified classicism, some years after study at the Art Students League, New York, where he claimed to have learned how to make an armature from Jo Davidson (1883-1952). By 1906, he studied with Solon Borglum (1868-1922) in the same city, modeling constantly. One year later Manship visited Spain with his friend, Hunt Diedrich, fashioning a few small figures from clay dug from a stream according to one biographer (Murtha 1957, 149). In 1909 Manship won the coveted Prix de Rome and set off for the American Academy at age twenty-three. *Centaur and Mermaid* dates from this Roman period, a work not unlike examples by Borglum, Grafly, and Konti, briskly modeled, free-flowing and energetic. The dramatic, simplified, archaicized style typical of his mature efforts (such as the *Lyric Muse*, 1912 or the *Prometheus Fountain*, 1934) was not yet expressed in this youthful work. That Manship was a sculptor committed to sketches or *bozzetti* in preparation for completed sculptures is proved in an interview given late in his life when discussing his tablet relief honoring J. Pierpont Morgan (Metropolitan Museum of Art, New York): "Of course, it was a great opportunity and I was perhaps impressed to a great degree by the responsibility involved. I made many, many, many sketches. Seemed like it was such a simple thing that it could have been done immediately. I changed. I decided on new ideas, and different ideas. I spent a whole year just making sketches" (Leach 1972, 25-26).

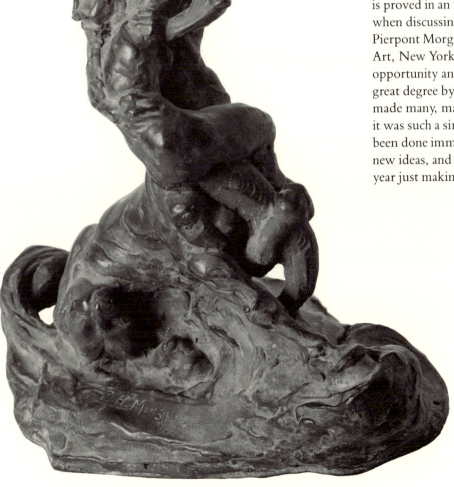

267

Samuel F. B. Morse 1791–1872

Born in Charlestown, Massachusetts. Graduated from Yale University. Studied in London, accompanying Washington Allston. Morse's activity as artist centered in Boston, beginning in 1816, and in Charleston, South Carolina. Excelled as portrait painter. Served as an organizer and first President of National Academy of Design. First experimented with telegraph about 1832. Ceased painting after 1837, devoting himself to inventing and scientific experiments.

268. The Dying Hercules

1812. Plaster. Height 20 inches (50.8 cm.). Inscribed: S.F.B. MORSE/ London fect./ 1812. Yale University Art Gallery, gift of Rev. E. Goodrich Smith, 1866.4

Morse arrived in London in 1811 as a green, untried artist in the company of American painter Washington Allston. Working assiduously and seeking Benjamin West's advice, Morse then painted two monumental works, *Dead Man Restored by Touching Bones of the Prophet Elisha* and *The Dying Hercules*, 1811-12. The latter work was exhibited at Somerset House, London, 1813, and is now in the Yale University Art Gallery. For both paintings, Morse modeled small clay studies (Wehle 1932, 5). These studies are early examples in American art of sculptured clay serving as preliminary exercises for paintings. Morse's preparatory sketch was cast in plaster, with the cast sent to the Society of Arts exhibition at the Adelphi, London, winning the gold medal for a work cast from a single sculptured figure (*Ibid.*, 6). The god's muscled torso is handled tentatively and stiffly, as might be expected by a sculptor so young and inexperienced. His knowledge of ancient works that might have inspired him, such as the famed *Farnese Hercules*, was limited to book illustrations and engravings. Another cast of this *bozzetto* was given to Charles Bulfinch, the architect. In 1842 while stringing wires for a demonstration of the telegraph in the cellars of the Capitol, Washington, D.C., Morse discovered this same cast. He presented the cast to the Reverend E. Goodrich Smith, who later gave it to Yale.

268

Elie Nadelman 1882-1946

269

Born in Warsaw, Poland. Studied at Warsaw Academy of Art and in Munich. Impressed by sculpture collection at Munich's Glyptothek and Bayerisches Nationalmuseum. Lived in Paris by 1904 and knew Leo Stein, Picasso, and Matisse. By 1905-07, experimented with Cubism along with Picasso. First one-man show, 1909, at Galerie Druet, Paris. Early patronage of Helena Rubenstein and trauma of World War I brought Nadelman to United States, 1914. Exhibited in Armory Show, 1913, and at Stieglitz's 291 Gallery, New York, 1915. Credited for creating earliest sculpture abstractions in America, employing simplified form, eliminating detail, and negating subject matter. Formed a notable collection of folk art but withdrew from public activity after 1929.

269. Concert Singer

(Destroyed). 1917. Painted plaster. Height 30 inches (76.2 cm.). Illustration courtesy of The Eakins Press: Lincoln Kirstein, *Elie Nadelman*, New York, 1973

The essence of Nadelman's style began and ended with the curve. A smooth, sinuous outline of volumes pervades his sculpture, whether the object was conceived in the artistically fruitful first decade of the twentieth century or just before his death in 1946. Nadelman wrote: "I employ no other line than the curve, which possesses freshness and force. I compose these curves so as to bring them in accord or in opposition to one another" (Kirstein 1973, 265). Nadelman's career before World War I placed him at the creative core of Europe, but by the late 1920s he became reclusive, out-of-touch. His influence would have been greater, no doubt, had he continued to exhibit, to accept commissions, and to move out of his self-imposed shell. Trained in the academic tradition, Nadelman modeled in clay and then cast his sketches in plaster. Few plaster casts exist to document the many works intended to be cast in bronze or carved in wood. Fortunately, Nadelman photographed a number of his sketches (as plaster casts) before they were lost or destroyed. It is thought that this study, *Concert Singer*, was never translated into wood or bronze (*Ibid.*, 221).

270

270. Cellist

(Destroyed). c. 1919-21. Painted plaster. Height 30 inches (76.2 cm.). Illustration courtesy of The Eakins Press: Lincoln Kirstein, *Elie Nadelman*, New York, 1973

After his marriage in 1920 to a wealthy widow, Nadelman purchased a house in Riverdale, New York, and set up a studio with three assistants. He also had a studio in Manhattan. At both sites during 1920-22 he was a prolific producer of drawings and sketches in clay of performers, musicians, and dancers. Plaster casts (and probably some works modeled directly in this material) were developed from drawings, exquisitely finished works in his mannered, neoclassical style. Sculptures like *Cellist* often were painted or tinted to suggest to the artist the appearance of a later work in wood or bronze.

271. Standing Woman in Hat

(Destroyed). c. 1921. Plaster. Height 30 inches (76.2 cm.). Illustration courtesy of The Eakins Press: Lincoln Kirstein, *Elie Nadelman*, New York, 1973

File marks and the transparent wash of color applied over Nadelman's *bozzetto* can be seen clearly in this stark and haunting figure. Reminiscences of Archaic Greek and Cycladic sculpture, Byzantine icons, and children's dolls were factored into the unique style by "the only sculptor who at this early time was consciously analyzing abstract form" (Craven 1968, 589).

271

272

272. Tango

(Destroyed). c. 1923-24. Painted plaster. Height 30 inches (76.2 cm.). Illustration courtesy of The Eakins Press: Lincoln Kirstein, *Elie Nadelman*, New York, 1973

Modeled as independent works, shown separately on occasion, but conceived as a group, the two figures in this *bozzetto* were copied in carved and painted cherrywood (height 34 inches) (Kirstein 1973, figure 115). The illustrated study differs from the sculpture in wood in the skirt's wrinkles, facial treatment of the male, and bow tie.

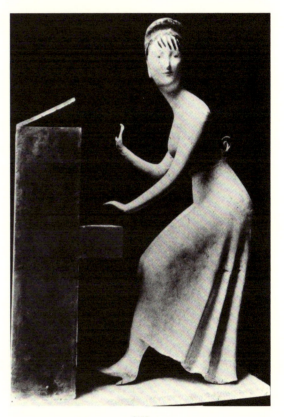

273

273. Woman at Piano

(Destroyed). c. 1922-23. Painted plaster. Height 36 inches (91.4 cm.). Illustration courtesy of The Eakins Press: Lincoln Kirstein, *Elie Nadelman*, New York, 1973

The wood sculpture (height 35⅛ inches) in the Museum of Modern Art, New York, derives from this *bozzetto*.

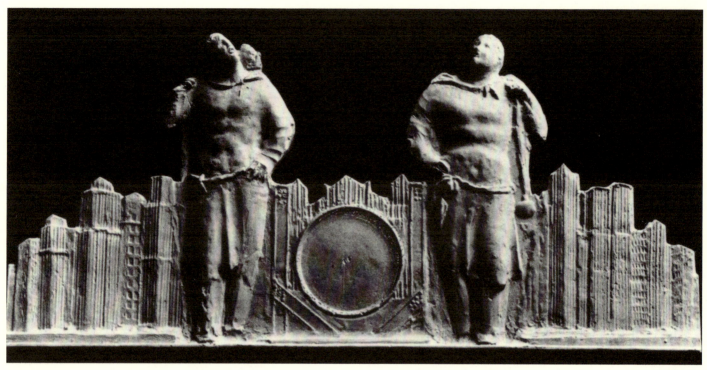

274

274. Construction Workers and Clock
(Destroyed)(for Fuller Building, New York).
1930–32. Plaster. Length 20 inches (50.8 cm.).
Illustration courtesy of The Eakins Press:
Lincoln Kirstein, *Elie Nadelman*, New York, 1973

Nadelman and his wife were devastated
financially by the crash that preceded the
Depression, an economic shock that forced the
sculptor further into seclusion. By the time he
received the commission from architect A.
Stewart Walker for the decoration over the main
entrance of the Fuller Building, Fifty-seventh
Street and Madison Avenue, New York,
Nadelman was not exhibiting his sculpture, and
he was largely ignored by a public that
considered him affluent, unconcerned, and not
needing their support. This rare *bozzetto*
foreshadowed his last stylistic development,
characterized by more mannered, plumper
figures, greater simplification, and a flattening
of forms.

Andrew O'Connor 1874-1941

Born in Worcester, Massachusetts. Studied with his father and worked in the studios of William Ordway Partridge and Daniel Chester French. He prepared sculptures for the Columbian Exposition, Chicago, 1891-92, and later worked in London, 1895-98. By 1904 he was established in Paris and exhibited at the *Salon*, 1906. O'Connor produced architectural sculpture for several firms, including McKim, Mead and White. As World War I approached, O'Connor established his studio in Washington, D.C.

275. Pro Patria

(for General Liscum Memorial, Arlington National Cemetery). 1902. Bronze. Height 24 inches (61 cm.). Signed: O'Connor. Inscribed, back of shield: Pro Patria. Founder's mark: Hebrard [seal]. Conner · Rosenkranz, New York

Occasionally, reductions of large-scale monuments were cast in bronze, providing sales opportunities for popular images. Rarely, however, were sketches or *bozzetti* preserved in such permanent material. It is difficult to determine which category applies to the work illustrated here.

275

Erastus Dow Palmer 1817-1904

Born in Pompey, New York. Engaged in carpenter work in Utica by 1840 and cameo-cutting by 1845. He continued making cameo portraits and turned to sculpture in Albany by 1848. Shunning the neoclassical idiom, he was one of the first artists who sought American subjects. Palmer was self-taught and went to Europe in 1873-76 only after his career was established. Sculptors Launt Thompson and Charles Calverley were his pupils.

276a

276. The White Captive

(Two views). 1857. Plaster. Height 19¾ inches (50.2 cm.). Signed on tree trunk: PALMER SC / 1857. Albany Institute of History and Art, Albany, New York

The subject was drawn from events in frontier life, specifically the kidnapping of women and children by Indians. Palmer employed a model "less than 18 years of age," and spent six weeks modeling the clay *bozzetto* from which this plaster cast was made (Webster 1983, 183). Commissioned by Hamilton Fish, once Governor of New York, the clay study earned $1000 for the artist when it was completed in 1857 (*Ibid.*, 181). Eventually the finished sculpture in marble was exhibited to great acclaim in New York City in 1859. Its only competitor for public interest in the nineteenth century was Hiram Powers' *Greek Slave*, also a female nude in bondage. The natural, expressive appearance of the captive is "wholesomely American, drawing its vitality directly from nature instead of from ancient art" (Craven 1968, 160). The *bozzetto* bears rasp marks and roughened modeling on the buttocks and thighs, a surface treatment undesirable in the finished marble.

277. Landing of the Pilgrims

(Fourteen figures for pediment, National Capitol, House Wing, Washington, D.C.). 1857. Clay. Height 16¾ inches (42.5 cm.), central figure. Signed on chest, *Charity* figure: E.D.P. 1857; on base, *Enterprise* figure: Olcott [?] inning [W?] 1857; on top of base of leading Indian: E.D. Palmer; on front edge: E.D.P. Albany Institute of History and Art, Albany, New York

Palmer began to model in the spring, probably in April, his clay *bozzetti* for pediment sculpture decorating the House of Representatives Wing in the nation's Capitol. While he did not receive the commission for the finished work, he was paid $1,000 for his design and model, but by November 1857, Palmer withdrew from further consideration (Webster 1983, 156). The sculptor's interpretation of the Pilgrim story and the major individuals in this brave band placed groups of figures within the triangular confines of the pediment so that crouching figures or animals are in the extreme corners,

276b

with progressively more erect figures ascending to the center (e.g., Elder Brewster, in center with upraised arms). These rare clay originals include, left to right: tree stump, wolf, rocks, a Pilgrim (*Fatigue*), Elder Robinson (*Fidelity*), [skull and antlers of dead stag and tree stump now missing], a child and Priscilla Mullen (*Purity*), Governor Bradford (*Enterprise*), Rose Standish (*Hope*), Elder Brewster (*Faith*, in exact center), Mrs. White and infant (*Charity*), Miles Standish (*Self-Defense*), John Alden and child (*Adventure*), Governor Carver (*Meekness*), two tree stumps, crouching Indian (*Danger*), rocks, and game. Palmer's impressive parade illustrating Pilgrim characters never was accepted by government officials in charge of the construction and decoration of the United States Capitol, perhaps because it focused on a regional episode in American history. The subject was not broad enough for general appeal. The figures were modeled in separate groups so that each element or figure could be free-standing when separated from the ensemble. Palmer's pediment group has a high degree of finish to each part, the modeling polished enough to suggest quite completely the appearance in marble of the final version, if it had been commissioned.

277

278

278. Robert R. Livingston

(Destroyed). 1874. Clay. Archives photograph, Albany Institute of History and Art, Albany, New York

This *bozzetto* in clay, now lost, for the large (height 74 inches) bronze of Livingston (1746-1813), American Minister to France and negotiator for the Louisiana Purchase, was commissioned by the State of New York in 1873 (Webster 1983, 216). Two bronzes resulted, one for the Court of Appeals in Albany and the other for Statuary Hall, United States Capitol, Washington, D.C. Palmer's nude study is recorded in an old photograph showing the work still on the sculptor's modeling stand, with tools embedded in the moist clay. The *bozzetto* was fashioned in Paris, where Palmer ended his only European tour, absorbing nearly two months and writing in his diary: "Finished statue after 57 days, hardest work of my artistic life" (*Ibid.*, 35).

William Ordway Partridge 1861-1930

279

Born in Paris. Educated in the United States, studying at Columbia University. By 1882, began studies abroad in Florence, Rome, and Paris. Returned to Milton, Massachusetts, by 1889. Importance as sculptor first recognized at Columbia Exposition, 1893. Impressionistic tendencies in his work evident by 1900. Renowned as portrait sculptor, particularly of authors, statesmen, and the famous. Leading proponent in Beaux-Arts tradition of modeled clay perpetuated in cast bronze.

279. Thomas Jefferson

(for School of Journalism, Columbia University, New York). 1912. Plaster. Height 20⅝ inches (52.3 cm.). Signed, left side, base: Partridge/ 19 [12?] New York Historical Society, gift of Mrs. W. O. Partridge, 1946.262

In 1911, Joseph Pulitzer's last will and testament bequeathed $50,000 for a fountain and $25,000 for a statue of Thomas Jefferson "to adorn some public place in New York . . . " (Sharp 1974, 61). Partridge was commissioned by the Pulitzer estate for the commemorative work honoring Jefferson, and by 1912, as the inscription suggests, the broadly and richly modeled *bozzetto* was finished. While Partridge's portrait in plaster is recognizable as the nation's patriot-president, the body is spared fussiness and details. The sculptor's version of the Ecole style, naturalism fused with impressionistic surface treatment, was an evolutionary process that developed from a small *bozzetto* through enlargements in clay to full-size example. By the spring of 1913, the large plaster was finished, and the final sculpture in bronze was erected at Columbia University on June 2, 1914. A reproduction in bronze of this sketch is in the collection of the Memorial Art Gallery, University of Rochester. This sketch is one of the rare survivors of an accident to plasters stored in Partridge's studio, 784 Park Avenue, New York (Balge 1982, 26).

Hiram Powers 1805-1873

Born in Woodstock, Vermont. Moved with family to New York State and Ohio and worked in a clock factory in Cincinnati as a youth. Sculpture career began at Dorfeuille's Western Museum, Cincinnati, modeling wax figures and panoramas. Leading member of group of sculptors patronized by Nicholas Longworth in that city. Lived in Washington, D.C., 1834-37, and in Florence, Italy, 1837-73, where his greatest work, *The Greek Slave*, was carved in 1843. Noted for portraits and ideal subjects, he was regarded as the leading American sculptor of the mid-nineteenth century.

280. George Washington

1855. Plaster. Height 24¾ inches (62.9 cm.). National Museum of American Art, Smithsonian Institution; Museum Purchase in Memory of Ralph Cross Johnson, 1968.155.121

As a young sculptor trained by Frederick Eckstein (1775-1852) in Cincinnati, Hiram Powers in 1823-25 was experienced in wax and clay modeling techniques. Later he demonstrated his mechanical abilities at Joseph Dorfeuille's Western Museum with animated figures that brought horrifying drama to the Queen City. Powers conceived his marble masterpieces first in clay, writing about several works and the process to patron-friends. The first sketch for *Eve Tempted* was modeled in December 1839 and nearly finished by January 1840 (Reynolds 1975, 133-134). The process from *bozzetto* to finished plaster occupied twenty-seven months to prepare the work for submission to marble cutter.

As Powers wrote of the necessity for sculptors to model in clay, it can be assumed he knew and practiced the technique himself. He developed about 1851, however, a procedure for eliminating the clay model and working directly in plaster (*Ibid.*, 247-248). Special tools and files were invented for this innovative technique. Powers' *bozzetto* is an important work, one of two extant sketches by the sculptor. The model is not yet draped, no accessories are shown, and the figure is roughly modeled and intended to give only the general idea of pose and stance. Although the surface of the *bozzetto* is heavily textured, with chisel and file marks prominent, the sketch still suggests the reserve and repose of Powers' finished sculpture. It does not reflect the degree of surface finish, of course, recognized as a trademark of Powers' marbles. The expressiveness, finish, and emotion expressed in a *bozzetto* by nineteenth-century American sculptors generally do not find parallels in the replica the patrons expected as the result of their commissions. Most *bozzetti* illustrate the

280

attempt to capture gesture, characterization, proportions, and the physical presence of the intended sculpture. Powers' sketch for the first President of the United States was modeled in 1855 and later translated into a full-size marble portrait statue for the capitol of Louisiana at Baton Rouge. The finished statue was destroyed in a fire that consumed the Mechanics and Agricultural Fair in New Orleans in May 1871, after it had been returned to Louisiana from Washington as war booty. Powers wrote of this work: "I have placed him in a meditative and dignified posture, the farewell address is in his left hand, and he leans with his right upon a column composed of rods banded together, at the base of which appear the sickle and the pruning hook, emblems of husbandry (Letter, Hiram Powers to Governor Joseph Walker of Louisiana, June 8, 1852, Smithsonian Institution Archives).

281. Edward Everett

c. 1865-70. Plaster. Height 29⅛ inches (74 cm.). National Museum of American Art, Smithsonian Institution; Museum Purchase in Memory of Ralph Cross Johnson, 1968.155.122

Powers advocated the study of anatomy and observation of anatomical figures in plaster: "Study them, commit the names of the parts to memory, model them in clay and in short make everything familiar to your memory as household words. Meanwhile, copy living heads, arms, legs, hands . . . " (Reynolds 1975, 231). This plaster sketch was the sculptor's preliminary study for the marble replica carved by artisans in Powers' studio. Discarded after a fire at Harvard University's Memorial Hall in 1956, the finished marble of Everett (1794-1865), member of the House of Representatives and famed orator, is remembered in Powers' sketch about which he wrote: "I shall represent him in his frock coat, buttoned up, and without a cloak or any other surplus drapery. He will appear as if speaking. I intend to make this statue in marble and I care not if it is never ordered" (Letter, Hiram Powers to Sidney Brooks, May 26, 1865, Smithsonian Institution Archives).

281

William Rimmer 1816-1879

Born in Liverpool, England. Lived in Nova Scotia and Boston, working there as painter of portraits and signs, and maker of gypsum statuettes. Rimmer's *Despair*, carved about 1830, probably was the first sculptured nude by an American. Painting portraits in and near Boston, he also worked as shoemaker and physician (1855-63). Serious interest in sculpture began at that time, lecturing on anatomy 1864-66 in Boston and Lowell. Director of School for Design for Women, Cooper Institute, New York 1866-70. Taught in Boston 1870-79.

282. Falling Gladiator

1861. Plaster. Height 62 inches (1.57 m.). Signed on base: W. Rimmer/Sc. National Museum of American Art, Smithsonian Institution; gift of Caroline Hunt Rimmer, 1915.5.1

Throughout a frustrated career and away from the main currents of American sculpture in the nineteenth century, Rimmer had insufficient patronage, no studio filled with assistants carving replicas, and no foreign study. He mixed the occupations of shoemaker, medical doctor, teacher, and artist. His anatomical studies were thorough and persistent, his nudes forceful and realistic. Unlike the sculptors who produced neo-classical, ideal works heavy with literary allusions, Rimmer was well aware of plastic form. This awareness was unappreciated by most critics and sculptors. Lorado Taft had little grasp of Rimmer's importance or difference: "His anatomical knowledge and his enthusiasm were extraordinary, and doubtless left their imprint upon many students as well as upon the public at large, which he interested to a certain degree; but his own works, however remarkable when the method of their production is considered, were valueless as sculpture. He persisted in executing models, and while he 'never missed a muscle nor forgot an attachment,' the results are curious rather than edifying" (Taft 1903, 187). Rimmer began work on the *Falling Gladiator* on February 4, 1861, in East Milton, Massachusetts. The sculpture probably evolved from *bozzetto* to finished clay in the same work, gradually smoothing the surface and defining the musculature with toothbrushes. It was not constructed over a proper armature (Kirstein 1946, n.p.). Bostonian Stephen H. Perkins provided Rimmer with $100 to start this work. No model was used, for the sculptor relied on his own body, dissections, and his memory of anatomical studies, finishing the clay model in June (Craven 1968, 350). The dramatic nude figure, full of vitality, was shown at the Paris *Salon* in 1862 as a plaster replica. It was dismissed by the public as "an exposition of muscles by an ingenious dilettante" (Kirstein 1946, n.p.).

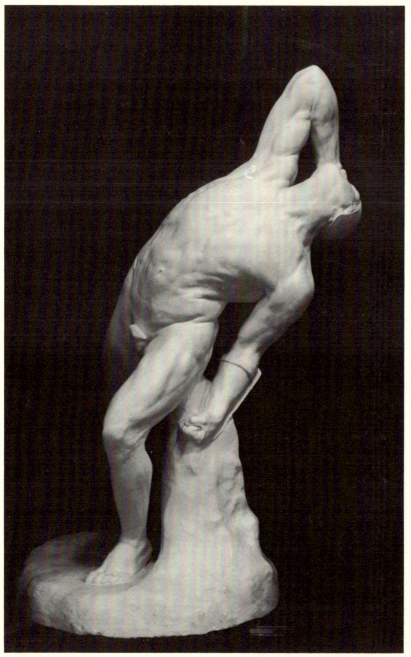

282

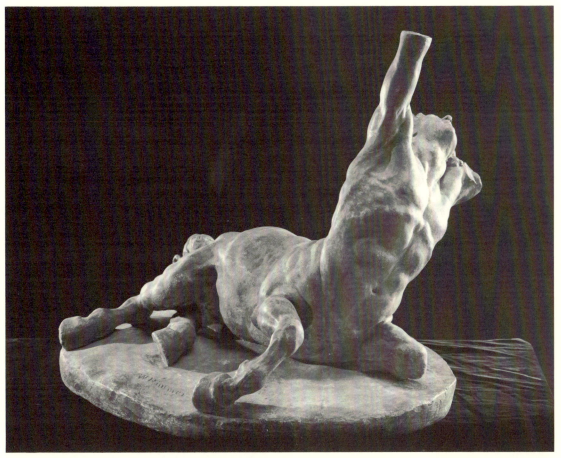

283

283. Dying Centaur

1869. Plaster. Height 21 inches (53.4 cm.).
Signed on top of base: W. Rimmer. Museum of
Fine Arts, Boston, bequest of Caroline Hunt
Rimmer, 1919.127

The *contraposto* and energy in this work and its
suggested reference to Hellenistic antiquity are
rarely encountered in nineteenth-century
American sculpture. Rimmer's innovative, very
personal style, powerful and realistic, was
unappreciated by a public who saw "A wild
pagan creature, half man, half myth, sinking to
the earth, with amputated arm stretching its
handless stump to a pitiless Puritan sky," but
could not see the tactile, plastic qualities so
richly displayed in the *Dying Centaur* (Gardner
1945, 38). While the work was not a sketch
intended for development into an enlarged,
more finished sculpture in marble or bronze, it
is close in concept and execution to the true
bozzetto. *Dying Centaur* was cast in bronze
(Metropolitan Museum of Art) from this
model.

284. Torso

1877. Plaster. Height 11¼ inches (28.6 cm.).
Signed on top of base: W. Rimmer 1877.
Museum of Fine Arts, Boston, bequest of
Caroline Hunt Rimmer, 1919.128

284

Reflections of Michelangelo in Rimmer's work
are suggested in this powerful plaster cast that
preserves the original clay sketch. Its
resemblance to earlier masterpieces, such as the
Hellenistic *Belvedere Torso* (Museo Vaticano,
Rome) or Michelangelo's *River God*
(Accademia, Florence), probably is
coincidental. Rimmer may have seen
illustrations to use as inspiration, but he never
traveled to Italy. In the same year, 1877,
Rimmer's book *Art Anatomy* was published, in
which his anatomical renderings and drawings
of carefully delineated muscles included one
plate (no. 188) especially close to *Torso*.

Randolph Rogers 1825-1892

Born in Waterloo, New York. Lived in Ann Arbor, Michigan, as a youth, going to Florence in 1848-50 to study with Lorenzo Bartolini. Periodic trips back to America, but expatriate for remainder of life in Rome. Very productive career, executing numerous ideal marble sculptures, but had many commissions in bronze, such as *Columbus Doors* and Civil War monuments. His most popular work and a principal image of the Victorian period was *Nydia, The Blind Flower-Girl of Pompeii.*

285. Lincoln and the Emancipated Slave

c. 1866-68. Plaster. Height 20½ inches (52.1 cm.). The University of Michigan Museum of Art, gift of Randolph Rogers, 1885.3

Rogers' interest in the martyred President Abraham Lincoln was evidenced by his bust portrait in marble, perhaps dating from 1866. This sketch was developed for a commission, probably the one for Philadelphia, contracted in 1868, and unveiled September 22, 1871, in Fairmount Park. The sculptor's *Journal*, April 1867, recorded: "Lincoln Monument Association of Phila. Group with Mr. Lincoln and Negress, etc." (Rogers 1971, 211). This *bozzetto* is one of the few remaining plaster casts from the contents of Randolph Rogers' studio that the sculptor donated to the University of Michigan in 1885.

285

286. Admiral David G. Farragut Monument

(Proposed). c. 1872. Plaster. Height 37½ inches (95.3 cm.). University of Michigan Museum of Art, gift of Randolph Rogers, 1885.2

The naval hero is shown lashed to the mast, his megaphone in hand. Although preceding Augustus Saint-Gaudens' famous memorial to Farragut by several years (Saint Gaudens' work was executed in 1877-80), Rogers' sketch lacks the fresh concept that dawned in Saint-Gaudens' masterpiece. Rogers' plaster, however, is more vigorously modeled and expressive than many of his marble and bronze sculptures, thus illustrating the spontaneity possible in the sketches of even the most dedicated and conservative neo-classicists.

286

Augustus Saint-Gaudens 1848–1907

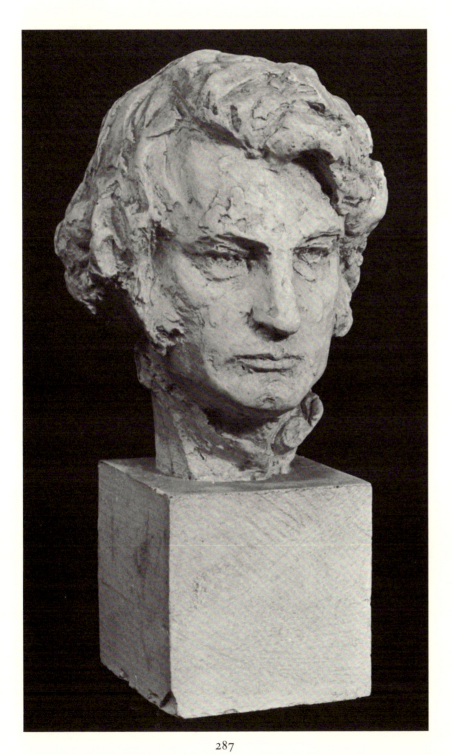

287

Born in Dublin, Ireland. Apprenticed to Louis Avet, a cameo-cutter, New York City, 1861. Studied at Cooper Union and National Academy of Design until 1867. Studied with Jouffroy in Paris and at Ecole des Beaux-Arts before 1870 when he went to Rome, returning to America in 1872. Founding member of Society of American Artists, a group of younger artists in disagreement with policies of the National Academy of Design. By 1885, he was well established and perhaps was best-known American sculptor of late nineteenth century. Taught at Art Students League after 1888. Cast collection housed in his last studio, Cornish, New Hampshire, maintained as National Historic Site since 1965, but preserved since artist's death and opened to public in 1922.

287. Roger B. Taney

1875–76. Plaster. Height 7¾ inches (19.8 cm.). United States Department of Interior, National Park Service, Saint-Gaudens National Historic Site, Cornish, New Hampshire

The finished marble portrait of Chief Justice Roger B. Taney (1777–1864) lacks the expressiveness of Saint-Gaudens' sketch, the latter reflecting none of the neo-classic idealization in William H. Rinehart's statue (1870) from which Saint-Gaudens' work was derived (Dryfhout 1982, 80). Such a vigorously modeled bust would not have been acceptable for its "unfinished" appearance. The sculptor clearly submitted to official taste in the final work, but beauty and forceful depiction of face and head, creating a moving portrait, were his in the sketch.

288a

288. Admiral David Farragut Monument

(Destroyed)(Two Views)(For Madison Square, New York). 1877-80. Clay. Archives photograph, Dartmouth College Library

Saint-Gaudens was a prolific modeler of sketches, as testified by the large number of objects preserved in archival photographs in the Dartmouth College Library. Many of his *bozzetti* are known only through these illustrations. Confirming the laborious, extensive immersion of the sculptor in his commissions, "There were twenty-seven sketches for the *Peter Cooper Monument*, with variations of hat, coat, and cane. There were more than thirty sketches made for the *Brooks Monument*, with earlier renditions developed so that an angel in the background changed to a figure of Christ. There were seventy models for the eagle destined for the United States coinage,

forty studies from life of black models for the soldiers in the *Shaw Memorial*, and thirty-six sketches for the *McCosh*, with five different positions tried for the hand" (Dryfhout 1982, 32). Saint-Gaudens' first major commission was the *Farragut Monument*, Madison Square, New York. The bronze full-length portrait of the Civil war hero dominates the base designed by Stanford White and the sculptor. The now-destroyed original in clay is illustrated in the archival photograph that captures the intended *exedra* shape of the sandstone base. This illustration records a rare example of an architectural sketch by Saint-Gaudens without any figural content.

Incorporated into the wings of the base are two seated female figures, Loyalty and Courage, carved in low relief, for which clay sketches once existed. The earliest *bozzetto* for Courage in its smoothed proportions and flattened look does not hint at the accomplished, realized relief, a rare instance where the expressiveness in a sketch was exceeded in the final work (Dryfhout 1982, 110-115, no. 90).

289. Edwin D. Morgan Tomb Project

(Destroyed)(for Cedar Hill Cemetery, Hartford, Connecticut). 1879-80, 1883. Clay. Archives photograph, Dartmouth College Library

288b

289

Morgan commissioned his tomb for Cedar Hill Cemetery, Hartford, Connecticut, with Saint-Gaudens to execute the sculpture and Stanford White the architecture. The project was never completed. The initial sketch in clay grouped three draped angels with hands clasped in prayer around a Greek cross. Architectural background and platform were roughly cut and contrived, the faces featureless, with the lines of the folds incised by the artist's modeling tool.

290. Edwin D. Morgan Tomb Project

(Two views). 1879-80, 1883. Plaster. Height 39 inches each (99 cm.). United States Department of Interior, National Park Service, Saint-Gaudens National Historic Site, Cornish, New Hampshire

The three angels were fashioned separately by Saint-Gaudens, larger and more detailed than the initial clay sketch, about one-third the size of the intended marble figures for the tomb. Botticelli-like in their languorous poses, two of the angels are known in the plaster casts made from the original clay sketches in this intermediate stage. The central figure of the trio (now destroyed) in this size was illustrated in Marianna van Rensselaer's *Book of American Figure Painters*, 1886, as part of the title page (Dryfhout 1982, 136-137).

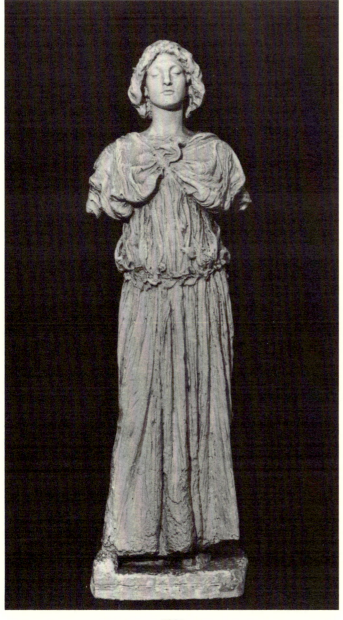

290a

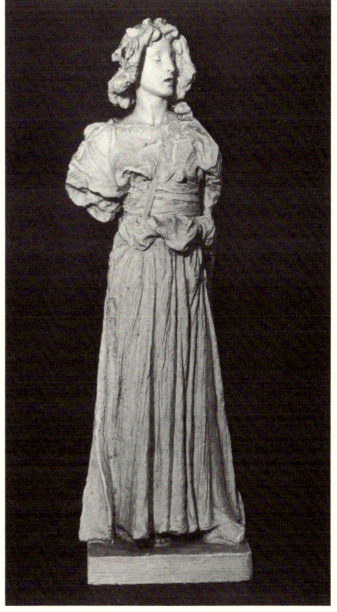

290b

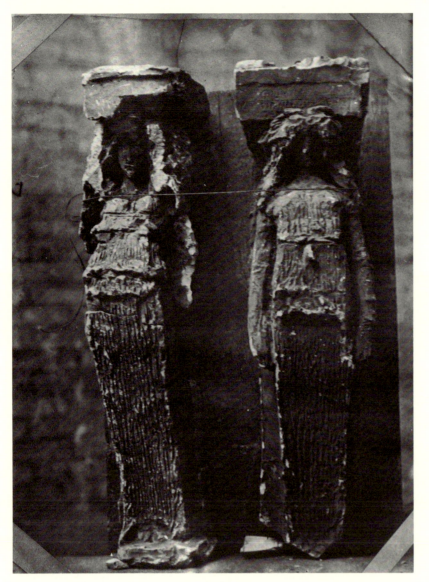

291

291. Mantelpiece,
Cornelius Vanderbilt II House

(Destroyed). 1881-83. Clay. Archives photograph, Dartmouth College Library

Saint-Gaudens participated along with architect George B. Post and painter John LaFarge in designing and decorating the New York City mansion commissioned by Cornelius Vanderbilt II (1843-1899). The hall mantelpiece for the house at Fifth Avenue and 57th Street is an elaborate, massive structure (now in the Metropolitan Museum of Art, New York) dominated by caryatids, one at each end, with upraised arms. Saint-Gaudens' clay sketches roughed out two free-standing figures, one with arms raised and one with arms downward, and with the drapery clinging to term-like figures. These two sketches, so freely delineated and block-like, are among the sculptor's most richly handled *bozzetti* (Dryfhout 1982, 130-131).

292. David Stewart Mausoleum

(Destroyed)(for Greenwood Cemetery, Brooklyn). 1883. Clay. Archives photograph, Dartmouth College Library

Two bronze reliefs are mounted left and right of the heavy door to the tomb commissioned by David Stewart (1810-1891) for Greenwood Cemetery, Brooklyn, New York. Saint-Gaudens filled each nearly square relief with a seated angel. His now-lost clay sketch suggested an angel holding an inverted trumpet. Two positions for the arms are shown. Directly below the heavily inscribed horizontal line at the angel's feet, indicating the lower edge of the relief itself, are rough indications apparently representing the façade of the mausoleum (Dryfhout 1982, 138-139).

292

293a

293b

293. Alexander H. Vinton Memorial

(Destroyed)(Three Views)(for Emmanuel Church, Boston). c. 1883. Clay. Archives photograph, Dartmouth College Library

While the finished, realized bronze relief was rectangular and with vertical axis, the several clay sketches, now lost, have a square format with the center figure of the Reverend Vinton contained in an enframement. Saint-Gaudens' first exercises, less detailed than the others, appear to be the three clay reliefs grouped together in one photograph. Rather than building up the surface with bits of clay pressed onto the flat surface and articulated with the fingers, the sculptor probably used a tool to incise lines and dots that suggest shape and form. The other two reliefs, one with Vinton's right arm raised, the other depicting Vinton enclosed in a circle, are in higher relief with evidence of applied clay and greater shaping. A grapevine motif dominates the border areas in each of the sketches in the single object illustrations. These two reliefs probably followed the three, less-finished sketches. The final bronze casting evolved from these sketches is installed in Emmanuel Church, Boston, and commemorates the ministry of the Reverend Vinton (1807-1881) at the church, 1869-77 (Dryfhout 1982, 140-141).

293c

294. The Puritan (Deacon Samuel Chapin)

(Destroyed) (Two views) (for Springfield, Massachusetts). 1883–86. Clay. Archives photograph, Dartmouth College Library

A larger-than-life *Puritan*, a Chapin ancestor of the donor of the bronze memorial, was unveiled in Stearns Square, Springfield, Massachusetts, to commemorate one of the city's three founders. The chunky and poorly articulated bodies and costumes of Saint-Gaudens' first sketches were discarded as models for the finished work. In only a few cases in his career was the sculptor's final bronze or marble so unrelated to the preliminary clay *bozzetti*. As a model is known to have posed in costume, and the Chapin family contributed advice on the costume's elements, Saint-Gaudens must have deserted his clay sketches and relied on direct observation, not a mental picture that initiated the *bozzetti*, in developing the *Puritan* (Dryfhout 1982, 162-166).

294a

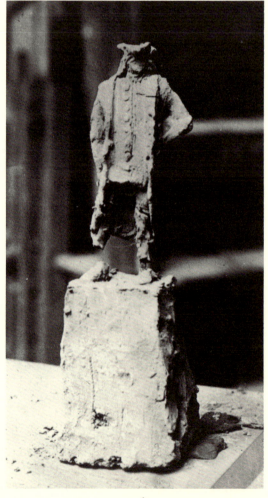

294b

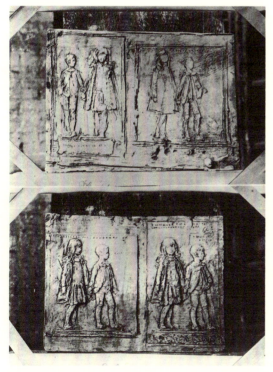

295a

295. Relief of Mortimer and Frieda Schiff

(Destroyed)(Three views). 1884-85. Clay.
Archives photographs, Dartmouth College
Library

The limitations of low-relief sculpture were
overcome by Saint-Gaudens who mastered the
art form probably better than any American
artist has done. The sculptor experimented
with several poses of the son and daughter of
Jacob Schiff, wealthy banker and
philanthropist, modeling over fourteen
sketches before settling on the final format that
incorporated a Scottish deerhound. The
sketches indicate various methods in Saint-
Gaudens' techniques: linear, incised suggestion
of form; slight build-up of form using flattened
pellets of added clay; and raised forms
combined with incised line (Dryfhout 1982,
152-153). In each sketch there were economical,
scant suggestions of shapes proving the master's
talents as modeler.

295b

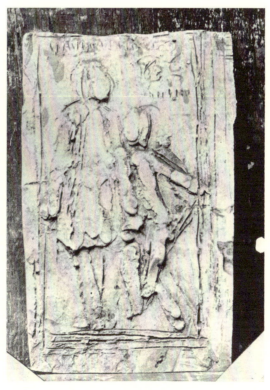

295c

296. Abraham Lincoln: The Man ("Standing Lincoln")

(Destroyed)(Two views) 1884–87. Clay.
Archives photographs, Dartmouth College
Library

Distinct and recognizable are Lincoln's features,
unusually accurate in rough sketches, most
often left featureless or merely suggested. The
contemplative mood of the finished bronze in
Lincoln Park, Chicago, follows Saint-Gaudens'
recollections of the president, whom he saw in
1860. His first studies, marked as such on one
archival photograph, were modeled at Cornish
in the summer of 1885. Rather static in their
frozen poses, the sketches appear to be exercises
in mastering the proportions of the figure and
the draping of clothes accurately (Dryfhout
1982, 158–162).

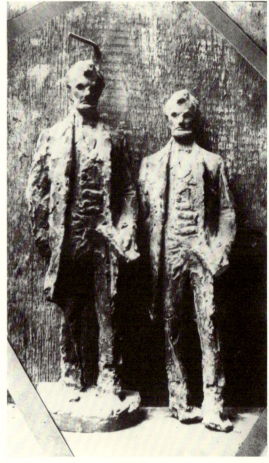

296a 296b

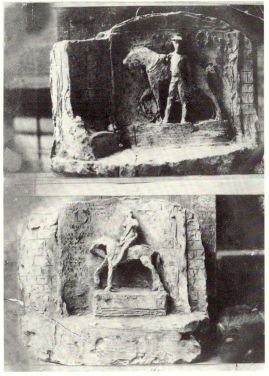

297

297. Robert G. Shaw Memorial

(Destroyed)(for Boston, Massachusetts).
1884-97. Clay. Archives photographs,
Dartmouth College Library

298. Robert G. Shaw Memorial

(for Boston, Massachusetts). 1884-97. Plaster.
Height 15 inches (38.1 cm.). United States
Department of Interior, National Park Service,
Saint-Gaudens National Historic Site, Cornish,
New Hampshire

Saint-Gaudens was commissioned in February
1884 to commemorate the exceptional
leadership and sacrifice of Colonel Robert
Gould Shaw (1837-1863), killed in action at Fort
Wagner, near Charleston, South Carolina,
heading his 54th Massachusetts Regiment, a
fighting force composed of black volunteers. A
committee was formed in 1865 to honor Shaw
and his troops, but nineteen years elapsed
before H. H. Richardson ensured that Saint-
Gaudens was chosen for this major work.

Numerous clay sketches were made for the
monument, apparently always conceived as an
equestrian figure placed against or within an
architectural surround. A large number of casts
of parts of the monument still exist. The earliest
sketches, now lost, for the monument,
depicting only horse and rider against a figure-
less masonry backdrop, were developed further
in the only extant *bozzetto* (in plaster) for the
monument. In it, against a flattened row of
soldiers and beneath a hovering angel with the
palm of martyrdom or victory, Shaw on
prancing horse moves to the left. A figure is
suggested on the bench below. While the
finished memorial reversed the direction of
Shaw and the architectural setting by Charles F.
McKim was changed slightly, the sketch was
faithfully translated in spirit and format
(Dryfhout 1982, 222-229).

298

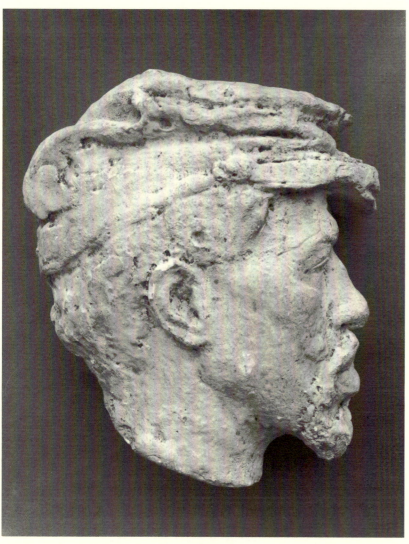

299a

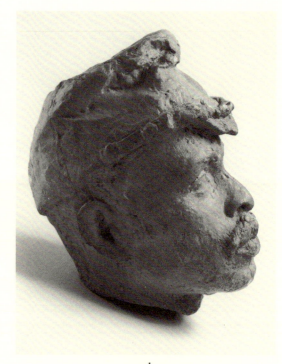

299b

299. Soldiers' Heads

(for Robert G. Shaw Memorial, Boston,
Massachusetts)(Six views). 1884-97. Plaster (six
heads). Height 5-7 inches (12.8-17.8 cm.). Menil
Foundation/Hickey & Robertson, Houston

In his New York studio, the sculptor prepared
forty studies from life for the soldiers trooping
beside Colonel Shaw. The heads, one-third life
size, were thoughtful, beautifully crafted
studies in clay, now preserved as bronze and
plaster casts. Because they lack the finish and
smooth surfaces of most of his bust or relief
portraits, they appear to have been fashioned at
sittings of brief duration with the sculptor
working directly from the posing soldiers
(Dryfhout 1982, 222-229).

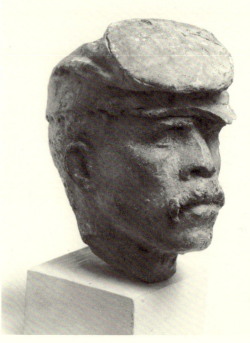

299c

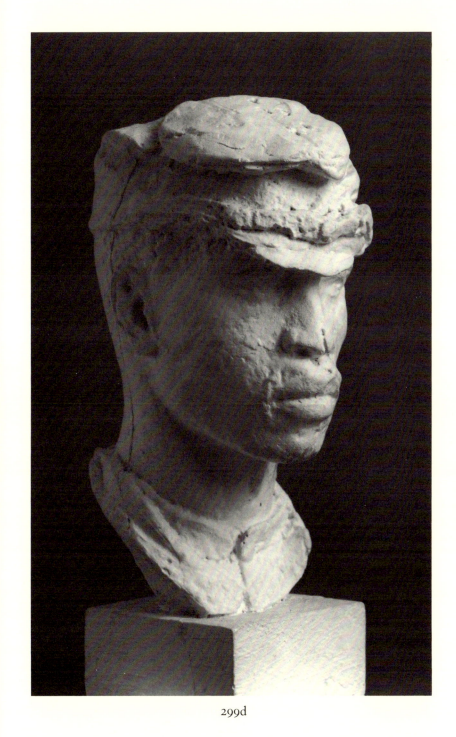

299d

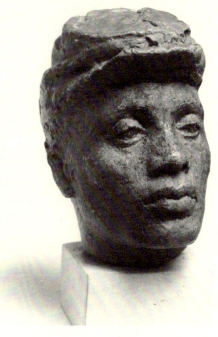

299e

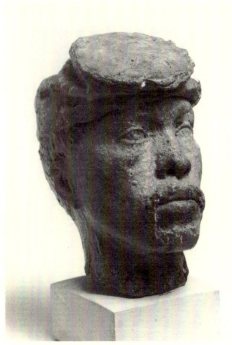

299f

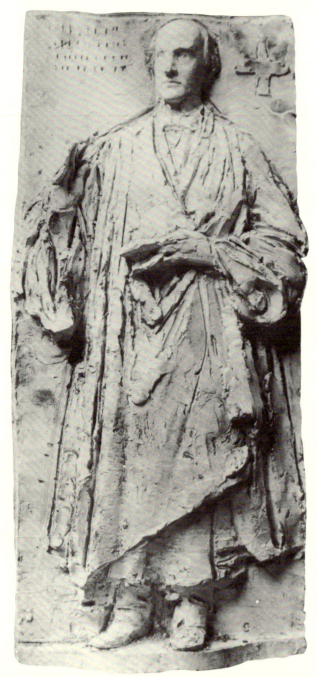

300

300. Henry W. Bellows Memorial

(Destroyed)(for All-Souls Unitarian Church,
New York). 1885. Clay. Archives photograph,
Dartmouth College Library

The clay sketch, now destroyed, was modeled
with Bellows' right hand raised; the left holds
an open book or sheaf of papers. Saint-Gaudens
emphasized the voluminous robe, tucking and
gathering here and there, using the heavy fabric
for its full dramatic effect. Bellows' face is
almost finished, nearly in full round. Only
slight attention was given to the background,
cryptic notations serving for cross and
inscription. In the finished bronze relief
installed in All-Souls Unitarian Church, New
York, the sculptor made the robe even fuller

than the sketch suggested. The inscription
pertaining to the Reverend Bellows (1814-1882)
forms part of the architectural surround
(Dryfhout 1982, 150-151).

301. Adams Memorial

(Destroyed)(Three views)(for Rock Creek
Cemetery, Washington, D.C.). 1886-91. Clay.
Archives photographs, Dartmouth College
Library

Arguably Saint-Gaudens' most important and
best-known work, the enigmatic, brooding
figure of the Adams Memorial was conceived as
part of a collaboration involving Stanford
White and John LaFarge. The stone and bronze
monument in Rock Creek Cemetery,
Washington, D.C., marks the graves of Henry
Adams (1838-1915) and his wife, Marion. She
committed suicide in 1885. Initially, the

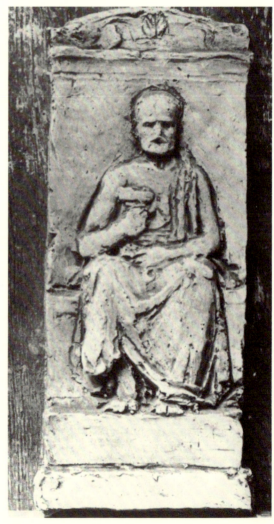

301a

sculptor planned the memorial as a classical stele; in one sketch there is a seated male figure in toga and in the other a female with hooded face, both in low relief. The free-standing female figure eventually developed from a small *bozzetto* of richly fashioned clay into the life-size bronze (Dryfhout 1982, 189-193).

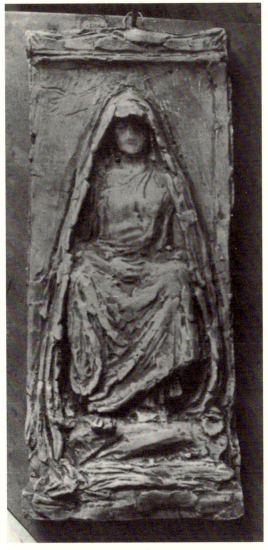

301b

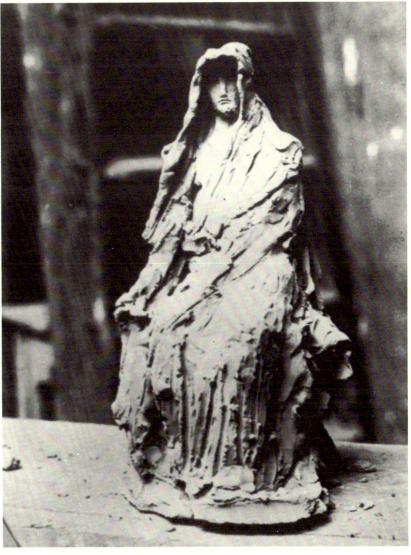

301c

302. Reverend James McCosh Memorial

(Destroyed)(Five Views)(for Princeton University). 1889. Clay. Archives photographs, Dartmouth College Library

Saint-Gaudens modeled thirty-six clay *bozzetti* for the McCosh relief, and seven were recorded in photographs (Saint-Gaudens 1913, 135). His son, Homer, recalled: " . . . in accordance with his custom of experimenting with many designs, the sculptor made thirty-six two-foot sketches for the McCosh relief, before arriving at the final form." This was an exceptionally large number of preliminary studies, especially for a commission of this type. Each sketch in clay depicts the Princeton University President, James McCosh (1811-1894), standing in his ecclesiastical robes, in two instances posed behind a lectern. Perhaps the most interesting and vigorously handled *bozzetto* is that showing three separate positions for the arms. The high relief in bronze resulting from these sketches posed McCosh with one arm extended and one arm resting on his stand, but the final work lacks the strength of any of the sketches (Dryfhout 1982, 179-180).

302a

302b

302c

303

303. Allegorical Figures

(for Boston Public Library). 1892-97. Plaster.
Height 8 inches (both groups)(20.4 cm.).
United States Department of Interior, National
Park Service, Saint-Gaudens National Historic
Site, Cornish, New Hampshire

In 1892, two groups of allegorical figures were
commissioned from Saint-Gaudens for the
piazza of the Boston Public Library. One group
was centered on Labor, supported by figures
representing Science and Art; the other trio was
led by Law, aided by Power and Love. Larger
sketches were developed from these raw, highly
abstract works over an extended period, with
the sculptor's assistants helping in the
modeling. The commission was never
completed before the sculptor's death in 1907,
but bronze casts were made in 1915 of the large
versions of the two groups (now in the Freer
Gallery of Art, Washington, D.C.). The six
seated figures handsomely express Saint-
Gaudens' dictum: "Art was simply a question of
knowing what to eliminate . . . do things
naively and as primitively as possible"
(Dryfhout 1982, 30, 239-240).

302d

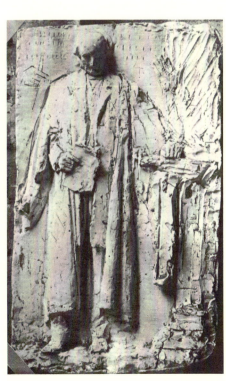

302e

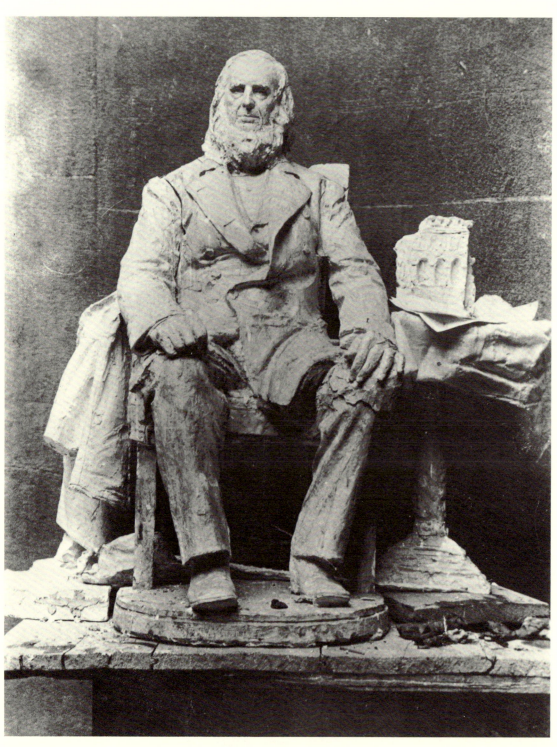

304

304. Peter Cooper Monument

(Destroyed)(for Cooper Square, New York).
1894. Clay. Archives photograph, Dartmouth
College Library

Saint-Gaudens modeled twenty-seven sketches
of the figure of Peter Cooper (1791–1883),
philanthropist and manufacturer, for the statue
in bronze at Cooper Square, New York City.
The archives photograph records a small
bozzetto, sections left rough and grainy, with
crumbs of clay indicating the work in progress.
A precariously placed architectural fragment on
top of the papers apparently was intended as a
prop to balance the composition (Dryfhout
1982, 220–221).

305

305. Christopher Lyman Magee Fountain-Stele

1905-08. Clay. Archives photograph,
Dartmouth College Library

306a 306b

306. Christopher Lyman Magee Fountain-Stele

(Two views). 1905-08. Plaster. Heights 33 and
48 inches (left to right)(83.8 cm. and 122 m.).
United States Department of Interior, National
Park Service, Saint Gaudens National Historic
Site, Cornish, New Hampshire

The classical stele form appealed to Saint-
Gaudens, particularly near the end of his career.
Greek key meanders, akroteria, volutes,
palmettes, and other motifs were arranged in
symmetrical patterns on bronze or granite
shafts, combined with figures in low relief. His
stelae (such as the *Whistler Memorial*, 1906-07,
and the *Dennis Bunker Tombstone*, 1897) were
commemorative monuments for the dead. This
fountain-stele honored Christopher L. Magee
(1848-1901), a Pittsburgh politician and
philanthropist. An allegorical figure,
Benevolence, with cornucopia in hand,
dominated each sketch and the finished bronze,
although each study in clay or plaster differs in
pediment treatment and in small details from
the final relief (Dryfhout 1982, 297-298).

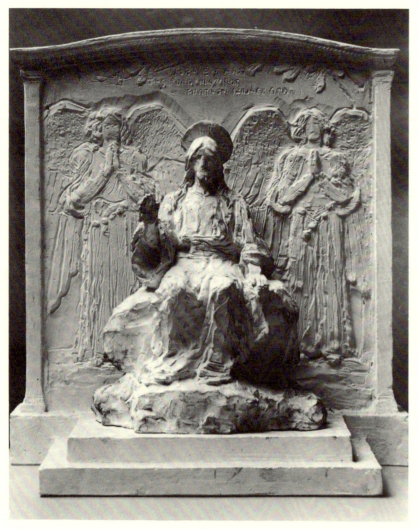

307a

307. George F. Baker Tomb

(Destroyed)(Two views)(for Mount Kisco, New York). 1906–07. Plaster. Archives photograph, Dartmouth College Library

Close to seventeenth-century *bozzetti* are the sketches prepared at the end of the sculptor's career, such as those for the Baker Tomb, Mount Kisco, New York. The seated Christ especially recalls French or Italian works in terra cotta. First modeled in clay, the plaster cast in the archives photograph was made from the original. The relief behind the seated Christ is gouged and cut from the flat plane, and traces of a rasp are seen on robe, proper left sleeve, across the footrest, and on the stepped base. The two standing angels holding scrolls are less sensitively modeled than similar figures in the sculptor's *oeuvre*, perhaps due to the sculptor's last illness. The final stage in the tomb's development was a cast bronze figure of Christ set against a pedimented marble relief. Baker's admiration for the Adams Memorial apparently prompted Saint-Gaudens to model a seated figure reminiscent of the masterpiece of twenty years before (Dryfhout 1982, 301).

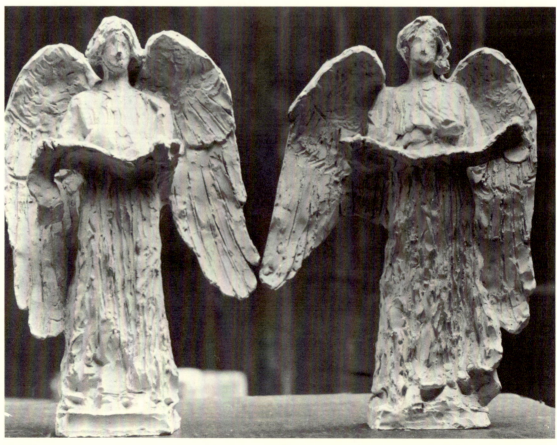

307b

308a

308b

308. Whistler Memorial

(Destroyed)(Two views)(for United States
Military Academy). 1906-07. Clay. Archives
photographs, Dartmouth College Library.

The sculptor's memorial to his American
contemporary, the artist James A. McNeil
Whistler (1834-1903), now installed at the
United States Military Academy, West Point,
resulted from a Copley Society commission
that required an architectural form, not a
sculptural one. The sculptor's first or earliest
sketch, was a simple block, rich with classical
elements and symbolically indicating Whistler's
craft with palette and brushes. The second
bozzetto in clay was photographed on the
sculptor's modeling stand with tools and wads
of fresh clay nearby. The illustration exudes the
freshness of the work. Discarded for the
restrained, slender stele shape that
symmetrically balanced each element (torches,
akroteria, inscription, etc.), Saint-Gaudens used
a device that is exquisite and sensitive, quite like
the prints and paintings created by the artist-
friend it commemorates. The sketches, sparse
in concept and handling, were quickly done, no
doubt, like his other *bozzetti* in clay (Dryfhout
1982, 289-290).

309

309. Caryatid

(for Albright-Knox Art Gallery, Buffalo, New York). 1906-08. Plaster. Height 30 inches (76.2 cm.). United States Department of Interior, National Park Service, Saint-Gaudens National Historic Site, Cornish, New Hampshire, gift of Mary Beaman Lagercrantz and Trustees of the Saint-Gaudens Memorial, 1984

Two groups of caryatids for decorative porches, four on each structure at either end of the neo-classical building designed by Edward Green, were commissioned by John T. Albright in 1906. Saint-Gaudens obviously depended on the caryatids of the Erectheum on the Acropolis, symbolic of Victory, Painting, Sculpture, and Music. One of the sculptor's assistants, Francis Grimes, modeled the figures from Saint-Gaudens' drawings. Although six caryatids were completed by 1907, the models remained in Albright's estate and the finished marbles were not installed until 1933. This rare plaster cast for Architecture is the only known *bozzetto* for this very late project in the sculptor's career (Dryfhout 1982, 302).

Lorado Taft 1860-1936

Born in Elmwood, Illinois. Graduated from the University of Illinois (then called Illinois Industrial University) in 1879. Taft studied at the Ecole des Beaux-Arts, 1880-83, and again in 1884-86. Taught sculpture at the Art Institute of Chicago, 1886-1929, and at the University of Chicago. Always concerned with education, writing, and lecturing, Taft is best known as the author of an important text, *History of American Sculpture* (1903). His large-scale symbolic sculptures and fountains graced the Columbian Exposition and various parks, with imposing figures of monumental proportions. More than 130 sketches by Taft in clay or plaster are housed in the Krannert Art Museum, University of Illinois.

310

310. Awakening of the Flowers

(for Horticultural Building, Columbian Exposition, Chicago). c. 1891-92. Clay. Height 5 inches (12.7 cm.). Krannert Art Museum, University of Illinois, 37-1-96

Lorado Taft joined Daniel Chester French and Frederick MacMonnies as major members of the corps of sculptors commissioned to decorate the complex of buildings, fountains, and arches comprising the Columbian Exposition. Chicago's leading sculptor, Taft provided the decorative schemes for the Horticultural Building, creating two works that perhaps were the last ones modeled under the strong stylistic influence of the Paris Ecole. *Sleep of the Flowers* and the *Awakening of the Flowers* were placed on either side of the main entrance, extravagantly modeled, highly Baroque. This small, richly crafted *bozzetto* illustrates as well as any sketch Taft's superb abilities. Both of the fifteen foot reliefs in the final works were destroyed at the conclusion of the Exposition.

311. Monument

After 1886. Lacquered clay. Height 6⅞ inches (17.5 cm.). Krannert Art Museum, University of Illinois, 37-1-44

The Civil War fostered the demand for memorialization of the fallen, with town and city squares, battlefields, and cemeteries sprouting bronze and stone monoliths. Most frequently employed format for these monuments by Taft and others was a standing soldier or symbolic figure atop a shaft, subordinate figures mounted to the base, and sometimes reliefs attached to the sides of the plinth. Taft's *bozzetto* for an unknown monument suggested in miniature a type seen across the country. After settling in Chicago, he was commissioned to execute at least ten Civil War monuments in Illinois, Indiana, Michigan, New York, and on the fields of Gettysburg, Chickamauga, and Vicksburg (Weller 1983, 2).

311

312. Despair

c. 1897-98. Clay. Height 3 inches (7.7 cm.). Krannert Art Museum, University of Illinois, 37-1-81

313. Seated Nude

Clay. Height 3 inches (7.7 cm.). Krannert Art Museum, University of Illinois, 37-1-60

Taft's figure in clay was the embodiment of the title's definition. Indeed, this sketch is typical of the keen characterization he realized in the modeled clay. Something of the monumental, broadly handled large-scale pieces is suggested in *Despair* as well. This early ideal sculpture was finished in 1898, and according to one biographer, Taft cast the figure from the live model (a criticism leveled at Rodin's *Age of Bronze*) (Williams 1958, 269).

312

313

314. Monument

Before 1900. Clay. Height 3¾ inches (9.5 cm.).
Krannert Art Museum, University of Illinois,
37-1-129

One of Taft's best examples of manipulated clay,
composed of fingerprinted pellets and incised
coils, this sketch for an unknown monument
echoes his *Awakening of the Flowers*, an earlier
bozzetto also in the Ecole tradition. When the
work is separated from the progression it
initiated toward final sculpture, it epitomizes
the American sculptor's foundation in
modeling and the abstraction we sometimes
equate with modernism.

315. St. Louis Universal Exposition Group

c. 1903-04. Clay. Height 4 inches (10.2 cm.).
Krannert Art Museum, University of Illinois,
37-1-43

The sculptor's symbolic fountain group for the
Exposition at St. Louis has not survived, but
this small sketch illustrates an early concept for
the finished sculpture. Karl Bitter assisted Taft
with this project by enlarging his small *bozzetti*
(Williams 1958, 258).

314

315

316. Six Figures Bearing a Coffin

c. 1905. Clay. Height 3 inches (7.7 cm.).
Krannert Art Museum, University of Illinois,
37-1-117

This unusual concept does not follow the
traditional model of tomb sculpture set by
Dumont, Falguière, and Mercié, the French
leaders of the nineteenth-century tradition that
influenced Taft in his formative years. Rather, it
recalls late medieval works that grouped
standing mourners around a casket.

317. Two Figures Seated on Stones

Terra cotta. Height 3⅞ inches (9.9 cm.).
Krannert Art Museum, University of Illinois,
37-1-118

318. Two Figures Kneeling

Terra cotta. Height 3 inches (7.7 cm.). Krannert
Art Museum, University of Illinois, 37-1-42

319. Civil War Monument

c. 1890-95. Terra cotta. Height 3⅜ inches (8.6
cm.). Krannert Art Museum, University of
Illinois, 37-1-76

The forage cap and baggy uniform of the
central figure in this small group indicates it
was a preparatory model for a Civil War
monument. A female figure clings to the
soldier, who strides away to war. Part of the
wire armature is exposed. The sculpture is
reminiscent of a John Rogers Group in compact
format and theme, but not in execution.

320. Fountain of the Great Lakes

(for Grant Park, Chicago). c. 1906-07 (1902?).
Painted plaster. Height 6¾ inches (17.2 cm.).
Krannert Art Museum, University of Illinois,
37-1-101

Five female figures, each holding a large basin
or shell, personified the five Great Lakes:
Superior, Michigan, Huron, Erie, and Ontario.
Sometimes titled "The Spirit of the Lakes"
(Moulton 1914, 14), the uppermost figure
depicts Superior flowing down into Michigan's
basin, and so on, until the lowermost crouching
figure, Ontario, dispatches the water into the
St. Lawrence River. Quickly modeled, the
sketch bears the sculptor's finger strokes and
tool cuts throughout. Because of its small size,
rough surfaces, and handling, it must be the
first *bozzetto* for this commission. The project's
theme was first explored by the sculptor for his
class at the Art Institute of Chicago in 1902,
with revisions made in 1906-07 (Williams 1958,
255-256). The bronze fountain (height 10 feet)
in Grant Park, Chicago, adjacent to the Art
Institute, finally totaled seven figures and was
dedicated September 9, 1913. It was the first
work commissioned from income derived from
the Benjamin F. Ferguson Fund.

316 317 318 319

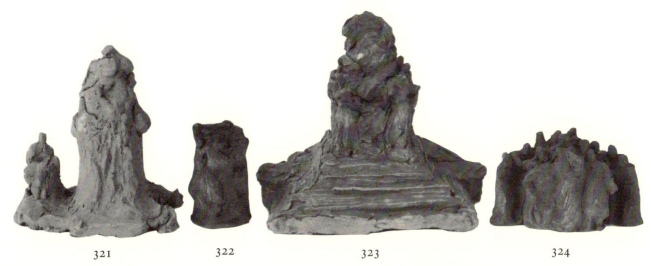

321 322 323 324

321. Monument

(for Fountain of Creation?). Terra cotta. Height 4¾ inches (12.1 cm.). Krannert Art Museum, University of Illinois, 37-1-58

An unusual format was devised in this sketch, pitting a taller shaft against a much smaller grouping (or perhaps single figure?), unlike anything known among Taft's remaining *bozzetti*.

322. Four Standing Women

Clay. Height 2⅝ inches (6.7 cm.). Krannert Art Museum, University of Illinois, 37-1-103

323. Monument

Terra cotta. Height 4¾ inches (12.2 cm.). Krannert Art Museum, University of Illinois, 37-1-45

This sketch for an unknown memorial illustrates the sculptor's preference for solid, balanced forms with a single shaft on a rather broad platform.

324. The Blind

c. 1906-07. Terra cotta. Height 4 inches (10.2 cm.). Krannert Art Museum, University of Illinois, 37-1-114

This is probably the first sketch for the large-scale work derived from Maurice Maeterlinck's play, *Les Aveugles*. The completed sculpture eventually reached massive dimensions (height 9 feet, width 10 feet). The group of sightless men and women, according to a scene in the drama, was guided by a sighted child held aloft by its mother. This is the moment Taft captured. Never realized in a permanent material, only a large plaster model was completed, probably in 1908. It is one of four major works modeled by Taft after 1900 and expresses his aesthetic credo that sculpture should be grand in scale, be given spacious settings, and have literary or ideal subject matter.

320

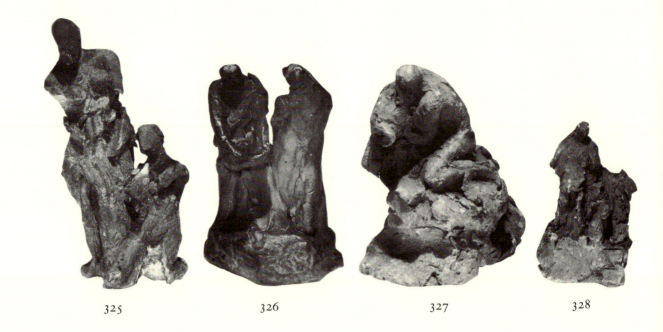

325 326 327 328

325. Two Figures

Clay. Height 3½ inches (8.9 cm.). Krannert Art Museum, University of Illinois, 37-1-78

326. Two Figures

Clay. Height 3 inches (7.7 cm.). Krannert Art Museum, University of Illinois, 37-1-83

327. Crouching Figure

(for *Fountain of the Great Lakes?*). c. 1906-07. Terra cotta. Height 3 inches (7.7 cm.). Krannert Art Museum, University of Illinois, 37-1-59

The single figure perhaps is related to studies for the *Fountain of the Great Lakes*, an early exploration of the theme, simply and less overtly exploring the five bodies of water.

328. Study

(for *Fountain of Creation?*). Terra cotta. Height 2¼ inches (5.7 cm.). Krannert Art Museum, University of Illinois, 37-1-62

329. Fountain of Time

(for Midway Plaisance, Chicago). c. 1909. Painted plaster. Length 22 inches (two sections)(55.9 cm.). Krannert Art Museum, University of Illinois, 37-1-65, 66

Greatly simplified, robed figures surge like ocean waves in this dramatically conceived *bozzetto* for Taft's sculpture on Chicago's Midway Plaisance. His inspiration came from British poet Austin Dobson's (1840-1921) couplet: "Time goes, you say? Ah no! Alas, Time stays, we go." By 1910, at least the *bozzetto* was completed. Taft's concept was recorded by a Chicago Tribune reporter, Harriet Monroe, who must have seen only the

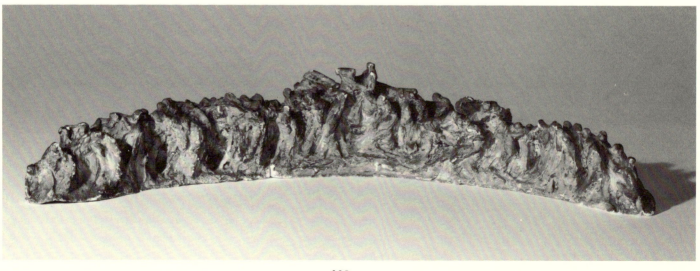

329

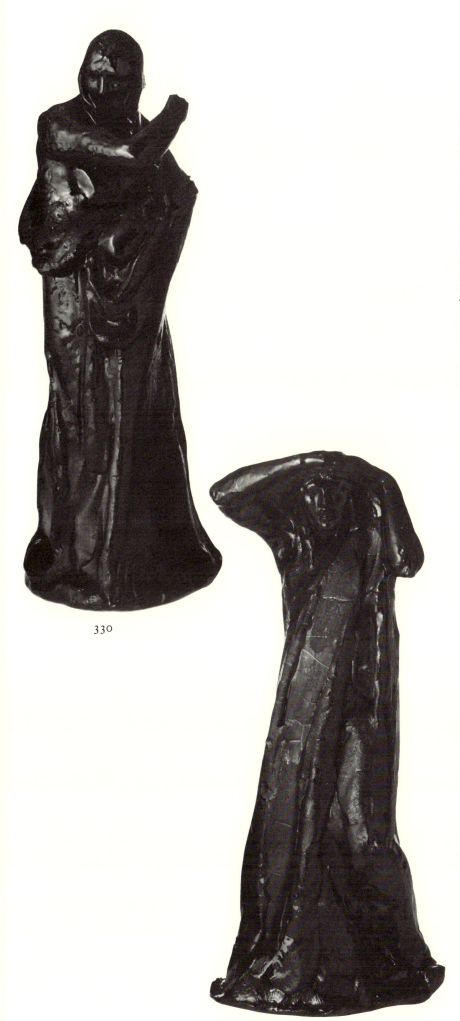

330

331

sketches in his studio: "The fountain of Time shows the human procession passing in review before the great immovable figure of Time. A warrior on horseback, flanked by banners and dancing figures, forms the center of the composition, which fades off at the ends into creeping infancy or the bent and withered figures of age" (Wight 1910, 344). The sculptor's inspiration was credited in a speech delivered to the University of Illinois Alumni Association, June 11, 1907: "The words brought before me a picture, which was speedily transformed by fancy into a colossal work of sculpture. I saw the mighty cray-like figure of Time, mantled like one of Sargent's prophets, leaning upon his staff, his chin upon his hands, and watching with cynical inscrutable gaze, the endless march of humanity – a majestic relief of marble. I saw it, swinging in a wide circle around the form of the lone sentinel, and made up of the shapes of hurrying men, women, and children, in a endless procession, ever impelled by the winds of destiny in the inexorable lock-step of the ages" (*Ibid.*, 349). Naturalistic detail is subordinated to monumentality in both the sketch and the finished monument that was cast in concrete and dedicated November 15, 1922. This work is not the smallest of the sketches for the fountain, for several studies and finished plaster models in various sizes exist in the Krannert Art Museum collection. Revisions were made to the models with each change increasing in size, until a full-scale plaster model was erected on the Midway site in 1920. The monument in its completed state is nearly 110 feet in length.

330. Indian Figure
c. 1910. Lacquered clay. Height 7¾ inches (19.7 cm.). Krannert Art Museum, University of Illinois, 37-1-14

331. Indian Figure
c. 1910. Lacquered clay. Height 7¾ inches (19.7 cm.). Krannert Art Museum, University of Illinois, 37-1-13

The mass of each figure, punctuated by arm gestures, is emphasized by the enveloping cloak or drapery. Both sketches may be studies for an American Indian monument, such as the colossal statue in concrete, *Black Hawk*, in Oregon, Illinois.

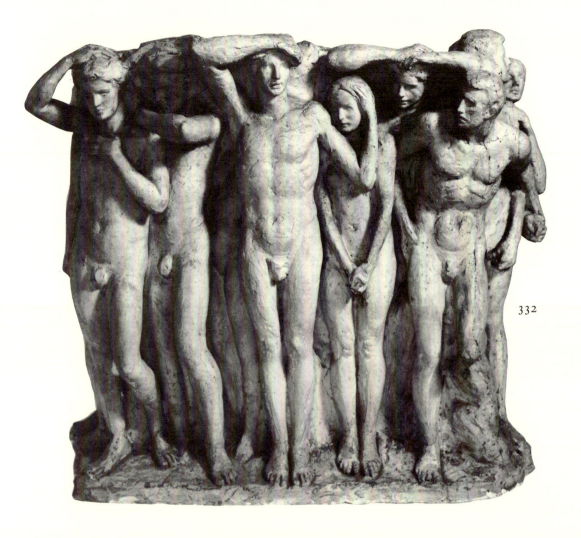

332

332. Figures: Central Group

(for proposed *Fountain of Creation*, Midway
Plaisance, Chicago). c. 1910. Plaster. Height 27
inches (68.6 cm.). Krannert Art Museum,
University of Illinois, 37-1-183

Taft conceived several monumental sculpture
projects that occupied him over many years.
The *Fountain of Creation* was one of these,
designed as a counterpart to the *Fountain of Time*
on Chicago's Midway Plaisance (Weller 1983,
24). This group from the *Fountain of Creation*, a
circular arrangement of male and female nudes
around a pool, was the dominant part of the
proposed work, never completed but worked
on for over twenty-five years. The *bozzetto* for
the entire scheme existed, at least by 1910, when
an article in the *Architectural Record* noted: "The
sketches for the fountains show a scheme,
colossal in its proportions founded on ideals of
elemental grandeur and yet profoundly modern
in their significance" (Wight 1910, 344). By
1928, Taft labored on, still hoping that his
fountain would be completed someday: "In the
midst of such activity he continues gradually
the work which probably he cherishes most,
the Fountain of Creation. By climbing a flight
of narrow stairs concealed behind tall casts in
the front studio, one may reach the small room
which is Mr. Taft's sanctum. Here is a sketch

model of the Fountain of Creation. A series of
groups that build up about a circular pool
represent the origin and development of man;
the first shows a primitive creature emerging (as
a Greek myth has it) from a block of stone.
Gradually this man is developing, until at last
he raises, through struggles, to a great height – a
civilized being who has learned to live with his
fellows in work and aspiration. This monument
will one day be erected in Chicago, it is hoped,
at the east end of the Midway, facing the
Fountain of Time which already stands at the
gates of Washington Park" (Mose 1928, 419).
Thus, by 1928, presumably the same *bozzetto*
seen eighteen months earlier remained in sketch
form. The theme of this incomplete, symbolic
work was a Greek myth of Deucalion and
Pyrrha, two individuals surviving a deluge,
who brought a new race to life from stone and
earth. Various sketches of single figures or
groups were made, at least one with vigorously
modeled surfaces, but most were smoothed and
generalized. Over the years, Taft's concept
progressed through many models; at least ten
small *bozzetti* were shown in an exhibition at
the University of Illinois (Weller 1983, 24) and
fourteen sketches were enlarged in plaster to
ten-foot size (Proske 1943, 50).

335

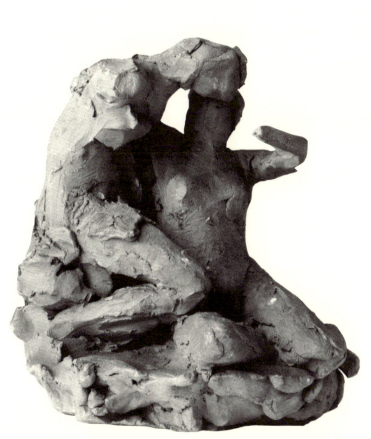

333

333. Embracing Figures
(for proposed *Fountain of Creation*). c. 1910.
Clay. Height 5 inches. (12.7 cm.). Krannert Art
Museum, University of Illinois, 37-1-49

334. Female Figure
(for proposed *Fountain of Creation*). c. 1910.
Terra cotta. Height 7¼ inches (18.4 cm.).
Krannert Art Museum, University of Illinois,
37-1-63

335. Male Figure
(for proposed *Fountain of Creation*). c. 1910.
Terra cotta. Height 6½ inches (16 cm.).
Krannert Art Museum, University of Illinois,
37-1-64

334

336. Stooping Male Figure

(for proposed *Fountain of Creation*). c. 1910.
Terra cotta. Height 7 inches (17.8 cm.).
Krannert Art Museum, University of Illinois,
37-1-31

337. Stooping Male Figure

(for proposed *Fountain of Creation*). c. 1910.
Plaster. Height 8½ inches (21.6 cm.). Krannert
Art Museum, University of Illinois, 37-1-18

338. Stooping Male Figure

(for proposed *Fountain of Creation*). c. 1910.
Terra cotta. Height 7 inches (17.8 cm.).
Krannert Art Museum, University of Illinois,
37-2-34

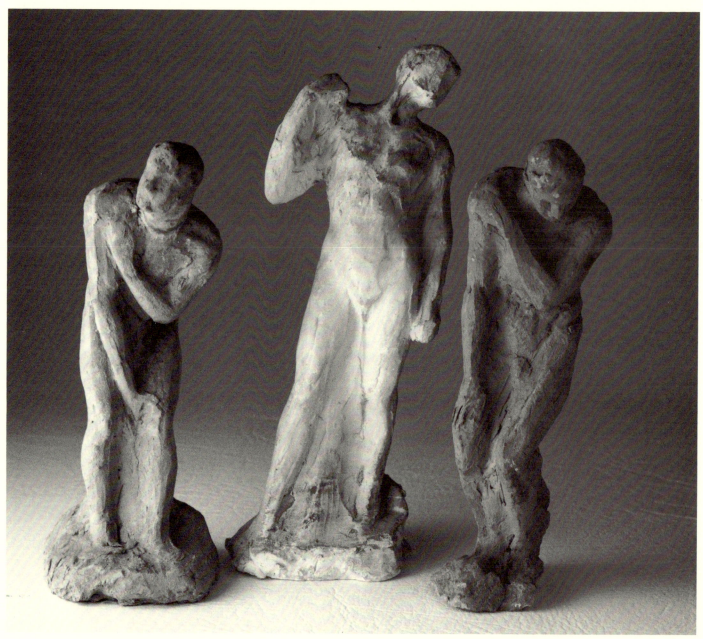

336 337 338

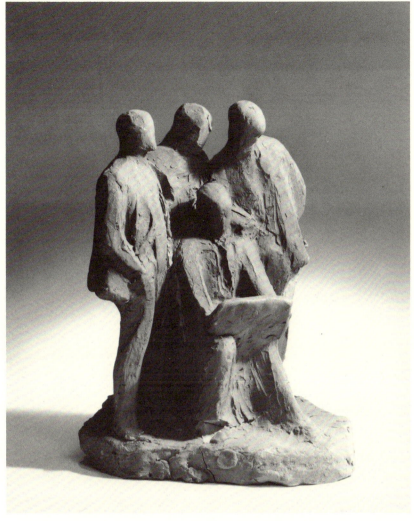

339

339. Group of Figures

c. 1910-20. Clay. Height 8¾ inches (22.3 cm.).
Krannert Art Museum, University of Illinois,
37-1-40

Little resembling earlier *bozzetti*, especially
those modeled under the influence of the Ecole,
this sketch for an unknown sculpture
demonstrates Taft's style in the years bracketing
World War I. Simplified forms and surfaces are
surprisingly abstract, although the sculptor
would have disdained any description of him as
a "modernist." Many artists in their maturity
have broadened their style, eliminating details,
feathering the edges of carved or modeled
surfaces. Taft was no exception: "It would be a
mistake to say that he became in any sense an
abstract artist, for the human figure, basically
realistic in proportion and design, remained the
single great theme of his work, but he was
increasingly conscious of abstract
compositional and material considerations"
(Weller 1983, 3).

340. Sculptor Working on a Bust

c. 1920-30. Clay. Height 2⅞ inches (7.3 cm.).
Krannert Art Museum, University of Illinois,
37-1-120

Apparently depicted is a modeling session for a
portrait bust, the smock-coated sculptor
standing at left with arm extended and the sitter
at right. This *bozzetto* may have some
relationship to the sculptor's dioramas, eight
diminuitive vignettes in clay illustrating
Michelangelo's, Phidias', Claus Sluter's, and
other sculptor's workplaces. A complete set of
these "peep shows" is in the University of
Illinois World Heritage Museum
(Weller 1983, 6).

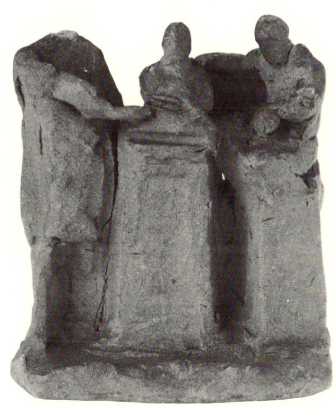

340

341

341. Foote Memorial Angel (Memory)

(for Woodland Cemetery, Jackson, Michigan). c. 1922. Lacquered clay. Height 5¼ inches (13.3 cm.). Krannert Art Museum, University of Illinois, 37-1-11

Taft realized, as did his sculptor contemporaries like Saint-Gaudens, French, and others, the economic necessity of designing grave monuments for private citizens as well as public monuments to honor Civil War dead. For at least fifty years after the great conflict, bronze and granite sculptured complexes were erected in many States and on numerous battlefields. Grief, death, and loss were expressed by the ideal and symbolic. Angels or diaphanous-gowned female figures were preferred for some monuments, and Taft's plan for the Foote family memorial in Woodland Cemetery, Jackson, Michigan, used this subject. The figure was developed from this *bozzetto*, enlarged, cast in bronze, and placed in front of a granite *exedra*. Sometimes called *Memory*, another cast of the same sculpture marks Taft's grave in Elmwood, Illinois (Williams 1958, 265).

342. Omaha War Memorial

c. 1925-26. Plaster. Height 9¼ inches (23.5 cm.). Krannert Art Museum, University of Illinois, 37-1-84

Bodies and costume meld into abstract volumes in this sketch for the Omaha War Memorial, never executed and originally intended for Albany, New York, perhaps as early as 1909-10 (Williams 1958, 274). Taft occasionally re-worked parts of his *bozzetti* for other commissions, as in this case. A monument's sketch, if unsuccessfully received by its commissioners, was easily retained as a plaster cast and resurrected for a later project.

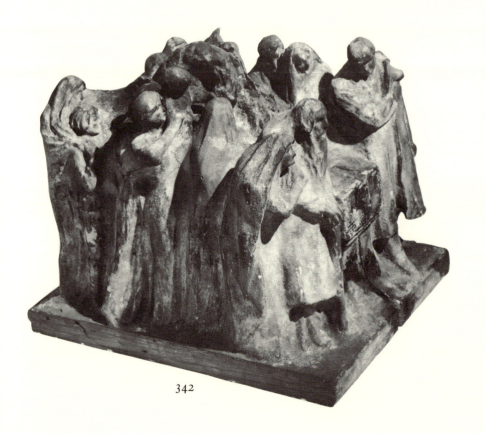

342

343

344

343. Two Fighting Male Nudes
c. 1930. Clay. Height 7 inches (17.8 cm.).
Krannert Art Museum, University of Illinois,
37-1-39

344. Struggling Figures
c. 1930. Terra cotta. Height 6¾ inches (17.2
cm.). Krannert Art Museum, University of
Illinois, 37-1-57

345

345. Lincoln–Douglas Debate Relief
(for Quincy, Illinois). c. 1935-36. Plaster.
Height 10 inches (25.4 cm.). Krannert Art
Museum, University of Illinois, 37-1-56

346. Lincoln–Douglas Debate Relief

(for Quincy, Illinois). c. 1935-36. Plaster. Height 18¾ inches (47.7 cm.). Krannert Art Museum, University of Illinois, 37-1-55

The reliefs illustrate the evolution common to *bozzetti* as the sculptor developed a theme. In the smaller, and slightly earlier of the two, the modeling is coarser and less finished, although Lincoln's and Douglas' physiques and features are detailed enough to recognize each man. Taft's work in low relief never approached the sensitive handling or originality shown in Saint-Gaudens' masterful reliefs. Taft signed the contract for a large bronze plaque (height 117 inches) based on these *bozzetti*, November 25, 1935, to be placed in Quincy, Illinois, the site of Lincoln's debate with Stephen A. Douglas, October 13, 1858. It was the last project he completed. The sculptor attended the dedication in 1936 (Williams 1958, 251-252).

347. Four Figures

Clay. Height 1½ inches (3.8 cm.). Krannert Art Museum, University of Illinois, 37-1-104

348. Two Figures

Clay. Height 2⅝ inches (6.7 cm.). Krannert Art Museum, University of Illinois, 37-1-79

349. Seated Figure

Clay. Height 2⅛ inches (5.4 cm.). Krannert Art Museum, University of Illinois, 37-1-159

346

350. Standing Figures

Clay. Height 2¾ inches (7 cm.). Krannert Art Museum, University of Illinois, 37-1-63

Pinched together in a few minutes, these small *bozzetti* are among Taft's most spontaneous manipulations. The essential elements of the seated figures are blocked in sufficiently to permit a reading of light, shadow, mass, outline and other factors resolved by the sculptor.

351. Standing Male Figure

Clay. Height 4⅛ inches (10.5 cm.). Krannert Art Museum, University of Illinois, 37-1-97

347 348 349 350

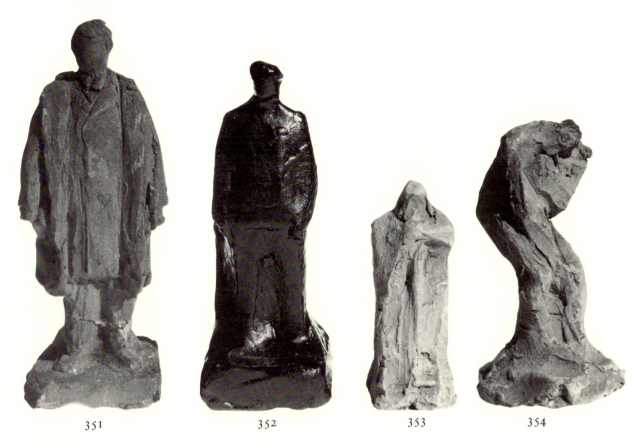

351

352

353

354

352. Standing Male Figure

Lacquered clay. Height 3¾ inches (9.5 cm.).
Krannert Art Museum, University of Illinois,
37-1-98

353. Standing Figure

Terra cotta. Height 2⅛ inches (5.4 cm.).
Krannert Art Museum, University of Illinois,
37-1-38

354. Slouching Figure

Terra cotta. Height 4 inches (10.2 cm.).
Krannert Art Museum, University of Illinois,
37-1-33

355. Seated Figure

Lacquered clay. Height 3¾ inches (9.5 cm.).
Krannert Art Museum, University of Illinois,
37-1-10

356. Two Figures

Clay. Height 5 inches (12.8 cm.). Krannert Art
Museum, University of Illinois, 37-1-22

357. Standing Figure

Lacquered clay. Height 4⅝ inches (11.7 cm.).
Krannert Art Museum, University of Illinois,
37-1-100

358. Standing Figure

Lacquered clay. Height 5½ inches (14 cm.).
Krannert Art Museum, University of Illinois,
37-1-61

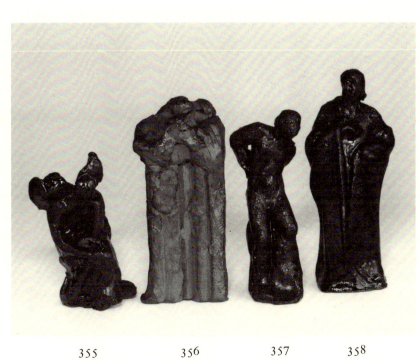

355 356 357 358

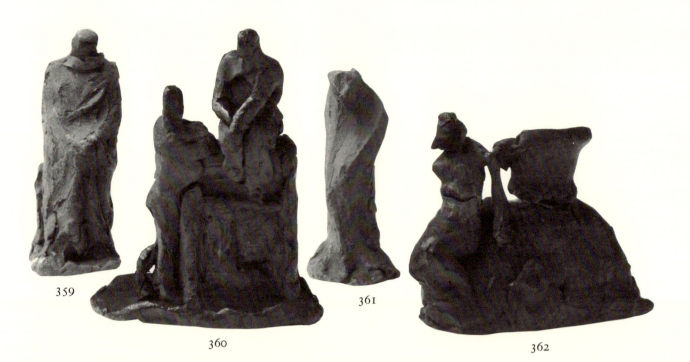

359

360

361

362

359. Standing Figure
Clay. Height 3¾ inches (9.5 cm.). Krannert Art Museum, University of Illinois, 37-1-98

360. Two Figures
Clay. Height 4½ inches (11.4 cm.). Krannert Art Museum, University of Illinois, 37-1-25

361. Standing Figure
Terra cotta. Height 3½ inches (8.9 cm.). Krannert Art Museum, University of Illinois, 37-1-116

362. Seated Female on Sphere
Clay. Height 3 inches (7.7 cm.). Krannert Art Museum, University of Illinois, 37-1-17

Taft's *bozzetti* often were modeled in simple planes, with elongated limbs and flattened surfaces, quite unlike the more naturalistic surface treatment of enlargements or second models. Abstraction for its own sake was not acceptable to the sculptor, of course, and rarely did a finished work retain any suggestion of the non-representational.

363. Female Half-Length
Clay. Height 3 inches (7.7 cm.). Krannert Art Museum, University of Illinois, 37-1-50

Although Taft was very active throughout his career beginning in Paris as a sculptor of bust portraits, this tiny bozzetto must be a study for a figure in a public monument. The hood and nearly crossed arms suggest it was a rough sketch for one of the figures in The Blind or Eternal Silence. None of his existing portraits are posed in this manner.

364. Two Figures Leaning on Bowl
Clay. Height 2¾ inches (7 cm.). Krannert Art Museum, University of Illinois, 37-1-48

363

364

365. Monument
Lacquered clay. Height 4½ inches (11.4 cm.).
Krannert Art Museum, University of Illinois,
37-1-16

366. Monument
Lacquered clay. Height 4½ inches (11.4 cm.).
Krannert Art Museum, University of Illinois,
37-1-9

367. Monument
Lacquered clay. Height 4¾ inches (12 cm.).
Krannert Art Museum, University of Illinois,
37-1-15

The gelatinous, shiny skin over these sketches for monuments may have been a protective coating for the unfired clay. Characteristic of Taft's bozzetti for outdoor monuments with single (or few) figures is the nearly pyramidal format and solid, broad base.

368. Kneeling Figure, Hand on Head
Terra cotta. Height 4 inches (10.2 cm.).
Krannert Art Museum, University of Illinois,
37-1-33

369. Crouching Figure
Terra cotta. Height 4¾ inches (12 cm.) Krannert Art Museum, University of Illinois, 37-1-32

370. Seated Male Nude
Terra cotta. Height 3¾ inches (9.5 cm.)
Krannert Art Museum, University of Illinois,
37-1-36

371. Seated Male Nude
Terra cotta. Height 4½ inches (11.4 cm.).
Krannert Art Museum, University of Illinois,
37-1-37

372. Seated Male Nude
Terra cotta. Height 3¾ inches (9.5 cm.).
Krannert Art Museum, University of Illinois,
37-1-35

Clearly each figure in this grouping echoes the others, illustrating the sculptor's interest in multiple small studies of the same pose or theme. The sketches may have been intended for the Fountain of Creation.

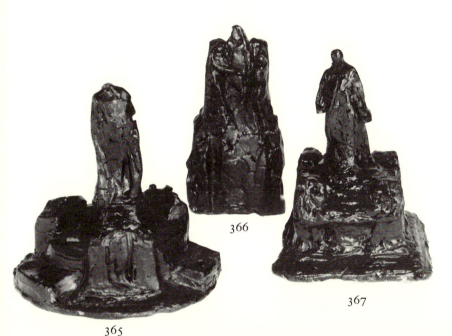

366

367

365

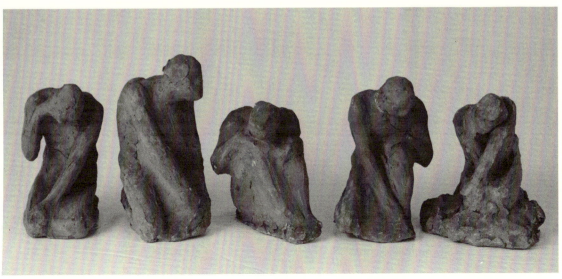

368 369 370 371 372

373

373. Woman at Wash Tub

Clay. Height 3⅛ inches (7.9 cm.) Krannert Art Museum, University of Illinois, 37-1-160

A homely task observed in Champaign, or perhaps on an excursion in France while a student, provided the sculptor with this genre subject. It is quite unlike a group by John Rogers, lacking any strong story-telling, anecdotal qualities and the crisp detail in Rogers' plaster vignettes.

374. Boy with Shell

Plaster. Height 4½ inches (11.4 cm.). Krannert Art Museum, University of Illinois, 37-1-157

Detail is subordinated to broader surfaces in this sketch, expressing Taft's belief that "To be suggestive rather than direct is what I aim at" (Proske 1943, 47). The subject may have been related to a fountain sculpture.

374

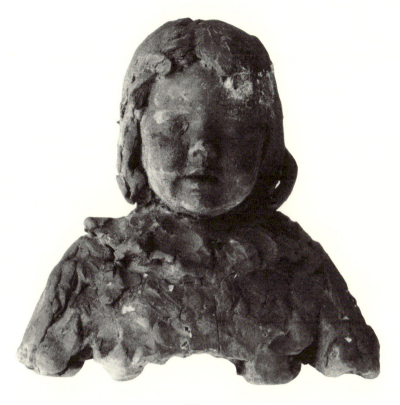

375

375. Bust of a Young Girl

Lacquered clay. Height 6⅞ inches (17.5 cm.). Krannert Art Museum, University of Illinois, 37-1-41

Portraits modeled in clay by the sculptor but cast or carved by others were produced from the Paris years to the end of his career in Chicago. Commissions for children's portraits were rare, so this work may depict one of Taft's daughters.

376. Standing Figure

Terra cotta. Height 8 inches (20.4 cm.). Krannert Art Museum, University of Illinois, 37-1-95

377. Eternal Silence

c. 1907-09. Terra cotta. Height 8 inches (20.4 cm.). Krannert Art Museum, University of Illinois, 37-1-30

378. Standing Figure

Terra cotta. Height 7¾ inches (19.7 cm.). Krannert Art Museum, University of Illinois, 37-1-93

The square plinths, size, and surface finish are typical of Taft's small *bozzetti*. Solidly modeled, the Ecole's technique of handling clay is subordinated to Taft's preference for simplified forms. *Eternal Silence* was commissioned as a cemetery monument.

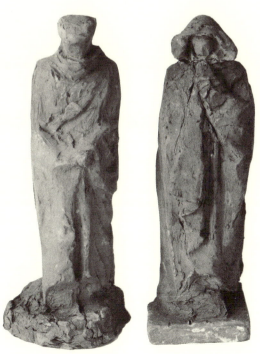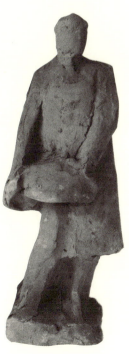

376 377 378

John Quincy Adams Ward

1830-1910

379. Standing Male Figure

Terra cotta. Height 8¼ inches (21 cm.).
Krannert Art Museum, University of Illinois,
37-1-94

Taft's sketches frequently were smoothed with
strokes of a modeling tool that cut or merged
areas giving them a dry, sandy appearance. In
this study the figure's solid form is heightened
by disinterest in surface effects, showing the
sculptor's insistence on "a simplification of
nature for purely formal purposes" (Craven
1968, 495).

Born in Urbana, Ohio. Began his study at age
nineteen with Henry Kirke Brown in
Brooklyn, remaining until 1856. Worked in
Washington, D.C. as portrait sculptor, 1857-60,
and from 1861 he had a studio in New York
City. With little foreign travel or study, Ward
was elected to the National Academy of
Design, 1863, and was first sculptor to serve as
president, 1873-74. First president of National
Sculpture Society, 1893-1905.

380. Study for the Indian Hunter

c. 1859. Wax. Height 4 inches (10.2 cm.).
American Academy and Institute of Arts and
Letters, New York, gift of Mrs. J.Q.A. Ward

Ward's famous work, the *Indian Hunter*, blended
a historical subject with the artist's vigorous
naturalism, the latter a break-away from the
neo-classicism of past decades. Finished
bronzes of *Indian Hunter* are dated 1860, but
Ward completed his modeling of this sketch by
1859 (Sharp 1986, 146). The standard size
(height 26 inches) bronze was first shown
publicly at the Washington Art Association,
Washington, D.C., 1859, and published in the
exhibition catalogue, no. 210, as *The Hunter*.
Indian Hunter derives from a smaller statuette
executed while he worked in Henry Kirke
Brown's studio (Craven 1968, 247) and from
studies made in the West. Henry Tuckerman's
account, written less than a decade after the
sculpture was conceived, extolled Ward's
abilities; "Although Ward has never practiced
modeling in an academy or foreign and famed
studio, he has labored with rare assiduity, to
master the principles of his art; he understands
proportions and anatomical conditions. His
little models of Indian heads in red wax, taken
from life, in Dakotah Territory, are amongst the
most authentic aboriginal physiognomical
types extant in plastic art" (Tuckerman 1867,
582).

379

381. Study for the Indian Hunter

c. 1859. Wax. Height 3¾ inches (9.5 cm.).
American Academy and Institute of Arts and
Letters, New York, gift of Mrs. J.Q.A.Ward

Nine small red wax sculptures by Ward are part
of the American Academy's collection. The
most interesting are the sketches for the brave's
head in the *Indian Hunter*, modeled directly
from life. Ward was asked by a writer in 1878,
"When is the moment of your greatest
enjoyment while modeling a statue?" Ward
replied, attesting to the significance of the
sketch in his creative process: "When I first
begin to realize my idea – when I first feel that I
am successful in reproducing what I intended to
reproduce. One has generally a sense of

dissatisfaction when his work is completed and
ready to leave his hands. The cause of this
dissatisfaction lies, I suppose, in the growth and
development of his perception as he proceeds
with his undertaking" (Sheldon 1878, 67). The
naturalism embodied in the *Indian Hunter*,
seldom seen in American sculpture to this
degree, inspired other sculptors including
Augustus Saint-Gaudens, who wrote: "His
work and career, his virility and sincerity, have
been a great incentive to me, from the day when
he exhibited his 'Indian Hunter' at an art store
on the east side of Broadway. It was a
revelation, and I know of nothing that had so
powerful an influence on those early years"
(Saint-Gaudens 1913, 52).

380

381

382. George Washington

1883. Plaster. Height 15½ inches (39.4 cm.).
Collection of the City of New York

The finished bronze, an over life-size sculpture
of America's first president, is well known due
to its photogenic setting in the New York City's
Wall Street district, a site in front of the Sub-
Treasury Building. Ward was commissioned by
the Chamber of Commerce of the State of New
York "to make a model in clay of the statue,
accompanied by suggestions in regard to size,
bas-reliefs, ornamentation of pedestal, exact
locality, etc. it being understood that, if the
Committee should approve and adopt his plans,
design, and terms, Mr. Ward will be employed
to do the work" (Sharp 1985, 210). Recording
the accepted likeness of the First President, the
bozzetto for the bronze is essentially a costume
piece showing no incompletely modeled
portions, except in the thin platform on which
it stands. Lorado Taft's perception of detail in
the final bronze does not apply to the sketch,
for the latter appears more highly finished than
most late nineteenth-century *bozzetti*: "It has in
it the essentials of Washington, while the
peculiarities, real or imaginary, are left out. The
statue is the greater for the well-weighed
omissions" (Taft 1924, 222).

382

383

383. Marquis de Lafayette

1882–83. Plaster. Height 15 inches (38.1 cm.).
Collection of the City of New York

On June 26, 1883, Burlington, Vermont,
dedicated the bronze enlargement developed
from this *bozzetto* of the Marquis de Lafayette,
depicted as he appeared in 1824–25 when
making his second and final visit to America.
Ward attempted to find a facial study or portrait
of Lafayette, but to no avail. On a trip to Mount
Vernon, probably in 1882, Ward found a
portrait bust in plaster and utilized it as his
model (Walton 1910, lxxxiv). The body's pose
derives, perhaps, from Houdon's impressive
standing portrait of Washington in the State
Capitol, Richmond, Virginia. The
identification of France's greatest contribution
to the American Revolutionary War, Lafayette,
was not made as readily as that of Washington,
even with the addition of such attributes as the
Frenchman's walking stick, Order of
Cincinnati, and greatcoat. Ward's *bozzetto* is
more freely handled than that of *Washington*, but
it is still overly dependent on costume elements
for dramatic effect.

384

384. Architectural Decoration (Fountain Figure)

Plaster. Height 13⅝ inches (34.6 cm.).
American Academy and Institute of Arts and
Letters, New York, gift of Mrs. J.Q.A. Ward

Modeled for an unknown use, this wreathed-
head *term* may have personified Music in a
decorative relief or monument involving the
arts. Musical instruments are depicted on the
plinth beneath the draped bust and at the base of
the relief. The sculpture, cast in plaster from
Ward's modeled clay, is classical and restrained
in its subject and finished surface.

385. Fountain Study

Plaster. Height 12¼ inches (31.2 cm.). American
Academy and Institute of Arts and Letters,
New York, gift of Mrs. J.Q.A. Ward

It is not known if this study was developed
further or enlarged in scale. The verticality of
its simple architectural background is
emphasized by the standing angel with its
drooping wings and skirt wrapped tightly
around the legs. A half-shell held in the angel's
left hand, perhaps suggesting that this was a
model for baptismal font, was the receptacle for
water. The sketch is cast from Ward's clay
original, a smooth, polished conception of
exceptional poise and serenity.

385

Gertrude Vanderbilt Whitney 1875-1942

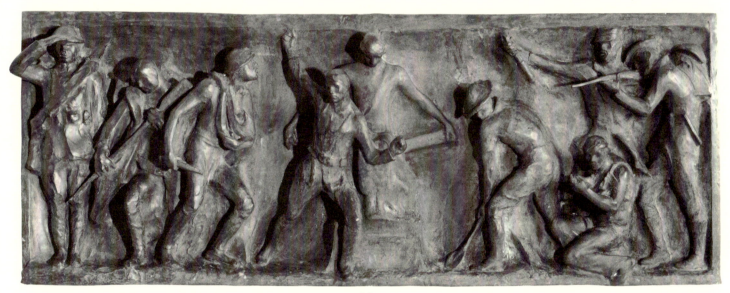

386

Born in New York City. Studied at the Art Students League with James Earle Fraser and by 1910 with Andrew O'Connor in Paris. Sculpture put aside at the outbreak of World War I, she established a field hospital in France. War memorials were sculpted after the war, 1918-24. Especially interested in architectural and fountain sculpture, she won numerous awards, including the bronze medal at the Panama-Pacific International Exposition, 1915. She championed liberal art causes in America, maintained a gallery to show artist's works, and founded the Whitney Museum of American Art in 1930.

386. Bas-Relief (for Victory Arch, New York) 1918-19. Bronze. Height 24 inches (61 cm.). Signed: Gertrude V. Whitney. Marked: Roman Bronze Works, N.Y. Conner·Rosenkranz, New York

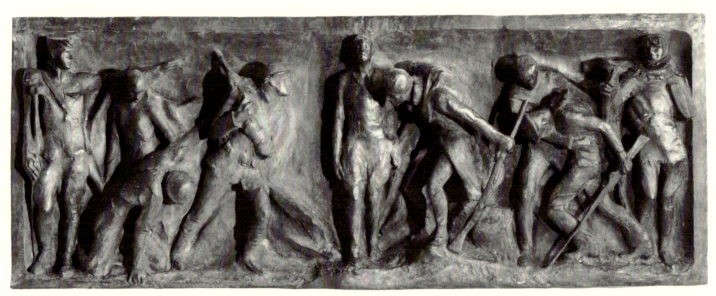

387

387. Bas-Relief (for Victory Arch, New York)
1918-19. Bronze. Height 24 inches (61 cm.).
Signed: Gertrude V. Whitney. Marked: Roman
Bronze Works, N.Y. Conner·Rosenkranz,
New York

Whitney's involvement in relief efforts during
World War I was substantial. Her considerable
wealth permitted the funding of a complete
hospital in France, in which she also served for
five months in 1914-15 (Pené du Bois 1919, 3).
Returning to New York, she modeled a large
number of small figures in clay that "reveal the
intensity of Whitney's feelings about the waste
of war and the dogged heroism of the
combatants, and are in marked contrast with
the more naturalistic and finished figures in her
commissioned war memorials of a few years
later" (Hill 1984, 16-17). Two relief panels for a
Victory Arch, a temporary structure set up in
1919 celebrating the return of the American
Expeditionary Force, were modeled. These
were based on the small, fully round
statuettes. The two reliefs in cast bronze
illustrate Whitney's free, spirited technique and
sensitively abstracted forms.

Bibliography

Adams, Adeline. *The Spirit of American Sculpture.* New York, 1929

———. *Daniel Chester French, Sculptor.* Boston and New York, 1932

Adams, Henry. "The Development of William Morris Hunt's The Flight of Night." *American Art Journal,* Spring, 1983, 43-52

Adeline, J. *The Adeline Art Dictionary.* New York, 1966

Auerbach, Arnold. *Modelled Sculpture and Plaster Casting.* New York, 1961

Avery, Charles. "Giambologna's Sketch-models and His Sculptural Technique." *Connoisseur,* September 1978, 3-11

Baldinucci, F. *Notizie dei Professori del disegno,* II. Florence, 1846 edition

Balge, Marjorie P. *William Ordway Partridge (1861-1930): American Art Critic and Sculptor.* Ph.D. dissertation, University of Delaware, 1982

Bartlett, T. H. *The Art Life of William Rimmer.* Boston, 1882

Bermingham, Peter. *Jacques Lipchitz Sketches and Models in the Collection of the University of Arizona Museum of Art.* Tucson, University of Arizona, 1982

Birnbaum, Martin. *Catalogue of a Memorial Loan Exhibition of the Works of Robert Frederick Blum.* Berlin Photographic Company, New York, 1913

Bogart, Michele H. "Four Sculpture Sketches of Paul W. Bartlett for the New York Public Library." *Georgia Museum of Art Bulletin,* VII, no. 2, 1982

Brinckmann, A.E. *Barock-Bozzetti,* 4 volumes. Frankfurt-am-Main, 1923-25

Broder, Patricia Jarvis. *Bronzes of the American West.* New York, 1974

Caffin, Charles H. *American Masters of Sculpture.* New York, 1903

Carr, Cornelia. *Harriet Hosmer, Letters and Memories.* New York, 1912

Catalogue of American Portraits in The New York Historical Society, I. London, 1974

Chamberlain, Georgia. *Studies on American Painters and Sculptors of the Nineteenth Century.* Annandale, Virginia, 1965

Cincinnati Art Museum, ed. William J. Baer. *Exhibition of Paintings and Studies of the Late Robert Frederick Blum.* Cincinnati, 1905

———. *A Retrospective Exhibition, Robert F. Blum, 1857-1903.* Cincinnati, 1966

Clark, Robert J. "Frederick MacMonnies and The Princeton Battle Monument," *Record of the Art Museum,* Princeton University, XLIII, no. 2, 1984

College Art Association of America, New York. "A Statement on Standards for Sculptural Reproduction and Preventive Measures to Combat Unethical Casting in Bronze." April 27, 1974

Conner, Janis C. *A Dancer in Relief, Works by Malvina Hoffman.* Hudson River Museum, New York, 1984

Cortissoz, Royal. "The Making of a Mural Decoration." *Century Magazine,* November 1899, 61-62

Crane, Sylvia E. *White Silence: Greenough, Powers, and Crawford.* Coral Gables, Florida, 1972

Craven, Wayne. *Sculpture in America.* New York, 1968.

———. "Henry Kirke Brown: His Search for An American Art in the 1840s." *American Art Journal,* IV, no. 2, November 1972, 44-58

———. "The Origins of Sculpture in America: Philadelphia, 1785-1830." *American Art Journal,* IX, No. 2, November 1977, 4-33

Dennis, James M. *Karl Bitter, Architectural Sculptor 1867-1915.* Madison, Milwaukee, and London, 1967

Domit, Moussa M. *The Sculpture of Thomas Eakins.* Corcoran Gallery of Art, Washington, D.C., 1969

Dryfhout, John, and Beverly Cox. *Augustus Saint-Gaudens, The Portrait Reliefs.* Smithsonian Institution, Washington, D.C., 1969

Dryfhout, John H. *The Work of Augustus Saint-Gaudens.* Hanover and London, 1982

Dunlap, William. *A History of the Rise and Progress of the Arts of Design in the United States,* 3 vols, 1834; reprint: Dover Publications, New York, 1969

Eliscu, Frank. *Sculpture Techniques in Clay, Wax, Slate.* Philadelphia and New York, 1959

Fairbanks, Mrs. Charles M. "Robert Blum, An Appreciation." *Metropolitan Magazine,* July 1904, 506-519

Fairman, Charles E. *Art and Artists of the Capitol of the United States of America.* Washington, D.C., 1927

Fanshaw, Daniel. "The Exhibition of the National Academy of Design, 1827. The Second." *The United States Review and Literary Gazette,* II, July 1827, 260

Florentia. "A Walk Through the Studios of Rome." *Art Journal,* VI, 1854, 184, 287, 322, 350

Fogg Art Museum, text by Arthur Beale, John Dryfhout, and Michael Richman, ed. Jeanne L. Wasserman. *Metamorphoses in Nineteenth-Century Sculpture.* Cambridge, Massachusetts, 1975

Fogg Art Museum and Arthur M. Sackler Foundation, ed. Lois Katz. *Fingerprints of the Artist, Terracotta Sculpture from the Arthur M. Sackler Collections.* Cambridge, Massachusetts, 1981

Gale, Robert L. *Thomas Crawford, American Sculptor.* Pittsburgh, 1964

Gardner, A.T., *Yankee Stonecutters: The First American School of Sculpture 1800-1850.* New York, 1945

Garrett, W.D., P.F. Norton, A. Gowans, and J.T. Butler. *The Arts in America, The Nineteenth Century.* New York, 1969

Gerdts, William H. "Sculpture by 19th Century American Artists in the Collection of the Newark Museum." *Museum* (Newark), n.s. 14, no. 4, Fall 1962, 1-22 .

———. "Marble and Nudity." *Art in America,* May 1971, 60- 67

———. "William Wetmore Story." *American Art Journal,* IV, no. 2, November 1972, 16-33

———. *American Neo-Classic Sculpture, The Marble Resurrection.* New York, 1973

Goodrich, Lloyd. *Thomas Eakins, His Life and Works.* Whitney Museum of American Art, New York, 1933

———. *Thomas Eakins,* 2 volumes. Cambridge, Massachusetts, 1982

Greenthal, Kathryn T. and Michael Richman. "Daniel Chester French's Continents." *American Art Journal,* VIII, no. 2, November 1976, 47-58

Greenwald, Alice M. *Ezekiel's Vision: Moses Jacob Ezekiel and the Classical Tradition.* National Museum of American Jewish History, Philadelphia, 1985

Greer, H. H. "Frederick MacMonnies, Sculptor." *Brush and Pencil,* April 1902, 1-15

Haggar, R.G. *A Dictionary of Art Terms.* New York, 1962

Hanser, Christian. *Art Foundry.* Geneva, Switzerland, 1972

Hawthorne, Nathaniel. *The Marble Faun, or The Romance of Monte Beni.* Pocket Library edition, New York, 1958 (first published 1860)

Hill, May Brawley. *The Woman Sculptor, Malvina Hoffman and Her Contemporaries.* Berry-Hill Galleries, New York, 1984

Hosmer, Harriet. "The Processes of Sculpture." *Atlantic Monthly,* XIV, December 1864, 734-737

Howarth, Shirley R. *C. Paul Jennewein, Sculptor.* The Tampa Museum of Art, Tampa, Florida, 1980

Hughes, Rupert. "The Sculpture of Gutzon Borglum." *Appleton's Magazine,* December 1906, 709-717

Jackson, Harry. *Lost Wax Bronze Casting.* Flagstaff, Arizona, 1972

James, Henry. *William Wetmore Story and His Friends,* 2 volumes. Boston, 1903

Janson, H.W. "Rediscovering Nineteenth-Century Sculpture." *Art Quarterly,* Winter 1973, 411-414

———. *19th Century Sculpture.* New York, 1985

Jarvis, James J. "American Art in Europe." *Art Journal,* XVIII, 1879, 137-139

Kashey, Robert and Martin L.H. Reymert. *Western European Bronzes of the Nineteenth Century.* New York, 1973

Keyzer, Frances. "Some American Artists in Paris." *The International Studio,* IV, June 1878, 247

Kirstein, Lincoln. *William Rimmer 1816-1879.* Whitney Museum of American Art, New York, 1946

———. *Elie Nadelman.* New York, 1973

Krakel, Dean. *End of the Trail: Odyssey of a Statue.* Norman, Oklahoma, 1973

Langdon, W.C. "William Ordway Partridge, Sculptor." *New England Magazine,* n.s. 22, June 1900, 382-398

Leach, Frederick D. *Paul Howard Manship, An Intimate View.* Minnesota Museum of Art, Saint Paul, Minnesota, 1972

Low, Will H. "Frederick MacMonnies." *Scribner's Magazine,* XVIII, November 1895, 617-628

Lydenberg, Harry Miller. *History of the New York Public Library, Astor, Lenox and Tilden Foundations.* New York, 1923

Lynes, Russell. *The Art-Makers of Nineteenth Century America.* New York, 1970

"The MacMonnies Pioneer Monument for Denver." *The Century Magazine,* LXXX, October 1910, 876-880

Madigan, Mary Jane. *The Sculpture of Isidore Konti (1862-1938).* Hudson River Museum, New York, 1974

Mayer, Ralph. *A Dictionary of Art Terms and Techniques.* New York, 1969

"The McConnell Statue." *Alumni Bulletin of the University of Virginia,* August-October 1919, 347-348

McLanathan, Richard. *The American Tradition in the Arts,* New York, 1968

McLaughlin, George. "Cincinnati Artists of the Munich School." *The American Art Review,* II, no. 14, 46-48

McSpadden, J. Walker. *Famous Sculptors in America.* New York, 1924

Moffett, Cleveland. "Grant and Lincoln in Bronze." *McClure's Magazine,* October 1895, 419-432

Mose, Ruth H. "Midway Studio." *The American Magazine of Art,* XIX, August 1928, 413-422

Moulton, Robert H. "Lorado Taft, Interpreter of the Middle West." *Architectural Record,* XXXVI, July 1914, 12-24

Murray, Peter and Linda. *A Dictionary of Art and Artists,* 3rd edition. Aylesbury, England, 1972

Murtha, Edwin. *Paul Manship.* New York, 1959

Newman, Thelma R. *Wax As An Art Form.* New York and London, 1966

O'Hara, Frank. *Nakian.* Museum of Modern Art, New York, 1966

The Oxford Companion to Art, ed. by Harold Osborne. Oxford, England, 1970

Partridge, William O. "An American School of Sculpture." *The Arena,* XLII, May 1893, 641-653

———. *The Technique of Sculpture.* Boston, 1895

Pené du Bois, Guy. *An Exhibition of Sculpture by Gertrude V. Whitney* MDCCCCXIX *(Impressions of the War).* New York, 1919

Pennsylvania Academy of the Fine Arts, text by

Linda Bantel, Dodge Thompson, Frank H. Goodyear, Jr., W. H. Gerdts, and Virginia N. Naude. *William Rush, American Sculptor*. Philadelphia, 1982

Phillips, Mary E. *Reminiscences of William Wetmore Story: The American Sculptor and Author*. Chicago and New York, 1897

Polk, R.A. "The Princeton Battle Monument." *The American Magazine of Art*, XIV, January 1923, 6-8

"The Processes of Sculpture." *Cosmopolitan Art Journal*, II, December 1857, 33

Proske, Beatrice G. *Brookgreen Gardens Sculpture*. Brookgreen, South Carolina, 1943

De Quelin, Rene. "Early Days with MacMonnies in St. Gaudens' Studio." *Arts and Decoration*, April 1922, 424-425, 479

Reynolds, Donald M. *Hiram Powers and His Ideal Sculpture*. Ph.D. dissertation, Columbia University, 1975

Rich, Jack C. *The Materials and Methods of Sculpture*. New York, 1947 (1970 ed.)

Richman, Michael. "The Early Public Sculpture of Daniel Chester French." *American Art Journal*, IV, no. 2, November 1972, 97-115

_____. *Daniel Chester French: An American Sculptor*. Metropolitan Museum of Art, New York, and the National Trust for Historic Preservation, 1976

Rogers, Millard F. Jr. *Randolph Rogers, American Sculptor in Rome*. Amherst, Massachusetts, 1971

Rogers, Randolph. *Journal, 1867-1891*. Manuscript in Michigan Historical Collections, Ann Arbor, Michigan

Rosenkranz, Joel. *Sculpture on a Grand Scale: Works from the Studio of Leo Friedlander*. Hudson River Museum, New York, 1984

Rusk, William S. *William Henry Rinehart, Sculptor*. Baltimore, Maryland, 1939

Saint-Gaudens, Augustus, ed. Homer Saint-Gaudens. *The Reminiscences of Augustus Saint-Gaudens*, 2 volumes. New York, 1913

Sculpture Collections of the Cincinnati Art Museum. Cincinnati Art Museum, Cincinnati, 1970

Shaff, Howard and Audrey K. *Six Wars at a Time: The Life and Times of Gutzon Borglum, Sculptor of Mount Rushmore*. Sioux Falls, South Dakota, 1985

Shapiro, Michael E. *Bronze Casting and American Sculpture 1850-1900*. Newark, London, and Toronto, 1985

Sharp, Lewis I. *New York City Public Sculpture*. Metropolitan Museum of Art, New York, 1974

_____. *John Quincy Adams Ward: Dean of American Sculpture*. Newark, Delaware, 1985

Sheldon, G.W. "An American Sculptor." *Harper's Magazine*, LVII, June 1878, 62-68

Shepard, Lewis A. *A Summary Catalogue of the Collection at the Mead Art Gallery*. Amherst, Massachusetts?, 1978

Siedler, Jan and Kathryn Greenthal. *The Sublime and The Beautiful: Images of Women in American Sculpture, 1840-1930*. Boston Museum of Fine Arts, Boston, 1983?

Simpson, Pamela H. *The Sculpture of Charles Grafly*. Ph.D. dissertation, University of Delaware, 1974

Strachan, W.J. *Towards Sculpture, Drawings and Maquettes from Rodin to Oldenburg*. Boulder, Colorado, 1976

Taft, Lorado. *The History of American Sculpture*. New York, 1924

Thorp, Margaret F. *The Literary Sculptors*. Durham, North Carolina, 1965

Tuckerman, Henry T. *Book of the Artists. American Artist Life*. New York and London, 1867

Vasari, Giorgio. *Vasari on Technique, Being the Introduction to the Three Arts of Design, Architecture, Sculpture and Painting, Prefixed to the Most Excellent Painters, Sculptors, and Architects*. Translated by Louisa S. Maclehose. London, 1907 (first published 1550)

"Visits to the Studios of Rome." *Art Journal*, X, 1871, 162-164

Walker, Katherine C. "American Studios in Rome and Florence." *Harper's New Monthly Magazine*, XXXIII, June 1866, 101-105

Wallace, David H. *John Rogers, The People's Sculptor*. Middletown, Connecticut, 1967

Walton, William. "The Works of J.Q.A. Ward, 1830-1910." *International Studio*, XL, June 1910, lxxxi-lxxxvii.

Wehle, Harry B. *Samuel F.B. Morse, American Painter*. Metropolitan Museum of Art, New York, 1932

Weller, Allen S. *Lorado Taft, A Retrospective Exhibition: January 16 to February 20, 1983. Krannert Art Museum Bulletin*, University of Illinois, VIII, No. 2, 1983

_____. *Lorado in Paris, The Letters of Lorado Taft 1880-1885*. University of Illinois Press, Urbana and Chicago, 1985

Wheeler, Charles V. "Bartlett (1865-1925)." *The American Magazine of Art*, XVI, November 1925, 572-583

Whitney Museum of Art, text by Tom Armstrong, Wayne Craven, Norman Feder, Barbara Haskell, Rosalind E. Krauss, Daniel Robbins, Marcia Tucker. *200 Years of American Sculpture*. New York, 1976

Williams, Lewis W. *Lorado Taft: American Sculptor and Art Missionary*. Ph.D. dissertation, University of Chicago, 1958

Wright, Nathalia. *Horatio Greenough, The First American Sculptor*. Philadelphia, 1963

Wright, Peter B. "Apotheosis of the Midway Plaisance." *Architectural Record*, XXVIII, November 1910, 335-349

"Z," "Sculpture and Sculptors in the United States." *American Monthly Magazine*, I, May 1829, 127-128

Photography Credits

All photographs were provided by the institution or reference noted in the illustration's credit line, unless noted otherwise below:

Pages 6, 8, 12: Grafly Manuscript Collection, Wichita State University

Page 14: *upper,* Photographs of Artists, Collection I, Archives of American Art, Smithsonian Institution
lower, American Jewish Archives, Cincinnati, Ohio

Page 15: *upper,* Jeffrey Nintzel
lower, Cincinnati Art Museum Archives

Page 17: Cincinnati Art Museum Archives

Page 19: *upper,* Fraser Collection, George Arents Research Library for Special Collections at Syracuse University
lower, Architect of the Capitol in the United States Capitol Art Collection

Page 20: *upper,* Rushmore-Borglum Story, Keystone, South Dakota
lower, Charles Scribner's Sons Papers, Archives of American Art, Smithsonian Institution

Pages 24-25: Illustrations from William O. Partridge, *The Techniques of Sculpture,* Boston, 1895, figures 1-4

Page 27: *Karl Bitter, Architectural Sculptor 1867-1915* by James M. Dennis, University of Wisconsin Press, Madison, Milwaukee, and London, 1967

Page 32: Jerry L. Thompson

Page 91: Scott Bowron

Page 92, no. 99: Scott Bowron

Page 93: Scott Bowron

Pages 94-126: Gary Buettgenbach

Pages 127-128: Scott Bowron

Page 133, no. 190: George Holzer

Page 154: Scott Bowron

Page 156, no. 241: Scott Hyde

Page 157: Scott Hyde

Page 158, no. 244: Scott Hyde; no. 245: Norlene Tips

Page 160: Scott Hyde

Page 161, no. 251: Scott Hyde

Pages 163-164: Scott Hyde

Pages 166-167: Scott Hyde

Page 168: Scott Bowron

Page 169: Jerry Mathiason, Minneapolis

Pages 171-174: Richard Benson

Page 175: Scott Bowron

Pages 229-230: Scott Bowron

Index